Carpenter Ants

of the United States and Canada

Carpenter Ants
of the United States and Canada

Laurel D. Hansen and John H. Klotz

Spokane Falls Community College University of California, Riverside

Comstock Publishing Associates

A DIVISION OF CORNELL UNIVERSITY PRESS

ITHACA AND LONDON

First published 2005 by Cornell University Press

Printed in China

Library of Congress Cataloging-in-Publication Data

Hansen, Laurel Dianne, 1940–
 Carpenter ants of the United States and Canada / Laurel D.
Hansen, John H. Klotz.
 p. cm.
 Includes bibliographical references and index.
 ISBN 0-8014-4262-1 (cloth : alk. paper)
 1. Carpenter ants—United States. 2. Carpenter ants—
Canada. I. Klotz, John H., 1946– II. Title.
QL568.F7H25 2005
595.79′6—dc22
 2004017456

Cornell University Press strives to use environmentally responsi-
ble suppliers and materials to the fullest extent possible in the
publishing of its books. Such materials include vegetable-based,
low-VOC inks and acid-free papers that are recycled, totally
chlorine-free, or partly composed of nonwood fibers. For further
information, visit our website at www.cornellpress.cornell.edu.

Cloth printing 10 9 8 7 6 5 4 3 2 1

To Roger D. Akre (1937–1994)

Contents

Preface

Carpenter ant is the common name for members of the genus *Camponotus* that excavate nests in wood. Most species in this genus, however, are not true carpenter ants because they nest in preformed cavities or soil. The primary focus of this book is on the carpenter ants that are structural or nuisance pests in the United States and Canada. The biology and control of *C. modoc* Wheeler is emphasized based on the comprehensive research of Laurel Hansen and Roger Akre. Some European references to *C. herculeanus* (L.) are included because this species is also found in the area under study. The scientific nomenclature is according to B. Bolton, *A New General Catalogue of the Ants of the World* (Harvard University Press, 1995), and the species names reflect current usage. References to former names are included in the chapter on taxonomy and distribution.

The first draft of this book, written by Laurel Hansen and Roger Akre, emphasized carpenter ants of the Pacific Northwest and Minnesota, information from the latter being based on Roger's frequent collecting trips to that state. John Klotz brings his experience with carpenter ants from Kansas, Indiana, Florida, and California. In preparing the final drafts, Laurel and John visited many parts of the country and exchanged information about carpenter ants with various researchers and pest management professionals, which significantly enhanced the content of this book.

Both authors began their studies of carpenter ants in graduate school. At Washington State University, Laurel Hansen was funded by grants from the Washington State Pest Control and Pacific Northwest Pest Management Associations. She received Orkin Awards in 1993 and 1999 for Excellence in Research, which were used partly to fund some of the illustrations in this book by Janet Reynolds. To a significant degree, though, Laurel's

carpenter ant studies were pursued on her own time without grant support, which is one of the reasons why it has taken so long to write this book.

John Klotz began his studies on carpenter ants as a graduate student at the University of Kansas, where he was fortunate to have as his mentor Rudolf Jander, a world-renowned authority on ant behavior. After teaching middle-school science for three years, John moved to California to join Lloyd Pest Control in San Diego as its technical director. After gaining valuable industry experience in pest control under the direction of Herb Field, John returned to academics as a postgraduate researcher at Purdue University with Gary Bennett, Byron Reid, and Bobby Corrigan. It was at Purdue that John first contacted Roger Akre about carpenter ants. After many conversations over the phone, John made a trip to Washington to meet Roger. John fondly remembers the two weeks he spent in the Pacific Northwest, visiting Roger's laboratory, his field research sites, and his home to meet his lovely wife, Edie Akre. In the best of scientific and human spirit, Roger freely shared with John his vast knowledge and understanding of carpenter ant biology and control. Later John joined the U.S. Department of Agriculture-Agricultural Research Service in Florida to continue his studies of carpenter ants with Richard Patterson, Dave Williams, Lloyd Davis Jr., Dan Suiter, David Oi, Karen Vail, and Jim Moss. He is now associate entomologist at the University of California, Riverside, where he is continuing his research on ants with Mike Rust and Les Greenberg.

Laurel and Roger completed the first draft of this book in August 1994, just one week before Roger's death. The authors recognize that Roger would have welcomed the addition of John as a coauthor. Laurel and John remember Roger not only as a colleague but also as a mentor and friend. They thank him for his support of both their careers in myrmecology and for his contributions to this book, which is dedicated to his memory.

Acknowledgments

We were fortunate to have Janet D. Reynolds from Spokane, Washington, as a scientific illustrator. All of her drawings were made freehand. In order to accurately depict ants in detail, Janet first had to carefully observe and study their morphology and behavior. In addition to being a first-rate scientific illustrator, she is also a naturalist and conservationist who has devoted her life to the study of organisms in their natural environment.

Our graphic illustrator, Sharon Carroll, assisted in the preparation of illustrations by adding labels to drawings after they were scanned. She is also responsible for the reproduction of many of the graphs and compiling the index. We greatly appreciate her proficiency, diligence, and patience when changes in format and terminology were needed.

We are also indebted to a number of other professionals who provided their expertise. David Smith, U.S. Department of Agriculture (USDA), U.S. National Museum, Systematic Entomology Laboratory, identified ants, checked distribution maps, and helped locate references. Roy Snelling, Los Angeles County Museum of Natural History, also identified ants, loaned us specimens, helped with the carpenter ant key, and answered many taxonomic questions, particularly with regard to the *Myrmentoma*. Among those who generously supplied specimens for use in the key and photographs were Lloyd Davis Jr. from the USDA-Agricultural Research Service in Florida, Michael Merchant from the University of Texas, Barb Ogg at the University of Nebraska, and Gerald Wegner from Varment Guard Environmental Services in Ohio. We also thank Walter J. Spangenberg, a colleague of Laurel's whose encouragement over the years has kept this book alive, and the remainder of the faculty and staff of Spokane Falls

Community College for their support. This work could not have been accomplished without the use of their equipment and space.

We want to thank the peer reviewers who devoted their time to reading and evaluating our entire manuscript. These include Richard Zack at Washington State University and Albert Wilson at Spokane Falls Community College, both of whom made many helpful editorial suggestions; Colleen Cannon at University of Minnesota, who provided valuable information on biology, foraging, and ecology; and Terry Whitworth at Whitworth Pest Control and Arthur Antonelli at the Washington State University Cooperative Extension, both of whom contributed to the chapters on ecology and economics. We are also indebted to Lloyd Davis Jr., USDA, for his review and suggestions on taxonomy.

This book would not have come to fruition without the staff at Cornell University Press; we are indebted to so many. Robb Reavill encouraged and started us on this project, followed by Peter Prescott who applied the incentive and direction we needed in our frequent lapses in writing. We appreciated the interest and enthusiasm of Katherine Lenz and Louise Robbins, the meticulous editing by Mary Babcock, and the final production process shepherded by Priscilla Hurdle. Their skills, patience, and support are gratefully acknowledged.

Finally, we thank the pest control industry. The exchange of information with pest management professionals at seminars, workshops, lectures, and informal discussions throughout the United States and Canada has been invaluable.

Carpenter Ants
of the United States and Canada

CHAPTER 1

Ecology

The family Formicidae comprises about 15,000 species of ants (Bolton 1994), of which more than 11,000 have been described (L. R. Davis Jr., pers. comm., 2004). The colonies of some species can grow to an incredible size. As many as 15 to 22 million workers were found in a colony of the African driver ant, *Dorylus wilverthi* Emery (Raignier and van Boven 1955), and 306 million workers in a supercolony of *Formica yessensis* Wheeler that was distributed among approximately 45,000 nests on the Ishikari coast in Japan (Higashi and Yamauchi 1979). But even these colonies pale in comparison to the supercolonies of Argentine ants, the largest one recorded stretching over 6000 km from Italy to Spain (Giraud et al. 2002). Undoubtedly, there were billions of ants in this supercolony.

Ants are major predators of forest-defoliating insects, especially during outbreaks, when these pests can make up more than 90% of an ant's diet (Petal 1978). The energy flow through ant populations is higher than that through populations of homeothermic vertebrates living in the same habitat (Petal 1978).

Worldwide, there are over 900 species of *Camponotus*, of which 50 are found in the United States and Canada (Bolton 1995). Mature colonies of *C. modoc* Wheeler and *C. vicinus* Mayr in the Pacific Northwest may contain over 50,000 and 100,000 workers, respectively (Akre et al. 1994). In comparison to the large cooperative units of Argentine ants, these are relatively small colonies; nonetheless, carpenter ants play a major ecological role in forest ecosystems as predators on forest defoliators (Table 1.1). Their potential as biological control agents remains an open question (Youngs 1983). One possible drawback is their predation on beneficial insects, such as the cinnabar moth (*Tyria jacobaeae* L.), which was intro-

TABLE 1.1

Species that prey on forest defoliators

Species	Prey species	Citation
Camponotus spp.	Forest tent caterpillar *Malacosoma disstria* Hubner	Green and Sullivan 1950
	Black-headed budworm larva *Acleris variana* (Fern.)	Otvos 1977
	Sawfly larva *Neodiprion swainei* Middleton	Ilnitzky and McLeod 1965
C. *modoc*	Douglas fir tussock moth pupa *Orgyia pseudotsugata* (McDunnough)	Torgerson et al. 1983
	Western spruce budworm pupa *Choristoneura occidentalis* Freeman	Youngs and Campbell 1984
C. *vicinus*	Spruce budworm larve *Ch. fumiferana* (Clem.)	Silver 1960
	Western spruce budworm pupa *Ch. occidentalis* Freeman	Campbell et al. 1983, Youngs and Campbell 1984
C. *laevigatus*	Western spruce budworm pupa *Ch. occidentalis* Freeman	Campbell et al. 1983, Youngs and Campbell 1984
C. *noveboracensis*	Jack-pine budworm larva *Ch. pinus* Freeman	Allen et al. 1970

duced into the United States to control the tansy ragwort weed (Myers and Campbell 1976).

Carpenter ants, having the biggest workers of all North American ants, are capable of subduing large prey. The foragers of *C. chromaiodes* Bolton (Fellers 1987), *C. herculeanus* (L.) (Savolainen et al. 1989), and *C. floridanus* (Buckley) (Wilkinson et al. 1980) are among the most aggressive and dominant ants in forest communities. For example, *C. chromaoides* was the most dominant of nine species of ants in a Maryland woodlot. It selected primarily large prey, but was slow at locating resources. In a laboratory comparison of the feeding habits of seven species of ants in southern Ontario, *C. herculeanus* was the most effective at capturing insects, along with *Crematogaster lineolata* (Say) and *F. excectoides* Forel (Ayre 1963). All three species preyed on cercopids, pentatomids, cocinellids, carabids, and chrysomelids, and scavenged dead insects.

RELATIONSHIPS WITH OTHER ORGANISMS

COEXISTENCE WITH *FORMICA*

The geographic distributions of *Camponotus* and *Formica* frequently overlap. In the San Bernardino Mountains of California, for example, *C. laevigatus* (Fr. Smith) nests close to *F. haemorrhoidalis* Emery and is sometimes displaced by the latter species (Mackay and Mackay 1982). In large parts of the Midwest and Pacific Northwest, species of *Camponotus* coexist with *F. montana* Emery and *F. neoclara* (Emery), respectively. In northern Idaho, *C. vicinus* and *F. podzolica* Francoeur even share the same foraging trails (Chen 1995). One way these two genera coexist is by resource partitioning. For example, *C. pennsylvanicus* (DeGeer) and *F. subsericea* Say share the same aphid colonies primarily by foraging at different times (Fig. 1.1) (Klotz 1984).

RELATIONSHIPS WITH BIRDS

Anting. Many species of birds perform "anting," a behavior where ants, including carpenter ants, are used during preening for their excretions. In active anting, the bird picks up the ants in its beak and places them in its feathers. In passive anting, the ants crawl onto the bird when it flattens its body against the ground (Potter 1970). Anting is accompanied by a peculiar twisting of the bird's wings and tail (Potter 1970). The purpose of anting is unknown, but it may serve an antiectoparasitic, antibiotic, or soothing function during molting (Potter 1970, Ehrlich et al. 1986, Osborn 1998).

As Food for Birds. Ants make up 97% of the diet of pileated woodpeckers, *Dryocopus pileatus* (L.), in the Pacific Northwest (Beckwith and Bull 1985, Bull et al. 1992). In the summer in northeastern Oregon, the woodpeckers feed primarily on *Formica* spp., shifting their diet to *C. modoc* in October through March (Bull et al. 1992). The pileated woodpecker and related genera *Dendrocopus* and *Picoides* are the most important predators of carpenter ants in New Brunswick (Sanders 1964). The deeper excavations of pileated woodpeckers make them more efficient predators of carpenter ants than are either hairy or downy woodpeckers (Figs. 1.2, 1.3) (Conner 1981). Ants are also important in the diet of the common flicker, *Colaptes auratus* (L.) (Cruz and Johnston 1979). In Florida, flickers primarily feed on the ground, but on Grand Cayman they

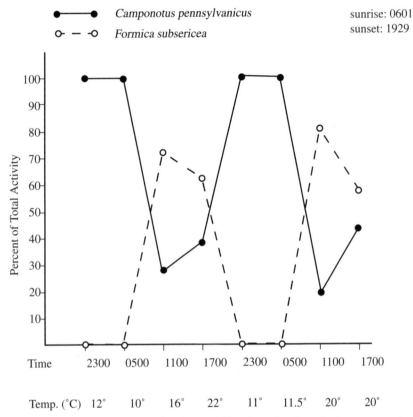

Figure 1.1. *Camponotus pennsylvanicus* and *Formica subsericea* sharing resources by foraging at different times.

have shifted to trees, where the ants, including species of *Camponotus,* are more abundant.

Carpenter ant alates are food for many birds during the swarming season. In Nevada, for example, Stellar's jays (*Cyanocitta stelleri* (Gmelin)) and robins (*Turdus migratorius* L.) fed on the alates of *C. modoc* during a mating flight in July (Wheeler and Wheeler 1986).

TROPHOBIONTS

Honeydew is the main source of energy for many ants and the focus of their foraging efforts. The insects that provide this honeydew to ants are

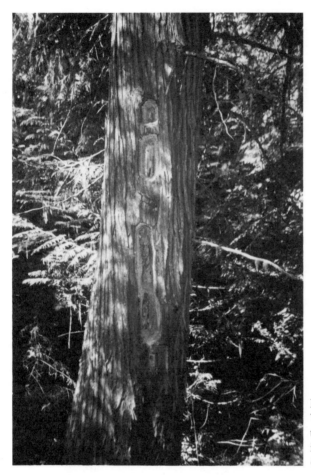

Figure 1.2.
Woodpecker damage
to western red cedar
infested with
Camponotus modoc.

called trophobionts (e.g., mealybugs, aphids, and scales). Their liquid excrement contains sugars, amino acids, lipids, vitamins, and minerals. The ants protect the trophobionts from predators and parasites. This symbiotic association is ancient, perhaps 50 million years old (Hölldobler and Wilson 1990), and ants have evolved specialized digestive tracts and feeding behaviors to collect, transport, and share honeydew. Many species in the subfamily Formicinae, such as carpenter ants, cultivate trophobionts for their honeydew (Fig. 1.4).

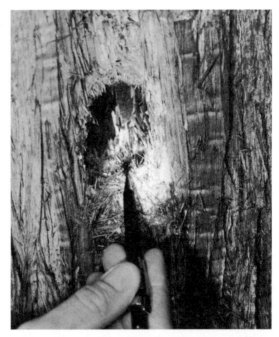

Figure 1.3. A worker of *Camponotus modoc* emerging from a woodpecker hole.

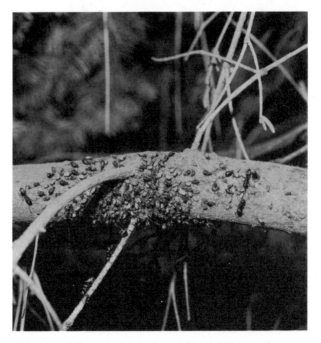

Figure 1.4. Workers of *Camponotus modoc* tending aphids on a fir tree.

Honeydew from the membracid *Vanduzea arquata* (Say) was a dietary staple for a colony of *C. noveboracensis* (Fitch) in New York (Gotwald 1968). The relationship was termed commensal because the ants appeared to be the sole benefactors. In a case of mutualism on white fir, *C. modoc* tends *Cinara occidentalis* Davidson, an aphid that cannot survive without the ants' protection from predators (Tilles and Wood 1982). The ants ensure a continuous food supply for themselves by suppressing the development of alates in the aphid colony, thereby preventing their dispersal. The waxy scale *Orthezia nigrocincta* Cockerell is tended by *C. vicinus* on tree roots (Wheeler and Wheeler 1986).

The cultivation of Homoptera by ants is usually considered detrimental to plants, but any damage may be offset by the ants' predation on defoliators. Another factor that may contribute to the stability of the ant-Homoptera-plant relationship is the ability of some homopterans to withdraw large quantities of sap without seriously injuring trees, thereby allowing them to feed on the same plant year after year (Bradley and Hinks 1968). A portion of the sap sustains the aphids, but most is passed on as honeydew to the ants. In return, the ants protect the aphids and the trees from their enemies.

MYRMECOPHILES

Like most ants, carpenter ants have guests, or myrmecophiles, that live within their nests, often at the expense of the colony. These guests belong to various arthropod groups including a wide range of insect orders from the primitive to the most evolutionarily advanced. The myrmecophiles are integrated to different degrees into colony life and use various strategies to gain acceptance by the ants, including tactile and chemical mimicry and the production of attractive secretions (Kistner 1982, Howard et al. 1990).

The Florida carpenter ant, *C. floridanus*, harbors an undetermined species of silverfish (Davis and Jouvenaz 1990); a fast-running cockroach, *Myrmecoblatta wheeleri* Hebard (Deyrup and Fisk 1984); and a small, wingless cricket, *Myrmecophila pergandei* Bruner (Davis and Jouvenaz 1990). Another apterous cricket, *Myrmecophila manni* Schimmer, has been collected with at least 13 species of ants, including *C. modoc* (Fig. 1.5) (Henderson and Akre 1986). Myrmecophilous crickets have also been found living with *C. laevigatus*, *C. pennsylvanicus*, and *C. sansabeanus* Buckley.

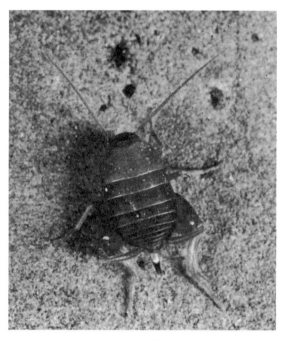

Figure 1.5. A wingless cricket, *Myrmecophila manni*, that lives with *Camponotus modoc*. Photograph by Roger D. Akre.

A variety of beetles live as parasites or commensals within the nests of carpenter ants. The staphylinid genus *Xenodusa* typically has two hosts. The beetle breeds in the nests of *Formica* spp. during the summer and hibernates in the nests of *Camponotus* spp. (Wheeler 1911, Hoebeke 1976), where larvae are present throughout the winter (Hölldobler and Wilson 1990). The larval and adult beetles prey on the ant larvae and are fed by the workers. The winter hosts of *X. cava* Leconte are *C. americanus* Mayr, *C. chromaiodes*, *C. pennsylvanicus*, and *C. noveboracensis*. Other species of *Xenodusa* found in the nests of *Camponotus* spp. include *X. angusta* Fail with *C. vicinus* (Wheeler and Wheeler 1986) and *X. reflexa* (Walker) with *C. essigi*, *C. modoc*, and *C. noveboracensis* (Hoebeke 1976, Wheeler and Wheeler 1986). The adult beetles have on the sides of their abdomen tufts of hairs called trichomes, which are associated with glandular secretions that attract the ants. In response to an approaching ant, the beetle curls its abdomen tightly over its head, exposing its trichomes (Fig. 1.6). Using rapid antennal movements, the beetle solicits trophallaxis

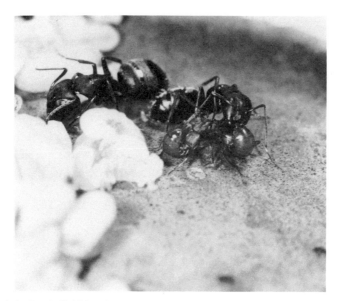

Figure 1.6. Staphylinid beetles, *Xenodusa reflexa*, with workers and brood of *Camponotus modoc*. Photograph by Roger D. Akre.

with the ants (Fig. 1.7). When the nest is disturbed, the ants carry the beetles in their mandibles to safety by grasping the edge of the pronotum or abdomen. The ants retreat from the beetles in some encounters, possibly owing to a chemical repellent. The cuticular hydrocarbons of *C. modoc* and *X. reflexa* are different, suggesting that the beetle relies on attractants and not chemical mimicry for acceptance (R. W. Howard, pers. comm., 1991).

The myrmecophilic beetles in the family Leiodidae lack secretory structures and are not transported by the ants (Kistner 1982). Among the numerous hosts of the leiodid *Nemadus parasitus* LeConte are *C. pennsylvanicus* and *C. chromaiodes* (Kistner 1982), while *Dissochaetus brachyderus* (LeConte), another leiodid, is common in the overwintering colonies of *C. herculeanus* (Sanders 1964).

Another family of small beetles, the Cerylonidae, is usually found in forest litter and under bark (Lawrence and Stephan 1975). A number of species in this family, however, live with ants. For example, the cerylonid *Hypodacne punctata* LeConte can be found in the nest galleries of *Camponotus* spp. (Lawrence and Stephan 1975). The larvae have piercing-sucking mouthparts, which is unusual for beetles.

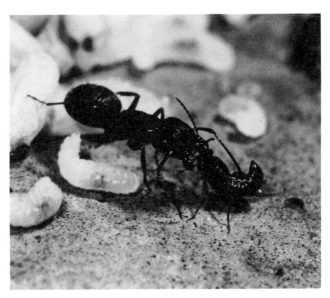

Figure 1.7. A staphylinid beetle, *Xenodusa reflexa*, being fed by a major worker of *Camponotus modoc*. Photograph by Roger D. Akre.

Scarab beetles in the genus *Cremastocheilus* are found mostly in the deserts of the Southwest and Mexico, with formicines and myrmicines as their hosts (Hölldobler and Wilson 1990). The adult beetles have trichomes, defensive secretions, and modified mouthparts for pumping body fluids from ant larvae (Alpert and Ritcher 1975). Wheeler (1908) regarded their association with *Camponotus* as "accidental or irregular," but Doyen (pers. comm. cited in Alpert and Ritcher 1975) reported that *Cremastocheilus* beetles fed on larvae and pupae of *Camponotus* in the laboratory.

Beetles collected from nests of *C. semitestaceus* in Nevada include larvae of carabids (*Pseudomorpha* sp.) and pupae of tenebrionids (*Coniontis* sp. and *Araeoschizus armatus* Horn) (Wheeler and Wheeler 1986). The carabid larvae resemble adult ants by being enlarged posteriorly and elongated anteriorly.

Flies and wasps parasitize carpenter ants as larvae and then become free-living as adults. The genus *Microdon*, for instance, is an unusual group of syrphid flies that are symbionts of social insects. In the United States and Canada, they are all associated with ants (Akre et al. 1990), but in other parts of the world a few species have been found with termites and

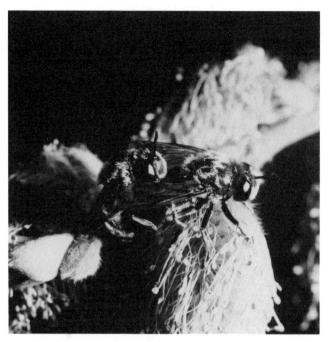

Figure 1.8. A mating pair of myrmecophilous syrphid flies, *Microdon piperi*. Photograph by Roger D. Akre.

wasps (Kistner 1982). In the Pacific Northwest, the adult flies occur briefly in the spring or early summer after their emergence from a nest. They live long enough to mate and lay eggs in or near the host nest (Fig. 1.8). The eggs hatch in about 10 days and the emerging first-instar larvae, which represent a dispersal phase, crawl deep into the nest. The second- and early third-instar larvae feed on brood (Figs. 1.9, 1.10) (Van Pelt and Van Pelt 1972; Duffield 1981; Akre et al. 1988, 1990). The third-instar larvae overwinter deep in the nest (Figs. 1.11, 1.12). In spring they move close to the surface of the nest, where they pupate (Figs. 1.13, 1.14) and then emerge to begin the cycle again.

The principal host of *M. piperi* Knab is *C. modoc*, although it is also found with other species of *Camponotus* (Akre et al. 1988). The larvae mimic their ant host chemically (Howard et al. 1990) and physically, with the first and second larval instars resembling ant cocoons (Garnett et al. 1985). The adult flies lack the protective mimicry and are readily attacked

Figure 1.9. A larva of the syrphid fly *Microdon piperi* on a *Camponotus vicinus* cocoon. Photograph by Roger D. Akre.

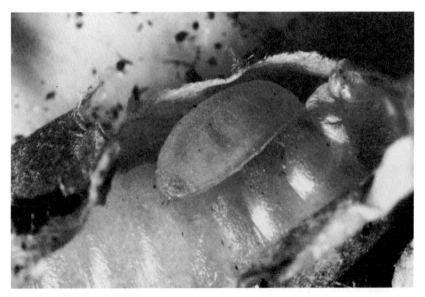

Figure 1.10. A second-instar larva of the syrphid fly *Microdon piperi* inside a *Camponotus vicinus* cocoon feeding on the prepupa. Photograph by Roger D. Akre.

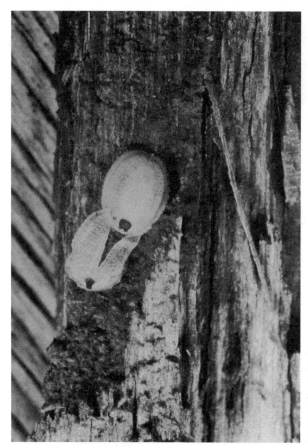

Figure 1.11. A second-instar larva of the syrphid fly *Microdon piperi* molting to the third instar. Photograph by Roger D. Akre.

and killed by the ants (Howard et al. 1990). Though they are highly effective predators, *Microdon* flies probably have only a minor impact on ant colonies due to the high mortality rate of the adult flies and first-instar larvae (Garnett et al. 1985).

Phorid flies are second only to beetles in the number of species associated with social insects (Kistner 1982). Many are wingless myrmecophiles or termitophiles. Particularly gruesome among the winged species are those that belong to the genus *Apocephalus*, commonly known as ant-decapitating flies. A number of species are known to parasitize *Camponotus* spp. (Disney 1981). The minute fly attacks and lays an egg in an adult worker ant. The egg hatches, and the larva develops in the head while consuming

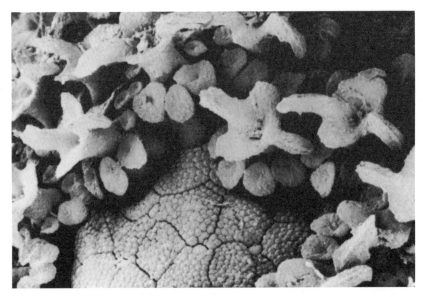

Figure 1.12. Dorsal integumentary surface of a larva of *Microdon piperi* as seen by scanning electron microscopy. Although these elaborate protrusions have been known for many years, nothing is known of their function. Photograph courtesy of G. Paulson, Shippensburg University, Shippensburg, Pennsylvania.

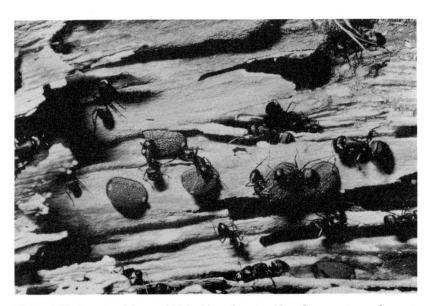

Figure 1.13. Puparia of the syrphid fly *Microdon piperi* in a *Camponotus modoc* nest. Photograph by Roger D. Akre.

Figure 1.14. Pupae of the syrphid fly *Microdon piperi* with protruding anterior spiracles. Photograph by Roger D. Akre.

the soft tissue. Immediately before pupation, the larva releases an enzyme that causes the head to fall off the body. Fox (1887) found the heads of several decapitated *C. pennsylvanicus* workers, each with a single white grub filling the cranial cavity. Surprisingly, the encapsulated larvae were moving across the substrate in inchworm fashion. Mankowski and Morrell (2003) found parasitized *C. vicinus* overwintering in the colony, which indicates that the flies had oviposited on foraging workers in the fall.

Species of *Apocephalus* in the United States and Canada include *A. horridus* Borgmeier, which parasitizes *C. vicinus* (Mankowski and Morrell 2003); *A. pergandei* Coquillett, which parasitizes *C. pennsylvanicus*; and *A. coquilletti* Malloch, which parasitizes both *C. pennsylvanicus* and *C. sansabeanus* (Borgmeier 1963). Other phorid parasites include *Rhyncophoromyia conica* Malloch, the type specimen of which was reared from the abdomen of a *C. pennsylvanicus* worker (Malloch 1912 cited in Brown and Feener 1993); *Trucidophora camponoti* (Brown), which parasitizes the female alates of *C. herculeanus*, *C. noveboracensis* and *C. pennsylvanicus* (Brown et al. 1991); and *Auxanommatidia boreotix* Beyer, which attacks

C. vicinus foragers (Chen 1995). In addition, Sanders (1964) found three females of a *Triphleba* sp. of phorid overwintering in the nests of *C. herculeanus.*

Chalcid wasps in the families Eucharitidae and Eulophidae parasitize the pupal stage of various species of *Camponotus* (Schauff and Boucek 1987; Heraty and Barber 1990). The female eucharitid *Obeza floridana* (Ashmead) oviposits in fruit (Davis and Jouvenaz 1990), which is collected by *C. floridanus*. When the eggs hatch, the first-instar larvae attach to mature ant larvae. The wasp larvae do most of their feeding after the ant larvae pupate. Only one parasitoid develops in each ant cocoon (Davis and Jouvenaz 1990). The female wasp of another eucharitid, *Pseudochalcura gibbosa* (Provancher), oviposits in flower buds. The eggs overwinter in the buds and in spring become exposed at flowering. When the eggs hatch, they release a fluid that contains the active first-instar larvae, which are picked up by the ants and taken to their nest. Two to four pupae of *P. gibbosa* were found in each parasitized cocoon of *C. noveboracensis* (Wheeler 1907). In a case of parasitization by the eulophid *Alachua floridanus* Schauff and Boucek, as many as 21 parasitoids developed from a single ant cocoon (Schauff and Boucek 1987). In contrast to eucharitids, parasitization by eulophids is rare in ants.

The larvae of a neuropteran, *Nadiva valida* Erichs, were discovered among the brood in a *C. floridanus* nest (Weber 1942). When the nest was uncovered, the blue larvae scurried away or were carried off by the ants. This chrysopid "was described from the United States but is also known from Brazil" (Nathan Banks cited in Weber 1942).

Most associations that ants have with lycaenid and riodinid butterflies are mutualistic (Hölldobler and Wilson 1990). The ants protect the caterpillars from their enemies in exchange for sweet secretions (Wheeler 1910); for example, *C. essigi* M. R. Smith tends the lycaenid *Philotes rita palescens* (Shields 1973 cited in Snelling 1988).

The caterpillar of the metalmark butterfly, *Anatole rossi* Clench, is a riodinid myrmecophile of *C. floridanus* in an isolated pine forest in Veracruz, Mexico (Ross 1966, 1985). The ants build small underground chambers at the base of the larval butterfly's food plant. The caterpillars stay in these pens during the day and emerge from them at night to ascend the plant and forage. The pens protect the caterpillars from predatory ponerine ants, cold winter weather, and fires that are set annually by the local people to clear underbrush. The caterpillars possess a pair of glands on the eighth abdominal segment, which produce honeydew that is highly attractive to the ants.

Laelaptid mites in the genera *Cosmolaelaps* and *Holostaspes* commonly overwinter in the colonies of *C. herculeanus* in New Brunswick (Sanders 1964). Unidentified mites have also been collected with carpenter ants in the Pacific Northwest by the senior author (L. D. H.).

OTHER PARASITES

In addition to parasitic myrmecophiles, carpenter ants are hosts to parasitic fungi, flatworms, and roundworms. Fungi rarely infect ants, probably because ants have fastidious grooming habits and glandular secretions with antibiotic activity (Hölldobler and Wilson 1990). However, there are cases of entomopathic fungi infecting carpenter ants. For instance, the fungus *Desmidiospora myrmecophila* Thaxter infects *C. pennsylvanicus* and *C. semitestaceus* Snelling (Thaxter 1891 cited in Bequaert 1922; Clark and Prusso 1986). Species of *Cordyceps* fungi also infect *Camponotus* spp. For example, *Cordyceps subdiscoidea* (Hennings), *C. lloydii* Fawcett, and *C. unilateralis* (Tulasne) Saccardo have been found growing on *Camponotus floridanus* (Bequaert 1922). The fungal mycelium invades the tissue and produces fruiting bodies on the exterior of the exoskeleton. Ants infected with *Cordyceps* fungus undergo behavioral changes (Samson et al. 1988). For example, arboreal species tend to come down from their natural habitat in trees to find harborage on the ground, while the normally ground-dwelling species tend to climb up the vegetation. Infected ants also exhibit abnormal behaviors such as twitching, excessive grooming, and loss of orientation. In the final stage of infection, the ant is often found gripping the substrate with its mandibles and legs.

Workers of *Camponotus herculeanus* and *C. modoc* are the second developmental hosts for a dicrocoeliid liver fluke, *Brachylecithum mosquensis* (Skrjabin and Isaitschikoff), which inhabits the bile ducts of the western robin, *Turdus migratorius* L. (Carney 1969, 1970). The first developmental host is a land snail, *Allogona ptychophora* (Brown). The snail secretes slime balls containing thousands of cercariae that are eaten by the ants. The ingested cercariae penetrate the wall of the crop of the ant and enter the hemocoel. Within 48 hours the cercariae encyst, transforming into metacercariae. While most metacercariae are found in the gaster of the ant, at least one is usually found in the supraesophageal region of the brain. The parasites cause behavioral and morphological changes in the ant, which seem to increase their vulnerability to predation by birds.

Poinar (1975) provides a host list of formicids that are associated with specific nematodes. Some of the records date back to 1893 and include

many unknown nematodes. Poinar cites Wheeler in a 1933 listing of an unknown nematode found in *C. floridanus*. A more recent entry (Poinar 1975) cites Nickle and Ayre in 1966 for *C. herculeanus* as a host for *Caenorhabditis dolichura* (Schn).

ENDOSYMBIONTS

The endosymbiotic bacteria of Formicidae were among the first discovered in insects (Blochmann 1884, 1886). In *Camponotus* spp., they are located within specialized mycetocytes in the midgut epithelium and follicle cells of the ovarioles. They are gram-negative, nonmotile, and variable in shape and lie freely in the cytoplasm without a surrounding membrane (Fig. 1.15) (Buchner 1965, Dasch et al. 1984). The bacteria are transmitted transovarily from the symbiont-rich follicle cells of a queen into her developing oocytes, and from there enter her offspring's follicle cells and midgut epithelium during embryogenesis (Steinhaus 1946, Buchner 1965). The role of the bacteria in the ant is unknown but suspected to be nutritional, possibly supplying essential amino acids (Dasch et al. 1984) or vitamins (Smith 1944) to their host. It has been speculated that they might help in cellulose digestion (Smith 1944), but this is not supported by feeding experiments with *C. herculeanus* and *C. ligniperdus* Latreille, or by enzyme analyses of their alimentary tracts (Graf and Hölldobler 1964). The ants lack the required enzymes to digest wood.

Schröder et al. (1996) were the first to apply molecular techniques to investigate the systematics and evolution of the endosymbionts from the midgut of four species of *Camponotus*. They identified them as belonging to the γ-subclass of Proteobacteria closely related to the Enterobacteriaceae. The symbiotic relationship between ant and bacteria is ancient, possibly predating the earliest ant fossils from Baltic amber, which are 35 to 40 million years old (Dasch et al. 1984). Molecular research by Sameshima et al. (1999) and Peloquin et al. (2001) supported a monophyletic relationship of both Old and New World *Camponotus* endosymbionts.

MICROBES IN THE INFRABUCCAL CHAMBER

Bacteria and yeasts have been isolated from the infrabuccal chamber of *C. modoc* workers (Hansen et al. 1999). The bacteria belong to the Bacilliiaceae and Enterobacteriaceae. Both families are widely distributed in soil, and the ants may obtain the bacteria by ingesting soil along with their prey.

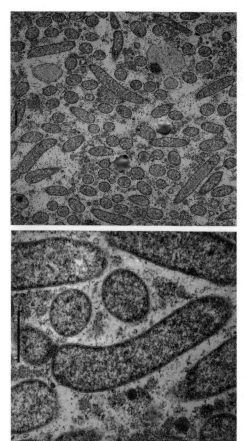

Figure 1.15. Bacterial endosymbionts from the ovary of a *Camponotus floridanus* queen as seen by transmission electron microscopy.

A variety of yeasts, including *Debaryomyces polymorphus* Kloecker, were isolated from the infrabuccal chamber and surrounding colony material of *C. vicinus* (Mankowski 2002). The role of these microbes is unknown, but they may serve a nutritional or digestive function in the ants.

NESTING SITES

In northern temperate forests, carpenter ants play a significant role in starting the degradation of tree cellulose. The ants do not consume wood but

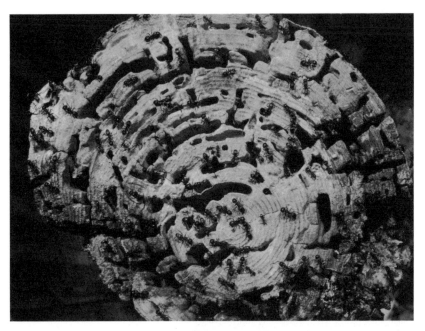

Figure 1.16. Nest of *Camponotus modoc* in trunk of Douglas fir.

excavate it for their nest galleries, thereby opening the way for fungi and other wood-decaying organisms to begin decomposition. The excavations of wood-infesting beetles such as cerambycids and buprestids are frequently the starting points for excavations by ants. Carpenter ants use their mandibles to excavate wood and transport the shavings to locations in the nest, where they can be stored, ejected through openings called windows, or packed into underground tunnels. The galleries and passageways have a smooth, sand-papered appearance (Fig. 1.16) and are constructed continuously to accommodate the growing colony. The galleries are irregular in shape and usually follow the grain and softer portions of the wood. Some of the harder layers of wood are left as walls that separate the galleries. Openings are cut in the gallery walls to create passageways for the ants.

Carpenter ants nest in both living and dead trees (Fig. 1.17), as well as in rotting logs and stumps (Table 1.2) (Hansen and Akre 1985). For example, *C. modoc* prefers partially decayed to undecayed wood and avoids the most decomposed logs (Torgersen and Bull 1995). In eastern

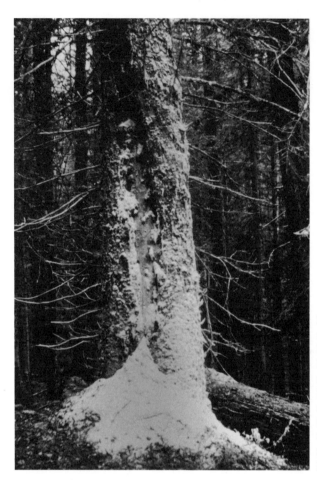

Figure 1.17. Nest of *Camponotus modoc* in standing dead Douglas fir in northern Idaho. Photograph courtesy of G. Paulson, Shippensburg University, Shippensburg, Pennsylvania.

Oregon, *Camponotus* spp. selected for nesting sites down logs of larch and fir with diameters greater than 37 cm over lodgepole pine (Torgerson and Bull 1995). In standing trees, nests can be found as high as 10 m but are usually located between the ground and 1 to 2 m above the ground. Main or "parent" colonies are usually confined to the base of the tree, with galleries extending down into the roots and up 1 to 1.5 m into the trunk. Nest entrances are often located underground, with ants entering live trees through cracks, scars, knotholes, and decayed wood. Inside the tree, the

TABLE 1.2

Characteristics of nesting sites in natural areas

	Species of *Camponotus*			
Site characteristics	*C. modoc* (13)	*C. vicinus* (5)	*C. noveboracensis* (2)	*C. laevigatus* (4)
Nest location				
Live tree	53.8	0	0	0
Dead tree	0	20	50	0
Stump	15.4	0	0	75
Fallen log	30.8	20	50	25
Wood debris	0	60	0	0
No. of nests				
4	7.7	0	0	0
3	0	40	0	0
2	30.8	40	50	0
1	61.5	20	50	100
Trails				
Surface	61.5	0	0	0
Subterranean	46.2	100	0	0
Unknown	23.1	0	100	100
Nesting indicators				
Foragers	100	100	100	100
Sawdust	76.9	60	100	100
Noises	30.8	0	0	0

Note: Surface and subterranean trails were found with *C. modoc*. Multiple nesting indicators were found with each species. Total numbers of sites are in parentheses. Numbers in table body are percentages.

ants remove decayed wood and extend their galleries into adjacent sound wood. Nests are also found in decaying roots, buried timbers, or wood debris beneath soil or rocks, which may aid in thermoregulation.

Colonies of *C. vicinus* most often nest in small logs (15 to 35 cm in diameter) on the forest floor or in the soil beneath them (Chen et al. 2002). Nests of *C. floridanus* are commonly located in rotten logs or in the ground beneath objects, and *C. laevigatus* nests in stumps or logs (Klotz et al. 1998). All of the 34 nests of *C. herculeanus* and *C. noveboracensis* found in a New Brunswick woodlot were located in standing trees, with the ants preferring softwoods, such as balsam fir (*Abies balsamea* (L.)) and eastern white cedar (*Thuja occidentalis* L.) (Sanders 1964). A single colony of *C. pennsylvanicus* was located in a largetooth aspen, *Populus grandidentata* Michx. All of the nests of *C. pennsylvanicus* in an Indiana woodlot were located in standing trees, mostly oak, *Quercus* spp. (Klotz et al. 1998).

Carpenter ants are a vital link in the forest food web. They play a key role as predators of forest defoliators, such as the western spruce budworm.

They in turn are prey for birds such as the pileated woodpecker, which depends on them for survival. They display a rich diversity of interspecies interactions, which include a variety of commensalistic, mutualistic, and parasitic relationships with other arthropods and microbes. Finally, their nesting habits initiate the degradation of cellulose to a form usable by other plants and animals. The interconnecting relationship among these biotic and abiotic factors forms a functional ecosystem (Torgersen and Bull 1995).

REFERENCES CITED

Akre, R. D., W. B. Garnett, and R. S. Zack. 1988. Biology and behavior of *Microdon piperi* in the Pacific Northwest (Diptera: Syrphidae). J. Kans. Entomol. Soc. 61: 441–452.

Akre, R. D., W. B. Garnett, and R. S. Zack. 1990. Ant hosts of *Microdon* (Diptera: Syrphidae) in the Pacific Northwest. J. Kans. Entomol. Soc. 63: 175–178.

Akre, R. D., L. D. Hansen, and E. A. Myhre. 1994. Colony size, and polygyny in carpenter ants (Hymenoptera: Formicidae). J. Kans. Entomol. Soc. 67: 1–9.

Allen, D. C., F. B. Knight, and J. L. Foltz. 1970. Invertebrate predators of the jack-pine budworm, *Choristoneura pinus*, in Michigan. Ann. Entomol. Soc. Am. 63: 59–64.

Alpert, G. D., and P. O. Ritcher. 1975. Notes on the life cycle and myrmecophilous adaptations of *Cremastocheilus armatus* (Coleoptera: Scarabaeidae). Psyche 82: 283–291.

Ayre, G. L. 1963. Laboratory studies on the feeding habits of seven species of ants (Hymenoptera: Formicidae) in Ontario. Can. Entomol. 95: 712–715.

Beckwith, R. C., and E. L. Bull. 1985. Scat analysis of the arthropod component of pileated woodpecker diet. Murrelet 66: 90–92.

Bequaert, J. 1922. Ants in their diverse relations to the plant world. Bull. Am. Mus. Nat. Hist. 45: 333–583.

Blochmann, F. 1884. Über eine Metamorphose der Ovarialeiern und über den Beginn der Blastoderm-bildung bei den Ameisen. Verhandl. Naturhist. Med. Ver. Heidelberg 3: 243–247.

Blochmann, F. 1886. Über die Reifung der Eier bei Ameisen und Wespen. Verhandl. Naturhist. Med. Ver. Heidelberg 5: 141–172.

Bolton, B. 1994. Identification guide to the ant genera of the world. Cambridge: Harvard University Press.

Bolton, B. 1995. A new general catalogue of the ants of the world. Cambridge: Harvard University Press.

Borgmeier, T. 1963. Revision of the North American phorid flies. Part 1. Studia Entomol. 4: 1–256.

Bradley, G. A., and J. D. Hinks. 1968. Ants, aphids, and jack pine in Manitoba. Can. Entomol. 100: 40–50.

Brown, B. V., and D. H. Feener Jr. 1993. Life history and immature stages of *Rhyncophoromyia maculineura*, an ant-parasitizing phorid fly (Diptera: Phoridae) from Peru. J. Nat. Hist. 27: 429–434.

Brown, B. V., A. Francoeur, and R. L. Gibson. 1991. Review of the genus *Styletta* (Diptera: Phoridae) with description of a new genus. Entomol. Scand. 22: 241–250.

Buchner, P. 1965. Endosymbiosis of animals with plant microorganisms. New York: Interscience.

Bull, E. L., R. C. Beckwith, and R. S. Holthausen. 1992. Arthropod diet of pileated woodpeckers in northeastern Oregon. Northwest Nat. 73: 42–45.

Campbell, R. W., T. R. Torgersen, and N. Srivastava. 1983. A suggested role for predaceous birds and ants in the population dynamics of western spruce budworm. Forest Sci. 29: 779–790.

Carney, W. P. 1969. Behavioral and morphological changes in carpenter ants harboring Dicrocoeliid metacercariae. Am. Midl. Nat. 82: 605–611.

Carney, W. P. 1970. *Brachylecithum mosquensis*: infections in vertebrate, molluscan, and arthropod hosts. Trans. Am. Microsc. Soc. 89: 233–250.

Chen, Y. 1995. Nesting sites, foraging behavior, and immature morphology of the carpenter ant, *Camponotus vicinus* (Mayr) (Hymenoptera: Formicidae). M.S. thesis, Washington State University, Pullman.

Chen, Y., L. D. Hansen, and J. J. Brown. 2002. Nesting sites of the carpenter ant, *Camponotus vicinus* (Mayr) (Hymenoptera: Formicidae) in northern Idaho. Environ. Entomol. 31: 1037–1042.

Clark, W. H., and D. C. Prusso. 1986. *Desmidiospora myrmecophila* found infesting the ant *Camponotus semitestaceus*. Mycologica 78: 865–866.

Conner, R. N. 1981. Seasonal changes in woodpecker foraging patterns. Auk 98: 562–570.

Cruz, A., and D. W. Johnston. 1979. Occurrence and feeding ecology of the common flicker on Grand Cayman Island. Condor 81: 370–375.

Dasch, G. A., E. Weiss, and K. P. Chang. 1984. Endosymbionts of insects. *In* J. G. Holt, and N. R. Krieg, eds., Bergey's manual of systematic bacteriology. Vol. 1, pp. 811–833. Baltimore: Williams & Williams.

Davis Jr., L. R., and D. P. Jouvenaz. 1990. *Obeza floridana*, a parasitoid of *Camponotus abdominalis floridanus* from Florida (Hymenoptera: Eucharitidae, Formicidae). Fla. Entomol. 73: 335–337.

Deyrup, M., and F. Fisk. 1984. A myrmecophilous cockroach new to the United States (Blattaria: Polyphagidae). Entomol. News 95: 183–185.

Disney, R. H. L. 1981. *Apocephalus laceyi* n. sp. (Diptera: Phoridae) attacking *Camponotus femoratum* (F.) (Hymenoptera: Formicidae) in Brazil. Entomol. Scand. 12: 31–34.

Duffield, R. M. 1981. Biology of *Microdon fuscipennis* (Diptera: Syrphidae) with interpretations of the reproductive strategies of *Microdon* species found north of Mexico. Proc. Entomol. Soc. Wash. 83: 716–724.

Ehrlich, P. R., D. S. Dobkin, and D. Wheye. 1986. The adaptive significance of anting. Auk 103: 835.

Fellers, J. H. 1987. Interference, and exploitation in a guild of woodland ants. Ecology 68: 1466–1478.

Fox, W. H. 1887. Notes on a new parasite of *Camponotus pennsylvanicus*. Entomol. Soc. Wash. 1: 100–101.

Garnett, W. B., R. D. Akre, and G. Sehlke. 1985. Cocoon mimicry, and predation by myrmecophilous Diptera (Diptera: Syrphidae). Fla. Entomol. 68: 615–621.

Giraud, T., J. S. Pedersen, and L. Keller. 2002. Evolution of supercolonies: the Argentine ants of southern Europe. Proc. Nat. Acad. Sci. U.S.A. 99: 6075–6079.

Gotwald, W. H. 1968. Food gathering behavior of the ant *Camponotus noveboracensis* (Fitch) (Hymenoptera: Formicidae). J. N.Y. Entomol. Soc. 76: 278–296.

Graf, I., and B. Hölldobler. 1964. Untersuchungen zur Frage der Holzverwertung als Nahrung bei holzzerstörenden Roßaameisen (*Camponotus ligniperda* Latr. und *Camponotus herculeanus* L.) unter Berücksichtigung der Cellulase-Aktivitat. Z. Angew. Entomol. 55: 77–80.

Green, G. W., and C. R. Sullivan. 1950. Ants attacking the larvae of the forest tent caterpillar, *Malacosoma disstria* Hbn. (Lepidoptera: Lasiocampidae). Can. Entomol. 82: 194–195.

Hansen, L. D., and R. D. Akre. 1985. Biology of carpenter ants in Washington State (Hymenoptera: Formicidae: *Camponotus*). Melanderia 43: 1–62.

Hansen, L. D., W. J. Spangenberg, and M. M. Gaver. 1999. The infrabuccal chamber of *Camponotus modoc* (Hymenoptera: Formicidae): ingestion, digestion, and survey of bacteria. *In* W. H. Robinson, F. Rettich, and G. W. Rambo, eds., Proceedings of the 3rd International Conference on Urban Pests, pp. 211–219. Grafické závody Hronov, Czech Republic.

Henderson, G., and R. D. Akre. 1986. Biology of the myrmecophilous cricket, *Myrmecophila manni* (Orthoptera: Gryllidae). J. Kans. Entomol. Soc. 59: 454–467.

Heraty, J. M., and K. N. Barber. 1990. Biology of *Obeza floridana* (Ashmead) and *Pseudochalcura gibbosa* (Provancher) (Hymenoptera: Eucharitidae). Proc. Entomol. Soc. Wash. 92: 248–258.

Higashi, S., and K. Yamauchi. 1979. Influence of a supercolonial ant *Formica (Formica) yessensis* Forel on the distribution of other ants in Ishikari coast. Jpn. J. Ecol. 29: 257–264.

Hoebeke, E. R. 1976. A revision of the genus *Xenodusa* (Staphylinidae, Aleocharinae) for North America. Sociobiology 2: 109–143.

Hölldobler, B., and E. O. Wilson. 1990. The ants. Cambridge: Harvard University Press.

Howard, R. W., R. D. Akre, and W. B. Garnett. 1990. Chemical mimicry in an obligate predator of carpenter ants (Hymenoptera: Formicidae). Ann. Entomol. Soc. Am. 83: 607–616.

Ilnitzky, S., and J. M. McLeod. 1965. Notes on ants associated with *Neodiprion swainei* Midd. in jack pine stands in Quebec. Can. Dept. For. Bimon. Progr. Rep. 21: 1–2.

Kistner, D. 1982. The social insects' bestiary. *In* H. R. Hermann, ed., Social insects. Vol. 3, pp. 1–244. New York: Academic Press.

Klotz, J. H. 1984. Diel differences in foraging in two ant species (Hymenoptera: Formicidae). J. Kans. Entomol. Soc. 57: 111–118.

Klotz, J. H., L. Greenberg, B. L. Reid, and L. Davis. 1998. Spatial distribution of colonies of three carpenter ants *Camponotus pennsylvanicus, Camponotus floridanus, Camponotus laevigatus* (Hymenoptera: Formicidae). Sociobiology 32: 51–62.

Lawrence, J. F., and K. Stephan. 1975. The North American Cerylonidae (Coleoptera: Clavicornia). Psyche 82: 131–166.

Mackay, W., and E. Mackay. 1982. Coexistence and competitive displacement involving two native ant species (Hymenoptera: Formicidae). Southwest. Nat. 27: 135–142.

Mankowski, M. E. 2002. Biology of the carpenter ants *Camponotus vicinus* (Mayr) and *Camponotus modoc* (Wheeler) in western Oregon. Ph.D. dissertation, Oregon State University, Corvalis.

Mankowski, M. E., and J. J. Morrell. 2003. Incidence of *Apocephalus horridus* in colonies of *Camponotus vicinus* and the effect of antibiotic/antimycotic mixtures on fly emergence. Sociobiology 42: 477–484.

Myers, J. H., and B. J. Campbell. 1976. Predation by carpenter ants: a deterrent to the spread of cinnabar moth. J. Entomol. Soc. B.C. 73: 7–9.

Osborn, S. H. 1998. Anting by an American dipper (*Cinclus mexicanus*). Wilson Bull. 110: 423–425.

Otvos, I. S. 1977. Some parasites and insect predators of the blackheaded budworm in Newfoundland. Can. For. Serv. Bimon. Res. Note 33: 11–12.

Peloquin, J. J., S. G. Miller, S. A. Klotz, R. Stouthammer, L. R. Davis Jr., and J. H. Klotz. 2001. Bacterial endosymbionts from the genus *Camponotus* (Hymenoptera: Formicidae). Sociobiology 38: 695–708.

Petal, J. 1978. The role of ants in ecosystems. *In* M. V. Brian, ed., Production ecology of ants, and termites, pp. 293–325. International Biological Programme 13. London: Cambridge University.

Potter, E. F. 1970. Anting in wild birds, its frequency and probable purpose. Auk 87: 692–713.

Poinar, G. O. 1975. Entomogenous nematodes. A manual and host list of insect-nematode associations. Leiden: E. J. Brill.

Raignier, A., and J. K. A. van Boven. 1955. Etude taxonomique, biologique et biométrique des *Dorylus* du sous-genre *Anomma* Ann. Mus. Royal Congo Belge, n.s. (Sci. Zool.) 2: 1–395.

Ross, G. N. 1966. Life-history studies on Mexican butterflies. IV. The ecology and ethology of *Anatole rossi*, a myrmecophilous metalmark (Lepidoptera: Riodinidae). Ann. Entomol. Soc. Am. 59: 985–1004.

Ross, G. N. 1985. The case of the vanishing caterpillar. Nat. Hist. 94: 48–55.

Sameshima, S., E. Hasegawa, O. Kitade, N. Minaka, and T. Matsumoto. 1999. Phylogenetic comparison of endosymbionts with their host ants based on molecular evidence. Zool. Sci. (Tokyo) 16: 993–1000.

Samson, R. A., H. C. Evans, and J. Latge. 1988. Atlas of entomopathogenic fungi. New York: Springer-Verlag.

Sanders, C. J. 1964. The biology of carpenter ants in New Brunswick. Can. Entomol. 96: 894–909.

Savolainen, R., K. Vepsäläinen, and H. Wuorenrinne. 1989. Ant assemblages in the taiga biome: testing the role of territorial wood ants. Oecologia 81: 481–486.

Schauff, M. E., and Z. Boucek. 1987. *Alachua floridensis*, a new genus and species of Entedoninae (Hymenoptera: Eulophidae) parasitic on the Florida carpenter ant, *Camponotus abdominalis* (Formicidae). Proc. Entomol. Soc. Wash. 89: 660–664.

Schröder, D., H. Deppisch, M. Obermayer, G. Krohne, E. Stackebrandt, B. Hölldobler, W. Goebel, and R. Gross. 1996. Intracellular endosymbiotic bacteria of *Camponotus* species (carpenter ants): systematics, evolution, and ultrastructural characterization. Mol. Molcrobiol. 21: 479–489.

Silver, G. T. 1960. Notes on spruce budworm infestation in British Columbia. For. Chron. 36: 362–374.

Smith, F. 1944. Nutritional requirements of *Camponotus* ants. Ann. Entomol. Soc. Am. 37: 410–408.

Snelling, R. R. 1988. Taxonomic notes on Nearctic species of *Camponotus*, subgenus *Myrmentoma* (Hymenoptera: Formicidae). *In* J. C. Trager, ed., Advances in Myrmecology, pp. 55–78. Leiden: E. J. Brill.

Steinhaus, E. A. 1946. Insect microbiology: an account of the microbes associated with insects and ticks, with special reference to the biologic relationships involved. Ithaca, N.Y.: Comstock Publishing.

Tilles, D. A., and D. L. Wood. 1982. The influence of carpenter ant (*Camponotus modoc*) (Hymenoptera: Formicidae) attendance on the development and survival of aphids (*Cinara* spp.) (Homoptera: Aphididae) in a giant sequoia forest. Can. Entomol. 114: 1133–1142.

Torgersen, T. R., and E. L. Bull. 1995. Down logs as habitat for forest-dwelling ants: the primary prey of pileated woodpeckers in northeastern Oregon. Northwest Sci. 69: 294–303.

Torgersen, T. R., R. R. Mason, and H. G. Paul. 1983. Predation on pupae of Douglas-fir tussock moth, *Orgyia pseudotsugata* (McDunnough) (Lepidoptera: Lymantriidae). Environ. Entomol. 12: 1678–1682.

Van Pelt, A. F., and S. A. Van Pelt. 1972. *Microdon* (Diptera: Syrphidae) in nests of *Monomorium* (Hymenoptera: Formicidae) in Texas. Ann. Entomol. Soc. Am. 65: 977–979.

Weber, N. A. 1942. A neuropterous myrmecophile, *Nadiva valida* Erichs. Psyche 49: 1–3.

Wheeler, G. C., and J. Wheeler. 1986. The ants of Nevada. Los Angeles: Los Angeles County Museum of Natural History.

Wheeler, W. M. 1907. The polymorphism of ants, with an account of some singular abnormalities due to parasitism. Bull. Am. Mus. Nat. Hist. 23: 1–93.

Wheeler, W. M. 1908. Studies on myrmecophiles. I. *Cremastochilus*. J. N.Y. Entomol. Soc. 16: 68–79.

Wheeler, W. M. 1910. Ants; their structure, development and behavior. New York: Columbia University Press.

Wheeler, W. M. 1911. Notes on the myrmecophilous beetles of the genus *Xenodusa* with a description of the larva of *X. cava* Leconte. J. N.Y. Entomol. Soc. 19: 163–169.

Wilkinson, R. C., A. P. Bhatkar, W. H. Whitcomb, and W. J. Kloft. 1980. *Formica integra* (Hymenoptera: Formicidae) 3. Trial introduction into Florida. Fla. Entomol. 63: 142–146.

Youngs, L. C. 1983. Predaceous ants in biological control of insect pests of North American forests. Bull. Entomol. Soc. Am. 29: 47–50.

Youngs, L. C., and R. W. Campbell. 1984. Ants preying on pupae of the western spruce budworm, *Choristoneura occidentalis* (Lepidoptera: Tortricidae), in eastern Oregon and western Montana. Can. Entomol. 116: 1665–1669.

Morphology

The external and internal anatomy of ants has been shaped over time to perform functions that are vital to the survival of the individual as well as the colony. For example, in their long coevolutionary relationship with honeydew-producing insects, many species of Formicinae have developed specialized digestive tracts and feeding behaviors for foraging and sharing liquid foods. Indeed, the form and structure of ants are intimately associated with their physiology, and underlie all the tasks performed by the colony.

A colony typically has a reproductive division of labor consisting of workers, queens, and males (Fig. 2.1). Workers are wingless and, depending on the subfamily, have a one-segmented pedicel consisting of a petiole or a two-segmented pedicel consisting of a petiole and a postpetiole. The petiole is the second abdominal segment; the first is the propodeum, which is fused to the thorax. Thus, the middle region is called the mesosoma or alitrunk, and not thorax. Posterior to the pedicel is the compact terminal region of the abdomen called the gaster.

The pedicel of ants in the Formicinae subfamily is one-segmented. Depending on genus, workers may be either polymorphic (many sizes) or monomorphic (one size). Workers of *Camponotus* are polymorphic and are commonly referred to by names that describe their size or function, such as majors or soldiers, medias, and minors.

The following description of the external and internal morphology of *Camponotus* spp. is based on the characteristics of *C. modoc* Wheeler, and adapted from illustrations and nomenclature found in the references listed by subject area in Table 2.1. Body segments are numbered from anterior to posterior with the arabic numerals 1, 2, and 3 referring to the protho-

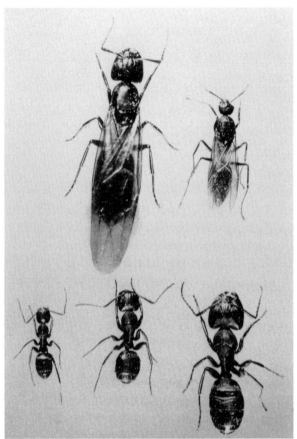

Figure 2.1. Winged female, male, and polymorphic workers of *Camponotus modoc*.

TABLE 2.1

References on morphology

General morphology	Snodgrass 1935, 1941, 1956; Jackson 1974; Sparks 1941; Schultz 1978; Bay and Elzinga 1980; Hermann and Blum 1981
Mouthparts	Gotwald 1969
Male genitalia	Snodgrass 1935, 1941; Forbes 1952; Smith 1970
Female genitalia	Hermann and Blum 1968, 1981
Alimentary canal and glands	Forbes 1938, Eisner and Wilson 1952, Eisner 1957, Forbes and McFarlane 1961, Ayre 1963
Respiratory system	Keister 1963
Nervous system	Gronenberg 1996
Reproductive system	Forbes 1954, 1956; Witherell 1991; Wheeler and Krutzsch 1992
Exocrine glands	Ayre and Blum 1971, Robertson 1968, Hermann et al. 1975

rax, mesothorax, and metathorax, respectively, and Roman numerals I, II, III, and so on, referring to the sequence of abdominal segments.

EXTERNAL MORPHOLOGY

The ant exoskeleton is composed of a series of plates called sclerites, which are separated by membranous regions or external grooves called sutures. The sclerites form a dorsal tergum and ventral sternum, which are separated by the lateral pleural regions on the sides. Each segment may have one or more sclerites in each of these three regions (dorsal, ventral, and lateral) called tergites, sternites, and pleurites, respectively. Apophyses and pits are internal inflections of the exoskeleton that give it strength and provide insertion points for muscle. The segmentation created by the succession of sclerites is grouped into three body regions called the head, mesosoma, and gaster.

The exoskeleton of *Camponotus* spp. has a shagreened (rough) appearance created by minute projections, which may be striate, reticulate, or catenulate (chain-shaped), for example, the catenulate sculpturing on the tip of the gaster of *C. pennsylvanicus* (DeGeer). A punctate (pitted) exoskeleton is often found surrounding hairs, for example, on the gaster of *C. chromaiodes* Bolton. A foveolate (round or elongate depression) exoskeleton is found on the gena of *C. castaneus* (Latreille). The pattern and dimensions of pubescence (fine body hairs) are used in the identification of several species of *Camponotus* (Table 2.2).

TABLE 2.2

Hair lengths in seven species

Species of Camponotus	Caste	Comparison of long to short hairs
C. pennsylvanicus	Queen	1 long hair = 3–4 short hairs
C. noveboracensis	Queen	1 long hair = 4–5 short hairs
C. hyatti	Queen	1 long hair = 7–7.5 short hairs
C. pennsylvanicus	Worker	1 long hair = 2–3 short hairs
C. castaneus	Worker	1 long hair = 14 short hairs
C. americanus	Worker	1 long hair = 15 short hairs
C. vicinus	Worker	1 long hair = 3.5 short hairs

Source: Adapted from Sparks 1941.
Note: Hairs are from the middorsal portion of the second gastral segment.

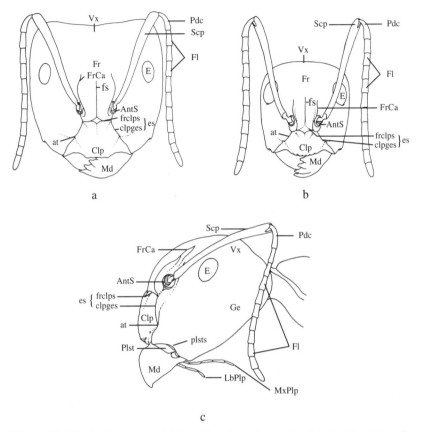

Figure 2.2. Head of a worker. (a) Anterior view of a major. (b) Anterior view of a minor. (c) Lateral view of a major. *AntS*, antennal socket; *at*, anterior tentorial pit; *Clp*, clypeus; *clpges*, clypeal genal suture; *E*, compound eye; *es*, epistomal suture; *Fl*, flagellum; *Fr*, frons; *FrCa*, frontal carina; *fs*, frontal suture; *frclps*, frontal clypeal suture; *Ge*, gena; *LbPlp*, labial palp; *Md*, mandible; *MxPlp*, maxillary palp; *Pdc*, pedicel; *Plst*, pleurostoma; *plsts*, pleurostomal suture; *Scp*, scape; *Vx*, vertex.

HEAD

General. The head of the ant bears the major sensory organs and mouthparts. The external features of the head of a major worker are illustrated in anterior (Fig. 2.2a), lateral (Fig. 2.2c), and posterior views (Fig. 2.3). In an anterior view, the head is a little wider than long when the mandibles are excluded, but square-shaped when they are included to form the lower

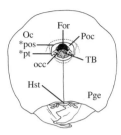

Figure 2.3. Head of a major worker, posterior view. *Beneath postocciput. *For*, foramen magnum; *Hst*, hypostoma; *Oc*, occiput; *occ*, occipital condyle; *Pge*, postgena; *Poc*, postocciput; *pos*, postoccipital suture; *pt*, posterior tentorial pit; *TB*, tentorial bridge.

edge. The compound eyes are dorsolateral, about one-third the distance from the occipital lobes to the mandibles (Fig. 2.2a, c). The antennal scapes arise from sockets near the lower end of the frontal carinae.

The frons or "face" is the upper region of the head between the eyes. The top of the head is the vertex. The genae or "cheeks" are located on the sides of the head below the eyes. The clypeus is a plate bounded by the epistomal suture on the top (frontoclypeal suture) and sides (clypeogenal sutures), and the mandibles below. A pair of lateral pits in the clypeogenal sutures marks the anterior origin of the tentorium (endoskeleton of the head). The malar region is the area below the compound eye, above the base of the mandible, and anterior to the gena.

In a posterior view (Fig. 2.3), there is a large opening, the occipital foramen or foramen magnum, between the head and thorax. The oesophagus, dorsal blood vessel, tracheae, nerves, and salivary ducts pass through the foramen magnum. The postocciput is a sclerite surrounding the foramen magnum and encircled by the postoccipital suture or sulcus. A pair of pits in this suture marks the posterior origin of the tentorium. Above and to the sides of the foramen magnum is a region of the head called the occiput or occipital arch. This region is enlarged in major workers to form occipital lobes, which extend posteriorly. Below and to the sides of the foramen magnum are the postgenae. The pleurostomal suture delimits the genae and postgenae from the narrow pleurostomal (Fig. 2.2c) and hypostomal sclerites, respectively (Fig. 2.3).

During development, the postgenal and hypostomal regions expand posteriorly and meet, creating the venter of the head. A postgenal ridge (Fig. 2.4) is formed internally and provides an insertion point for muscles.

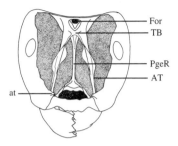

Figure 2.4. Tentorium in a major worker. *AT*, anterior tentorial arm; *at*, anterior tentorial pit; *For*, foramen magnum; *PgeR*, postgenal ridge; *TB*, tentorial bridge.

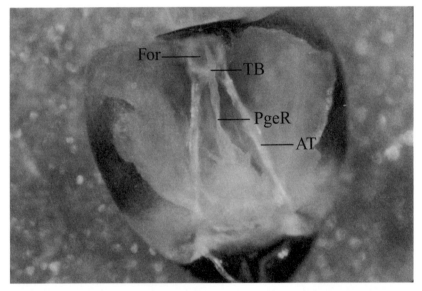

Figure 2.5. Anterior view of the tentorium in a *Camponotus modoc* major worker. *AT*, anterior tentorial arm; *For*, foramen magnum; *PgeR*, postgenal ridge; *TB*, tentorial bridge.

The tentorium (Figs. 2.4, 2.5) consists of two sclerotized struts, the anterior tentorial arms. These arms extend from the anterior to the posterior tentorial pits. The tentorial bridge, which is visible through the foramen magnum, is located between the posterior ends of the tentorial arms. The

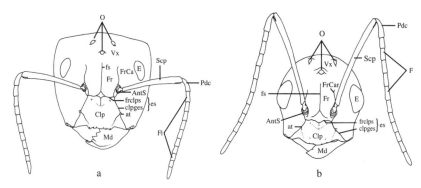

Figure 2.6. Anterior view of the head. (a) Winged female. (b) Male. *AntS*, antennal socket; *at*, anterior tentorial pit; *Clp*, clypeus; *clpges*, clypeal genal suture; *E*, compound eye; *es*, epistomal suture; *Fl*, flagellum; *Fr*, frons; *FrCa*, frontal carina; *frclps*, frontal clypeal suture; *fs*, frontal suture; *Md*, mandible; *O*, ocelli; *Pdc*, pedicel; *Scp*, scape; *Vx*, vertex.

tentorium provides a structural brace for the head capsule, as well as surface area for the attachment of muscles for the antennae and mouthparts, and helps support the brain and foregut.

The shape and structure of the head vary depending on the caste and size of the ant. For example, the head of a minor worker (Fig. 2.2b) is elongate, and the occipital region is greatly reduced in comparison to that of a major worker. The head of the queen (Fig. 2.6a) is also elongate; however, it differs from that of the worker by possessing ocelli, which are located on the vertex. The male also has ocelli, but its head (Fig. 2.6b) in comparison to that of the queen is smaller, rounder, and narrower on the lower edge above the mandibles. The mandibles on the male also lack teeth.

The antenna is composed of the scape, which attaches to the head, and the funiculus, which consists of a basal segment, the pedicel, and a long multisegmented flagellum. The antennae have an "elbowed" appearance due to their elongated scapes.

Mouthparts. The mouthparts of a typical insect consist of a labrum, gnathal appendages, and a hypopharynx or "tongue." The gnathal appendages consist of the mandibles, maxillae, and labium, with the latter developing from the fusion of the second maxillae. Both larval and adult Hymenoptera are characterized by having a maxillolabial complex (Fig. 2.7), which is formed by the union of the maxillae with the labium. This complex is suspended from the hypostomal bridge and forms a channel

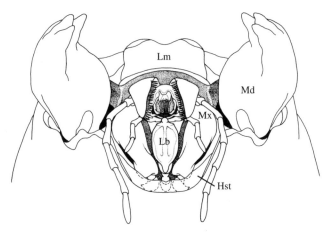

Figure 2.7. Maxillolabial complex of a major worker, ventral view. *Hst*, hypostoma; *Lb*, labium; *Lm*, labrum; *Md*, mandible; *Mx*, maxilla.

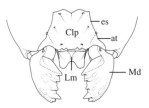

Figure 2.8. Labrum extended on a major worker, anterior view. *at*, anterior tentorial pit; *Clp*, clypeus; *es*, epistomal suture; *Lm*, labrum; *Md*, mandible.

along which food travels to the mouth. Food first enters a preoral cavity, which is created by the mouthparts and hypopharynx.

Labrum/epipharynx. The labrum (Figs. 2.8, 2.9) is a flaplike structure suspended posteriorly from the lower edge of the clypeus. It is not visible from an anterior view of the head. The labrum has a medial cleft with a concentration of heavy setae on its distal margin. A medial lobe on the inner surface of the labrum forms the epipharynx (Fig. 2.14), a membranous, padlike, triangular structure. The epipharynx fits closely against the hypopharynx when the mouth is closed.

Mandibles. The mandibles (Fig. 2.10) are broad and triangular with one apical and four prominent subapical teeth on the masticatory margin. The

Figure 2.9. Anterior view of the mouthparts showing labrum and mandible. *at*, anterior tentorial pit; *Clp*, clypeus; *es*, epistomal suture; *Lm*, labrum; *Md*, mandible.

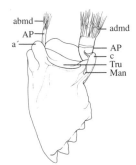

Figure 2.10. Mandible of a major worker, dorsal view. *a′*, primary dorsal cranial articulation of mandible; *abmd*, abductor muscle of mandible; *admd*, adductor muscle of mandible; *AP*, apodeme; *c*, secondary ventral articulation of mandible; *Tru*, trulleum; *Man*, mandalus.

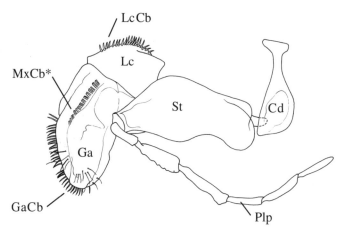

Figure 2.11. Maxilla of a major worker, external surface. *Maxillary comb (*MxCb*) on internal surface has been drawn as though the galea were transparent. *Cd*, cardo; *Ga*, galea; *GaCb*, galeal comb; *Lc*, lacinia; *LcCb*, lacinial comb; *Plp*, palp; *St*, stipes.

mandible articulates with two condyles at the pleurostomal margin of the cranium. On the dorsal surface of the mandible is the trulleum, a basin-shaped depression, and the mandalus, a small unpigmented area at the base. Both regions are distinct only in the disarticulated mandible. The adductor and abductor muscles attach the mandible to the mandibular apodemes.

Maxillae. The maxilla (Fig. 2.11) is composed of the cardo, stipes, lacinia, galea, and maxillary palp. The palp is divided into six segments and is attached to the stipes. The stipes is elongated and joined to the galea and lacinia on its internal surface. The galea and lacinia are broadly joined and appear as one continuous structure. The galea has a flattened galeal crown with numerous long, thin setae and a series of short, stout setae. Rows of large peglike setae form the galeal comb. On the internal surface of the galea is a series of regularly spaced, rigid setae called the maxillary comb. The lacinia is triangular with a rounded apex and a row of setae along its free margin called the lacinial comb.

Labium. The labium (Fig. 2.12) consists of the prelabium, which is divided into the prementum, palp, glossa, and paraglossa, and the post-labium or postmentum, which is divided into a proximal submentum and a distal mentum. The labial palp is composed of four segments and inserts near the distal, lateral angles of the premental shield, which is sclerotized

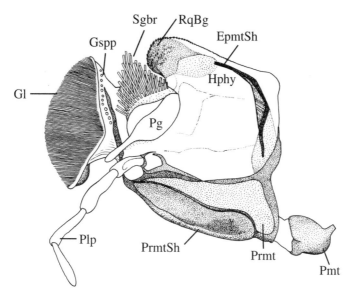

Figure 2.12. Labium of a major worker, lateral view. *EpmtSh*, epimental shield; *Gl*, glossa; *Gspp*, gustatory papillae; *Hphy*, hypopharynx; *Pg*, paraglossa; *Plp*, palp; *Pmt*, postmentum; *Prmt*, prementum; *PrmtSh*, premental shield; *RqBg*, raquettes of Bugnion; *Sgbr*, subglossal brush.

on its ventral surface. The membranous dorsal surface on the prementum is fused with the hypopharynx. The opening of the salivary duct, which can be used to delineate the hypopharyngeal region from the premental area of the labium, lies beneath the distal end of the hypopharynx (Fig. 2.13). The epimentum or epimental shield is located on each side of the labium at its proximal border (Fig. 2.12). This shield which is inserted on the proximal lateral angles of the premental shield, lies on the dorsal side of the labium and angles anteriorly to terminate in a triangular expansion. The terminal expansions of the epimental shields are called raquettes of Bugnion (Bugnion 1924 cited in Gotwald 1969). The glossa is located at the distal end of the labium and is covered with a series of transverse ridges. Subglossal brushes are located proximal to the glossa and are composed of a set of large, rigid setae. A row of sensory structures, the gustatory papillae, is located between the edges of the transverse ridges and the subglossal brush.

Infrabuccal pocket. The hypopharynx together with the epipharynx forms a preoral food chamber, the cibarium (Fig. 2.13). This chamber opens into

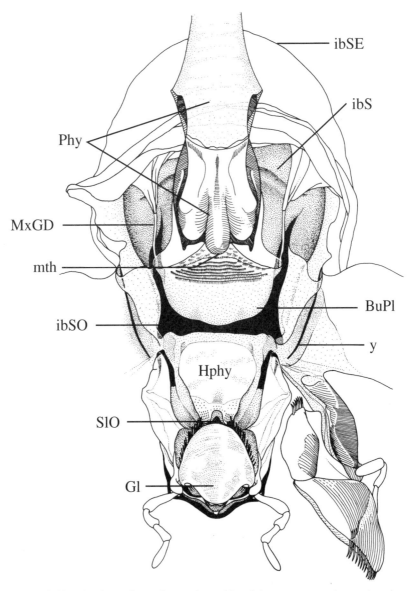

Figure 2.13. Cibarium of a major worker with epipharynx removed, anterior view. *BuPl*, buccal plate; *Gl*, glossa; *Hphy*, hypopharynx; *ibS*, infrabuccal sac (pocket); *ibSE*, infrabuccal sac envelope; *ibSO*, infrabuccal sac orifice; *mth*, mouth; *MxGD*, maxillary gland duct; *Phy*, pharynx; *SlO*, salivary orifice; *y*, suspensoria.

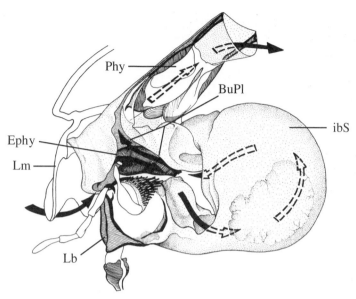

Figure 2.14. Feeding apparatus of the major worker, lateral view, showing route of the food through the cibarium, infrabuccal pocket, and mouth. *BuPl*, buccal plate; *Ephy*, epipharynx; *ibS*, infrabuccal sac; *Lb*, labium; *Lm*, labrum; *Phy*, pharynx.

a second chamber, the infrabuccal pocket or infrabuccal chamber (Figs. 2.14, 2.15), which is formed from a diverticulum off the posterior hypopharynx. The infrabuccal pocket is a collection site for particles of food and debris (from grooming). Ducts from the propharyngeal, post-pharyngeal, maxillary, labial, and mandibular glands empty into the cibar-ium and infrabuccal pocket.

Food is filtered by the glossal ridges on the buccal plate, which form the dorsal side of the infrabuccal pocket. The buccal plate is thick and has hair-like projections on its walls that are directed toward the entrance to the infrabuccal chamber. As food is pumped out of the infrabuccal pocket into the pharynx, the buccal plate meets with the posterior surface of the epipharynx, which contains ridges and hairs also projecting toward the infrabuccal pocket. The "buccal tube" of Forbes (1938) and Forbes and McFarlane (1961) is not really a tube but a flat surface that is an extension of the posterior surface of the pharynx into the dorsal surface of the infrabuccal pocket. Therefore, the term buccal plate is used in these descrip-tions because it more accurately describes its structure and function.

Figure 2.15. Longitudinal section through the head of *Camponotus modoc* worker with the infrabuccal pocket. *ibS*, infrabuccal sac; *Lb*, labium; *MxG*, maxillary gland.

A thin layer of tissue called the pocket envelope separates the infrabuccal pocket from other internal structures. This layer encloses the pocket and attaches anteriorly to the base of the mouthparts (Figs. 2.13, 2.14).

MESOSOMA

General. The thoracic segments of an insect are divided into four sclerites: a dorsal tergum, called the notum; a ventral sternum, which is divided into an anterior plate, the basisternum, and a posterior plate, the sternellum; and two lateral pleura, one on each side between the wings and legs. The pleuron is divided by a suture into an anterior sclerite, the episternum, and a posterior sclerite, the epimeron.

The mesosoma of ants, as well as other hymenopterans in the suborder Apocrita, is made up of three thoracic segments, the prothorax, mesothorax, and metathorax, plus the first abdominal tergum called the propodeum or epinotum, which is fused with the thorax. Thus, the constriction separating the gaster from the mesosoma in carpenter ants is between the first

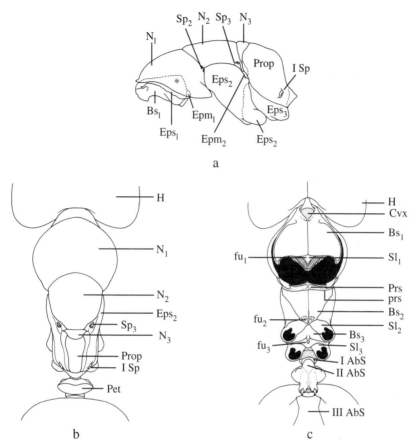

Figure 2.16. Mesosoma of a major worker. (a) Lateral view. (b) Dorsal view. (c) Ventral view. *Area beneath N_1. *AbS*, abdominal sternum; *Bs*, basisternum; *Cvx*, cervix; *Epm*, epimeron; *Eps*, episternum; *fu*, median sternal groove marking the furca externally; *H*, head; *N*, notum; *Pet*, petiole; *Prop*, propodeum; *Prs*, presternum; *prs*, presternal suture; *Sl*, sternellum; *Sp*, spiracle.

and third abdominal segments, with the second segment forming the petiole.

In workers (Fig. 2.16a, b) the pronotum is large and prominent and partially covers the episternum, which extends forward into the cervix or neck. At the posterior edge of the episternum just above the coxa is the small epimeron. In contrast to many insects where the epimeron and episternum are oriented vertically, in ants they are nearly horizontal. The pleural

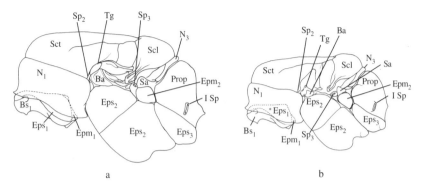

Figure 2.17. Lateral view of the mesosoma. (a) Winged female. (b) Male. *Area beneath N_1. *Ba*, basalare; *Bs*, basisternum; *Epm*, epimeron; *Eps*, episternum; *N*, notum; *Prop*, propodeum; *Sa*, subalare; *Scl*, scutellum; *Sct*, scutum; *Sp*, spiracle; *Tg*, tegula.

sutures are also horizontal, but difficult to delimit. The epimeron of the mesothorax has been reduced to a small sclerite. The mesothoracic episternum, above the middle leg, and the mesonotum are enlarged. The metathorax is greatly reduced, with a small notum and episternum dorsal to the third coxa, and no epimeron. A ventral view (Fig. 2.16c) shows the well-developed first two thoracic segments and the reduced metathoracic segment. The basisterna compose the primary sclerites on the ventral surface, with the prothoracic segment being the largest. Each segment bears a smaller sternellum or furcasternum bearing the endosternal process, the furca. Each sternellum articulates with a coxa. The sternum of the first abdominal segment is greatly reduced.

The thoracic segments of alates are modified for flight (Fig. 2.17). The pronotum curves posteriorly and covers the episternum and epimeron. The epimeron is reduced to a small sclerite on the posteroventral edge of the episternum. The mesothorax is highly developed, with a prominent scutum and scutellum. The metathoracic notum is reduced to a narrow sclerite just anterior to the propodeum. As in the worker, the episterna and epimera are horizontally oriented, the second epimeron is reduced, and the third epimeron is absent. The thorax of male and female alates is similar, except that the female is more robust and has a proportionately longer propodeum.

The mesosoma has three pairs of spiracles (Figs. 2.16a, b; 2.17): (1) the mesothoracic on the front edge of the mesonotum; (2) the metathoracic on the posterior edge of the mesepisternum and mesonotum; and (3) the propodeal on the lower side, which is the largest.

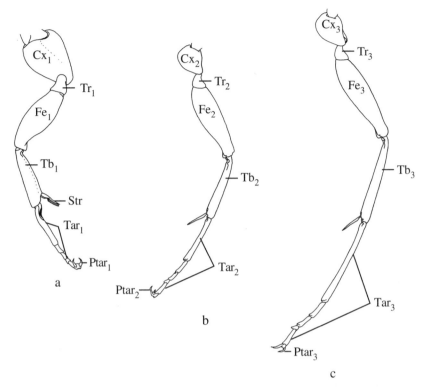

Figure 2.18. Legs of a major worker. (a) Prothoracic. (b) Mesothoracic. (c) Metathoracic. *Cx*, coxa; *Fe*, femur; *Ptar*, pretarsus; *Str*, strigil; *Tar*, tarsus; *Tb*, tibia; *Tr*, trochanter.

Legs. The leg of an ant has the typical segments found in other insects: coxa, trochanter, femur, tibia, tarsus, and pretarsus with tarsal claws (Fig. 2.18). The tarsus is five-segmented with an elongated first segment, the basitarsus. The tibia has a distal tibial spur. The basitarsus and the tibial spur of the prothoracic legs are fringed with bristles and function together as an antennal cleaner, the strigil.

Wings. The wing venation of *Camponotus* spp. can be used to differentiate them from species of other genera (Fig. 2.19). The venation of the forewing is reduced by the fusion of the subcostal with the radial, and the medial with the cubital veins. A large stigma is located just past the median point on the anterior margin, and there is only one submarginal cell.

The hindwing is much smaller than the forewing but has the same fused veins as the forewing. The submarginal and discoidal cells as well as the

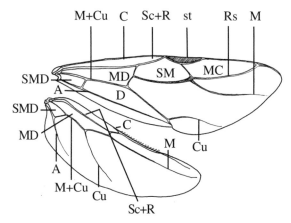

Figure 2.19. Wings of an alate female. Veins: *A*, anal; *C*, costa; *Cu*, cubitus; *M*, media; *R*, radius; *Rs*, radial sector; *Sc*, subcosta. Cells: *C*, costal; *D*, discoidal; *MC*, marginal; *MD*, median; *SM*, submarginal; *SMD*, submedian; *st*, stigma.

stigma are absent. The hamuli, a series of hooks on the anterior margin of the hindwing, connect to the forewing during flight.

ABDOMEN

General. The first abdominal segment in ants, the propodeum, is fused with the thorax. The gaster (metasoma) is joined to the propodeum by the pedicel, which is composed of one or two segments. The one-segmented pedicel of *Camponotus* bears a spiracle and is elongated dorsally to form a node. The remaining abdominal segments constitute the gaster, which tapers posteriorly to a point. The sclerotized plates on the gaster (Fig. 2.20) consist of a dorsal tergum and a ventral sternum. In the female, the seventh abdominal sternum is the subgenital plate, and the eighth and ninth segments are hidden. In the male, the last exposed segmental plates are tergum VIII and sternum IX (Fig. 2.21), the latter being the subgenital plate.

Segments III to VI in the female and segments III to VII in the male are fairly uniform. The terga overlap the sterna in the ventrolateral areas. The spiracles are located in the lateral areas of the terga in segments III through VII. Segment VIII bears a spiracle on a plate that is retracted into VII. The lateral membranes connecting the terga and sterna allow for dorsoventral expansion and compression. The abdominal segments of the

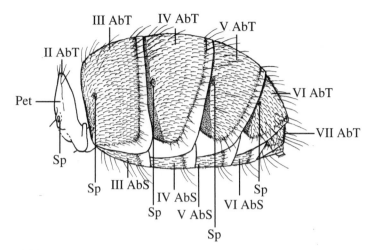

Figure 2.20. Petiole and gaster of a major worker, lateral view. *AbS*, abdominal sternum; *AbT*, abdominal tergum; *Pet*, petiole; *Sp*, spiracle.

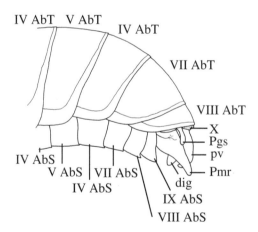

Figure 2.21. Gaster of a male, lateral view. Abdominal tergum IX is concealed and X is membranous. Abdominal sternum IX is also the subgenital plate. *AbS*, abdominal sternum; *AbT*, abdominal tergum; *dig*, digitus volsellaris; *Pgs*, pygostyle; *Pmr*, paramere; *pv*, penis valve.

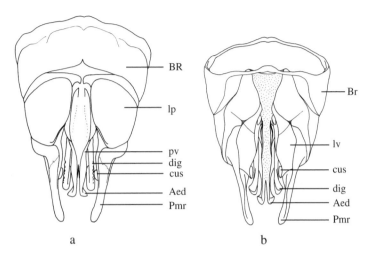

Figure 2.22. Male genitalia. (a) Dorsal view. (b) Ventral view. *Aed*, aedeagus; *BR*, basal ring; *cus*, cuspis volsellaris; *dig*, digitus volsellaris; *lp*, lamina parameralis; *lv*, lamina volsellaris; *Pmr*, paramere; *pv*, penis valve.

gaster are connected by intersegmental membranes, which enable them to telescope or expand anteroposteriorly. Telescoping is evident when the queen becomes physogastric (swollen with eggs), when workers have enlarged fat bodies for overwintering, and when foragers are replete with liquids. When the gaster is stretched, it has a striped appearance because the anterior portion of each tergite, which is normally hidden, is lighter in color and lacks pubescense.

Male genitalia. The male genitalia are derived from the ninth segment and project ventrally from between the ninth sternum and the tenth tergum, which is a membrane concealed under the eighth tergum (Fig. 2.21). Tergum X bears the anus and a pair of pygostyli, which project beyond the margin of the eighth tergum. The basal segment of the genitalia is the lamina annularis or basal ring, which is roughly circular but reduced to a narrow band ventrally (Fig. 2.22). The posterior margin of the basal ring supports three pairs of valves, which constitute the genitalia. The outer pair consists of the basal lamina parameralis, and a long, narrow, distal extension, the paramere. These partially cover the middle and inner pairs of valves. The middle pair consists of the basal lamina volsellaris, from which two sets of lobes extend. The lateral lobe, the cuspis volsellaris, is shorter and rounded, with the distal end directed dorsally. The medial lobe, the

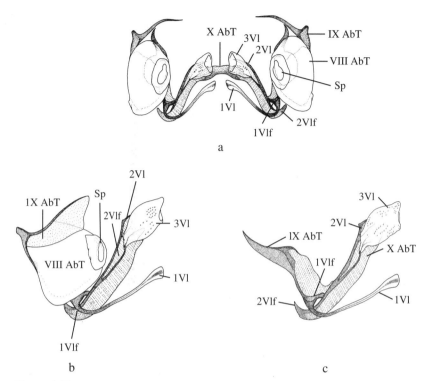

Figure 2.23. Female genital plates. (a) Posterior view. (b) Lateral view. (c) Lateral view with eighth spiracle plate removed. *AbT*, abdominal tergum; *Sp*, spiracle; *Vl*, valvula; *Vlf*, valifer.

digitus volsellaris, extends beyond the cuspis volsellaris and is pointed ventrally. This middle pair of valves is assumed to have a clasping function because of the forceps-like arrangement of the lobes. The inner pair of valves forms the aedeagus and consists of two laterally compressed plates, the penis valves. These plates are fused dorsally by a thinly sclerotized membrane.

Female Genital Plates. The genitalia of the queen and workers of *C. modoc* are similar in structure to those in stinging ants and are located on segments VIII and IX, which are not visible externally (Fig. 2.23a, b). The valvifers of VIII and IX are located behind the eighth spiracular plate. The valvulae extend posteriorly (Fig. 2.23c) to form structures around the acidopore, where venom is sprayed. The first valvifers are small triangular plates that articulate dorsally with the quadrate plates and anteriorly with

the second valvifers, which are slightly sclerotized, elongate plates. The first valvulae, which are elongate rods with spatulate distal ends, extend posteriorly from the first valvifers and are located ventral to valvulae 2 and 3. Valvulae 2 and 3 are fused proximally, with valvulae 3 forming the middle pair, which are cup-shaped and membranous and have setae at their distal ends. The third valvulae form the gonostyli, which extend from the distal ends of the second valvifers or oblong plates. A small tenth tergal plate is present under valvulae 2 and 3 (Fig. 2.23a, c).

INTERNAL MORPHOLOGY

ALIMENTARY CANAL

The insect digestive tract is divided into three main regions: foregut, midgut, and hindgut. Developmentally, the foregut and hindgut are ecto-dermal in origin, and the midgut is endodermal. The digestive tract varies in structure, length, and diameter according to the diet of the insect. For example, insects that feed primarily on protein typically have shorter digestive tracts than carbohydrate feeders. The digestive tracts of many species of ants in the Formicinae subfamily are specialized for feeding on fluids, especially honeydew (Hölldobler and Wilson 1990).

Food enters the foregut via the pharynx (Figs. 2.14, 2.24, 2.25), which is dorsoventrally compressed. On its walls are rows of hairs that point ven-trally toward the opening of the infrabuccal pocket, a filtering apparatus that keeps the liquid diet of these ants particle-free (Fig. 2.13) (Eisner and Happ 1962). A set of specialized dilator muscles attach the pharynx to the dorsal and lateral sides of the head, creating a pharyngeal pump that can be opened and closed to suck fluids. The pharynx narrows into the oesoph-agus, a tube that passes under the supraesophageal ganglia, through the entire length of the mesosoma and petiole, and into the gaster.

In the gaster, the oesophagus enlarges to form the crop, a thin-walled sac for storing food (Fig. 2.26). The crop opens into the proventriculus, which is divided into three regions: an anterior funnel-shaped calyx, a middle muscular bulb, and a posterior cylindrical section that ends as a knobby valve in the ventriculus. Four chitinous rods or sepals extend along the length of the calyx and converge at the base to form a gastric valve. The proventriculus is a pump that regulates the flow of food from the crop to the elliptically shaped stomach or ventriculus, the largest structure in the digestive system.

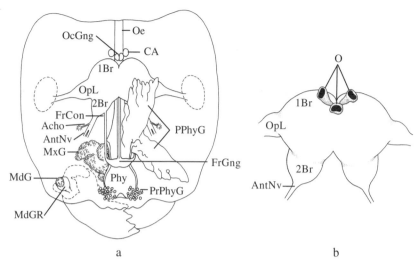

Figure 2.24. Anterior view of the brain and glands of the head. (a) Major worker. (b) Winged female. *Acho*, antennal chordotonal organ; *AntNv*, antennal nerve; *Br*, brain; *CA*, corpus allatum; *FrCon*, frontal connective; *FrGng*, frontal ganglion; *MdG*, mandibular gland; *MdGR*, mandibular gland reservoir; *MxG*, maxillary gland; *O*, ocelli; *OcGng*, occipital ganglion; *Oe*, oesophagus; *OpL*, optic lobe; *PPhyG*, postpharyngeal gland; *Phy*, pharynx; *PrPhyG*, propharyngeal gland.

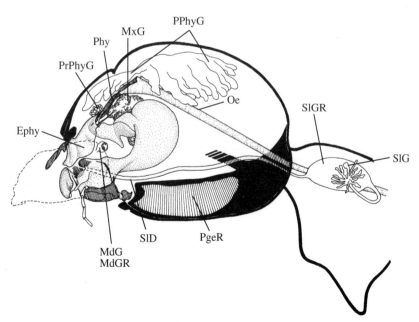

Figure 2.25. Glands of the head appendages and other anterior glands in a major worker, lateral view. *Ephy*, epipharynx; *MdG*, mandibular gland; *MdGR*, mandibular gland reservoir; *MxG*, maxillary gland; *Oe*, oesophagus; *PgeR*, postgenal ridge; *PPhyG*, postpharyngeal gland; *Phy*, pharynx; *PrPhyG*, propharyngeal gland; *SlD*, salivary duct; *SlG*, salivary gland; *SlGR*, salivary gland reservoir.

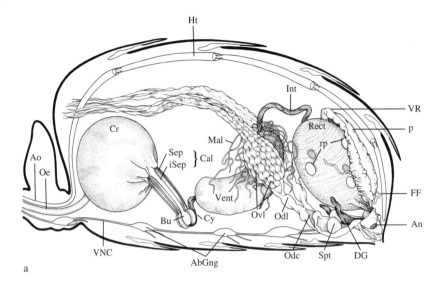

a

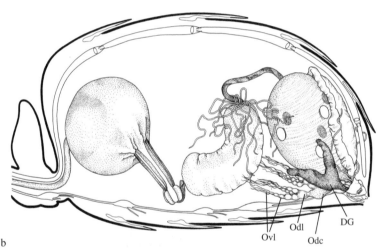

b

Figure 2.26. Digestive, circulatory, nervous, and reproductive systems in the gaster, lateral view. (a) Inseminated queen. (b) Major worker. *AbGng*, abdominal ganglia; *An*, anus; *Ao*, aorta; *Bu*, bulb of proventriculus; *Cal*, calyx; *Cr*, crop; *Cy*, cylinder portion of proventriculus; *DG*, Dufour's gland; *FF*, free filaments of venom gland; *Ht*, heart; *Int*, intestine; *iSep*, intersepalary space; *Ma*, Malpighian tubules; *Odc*, median oviduct; *Odl*, lateral oviduct; *Oe*, oesophagus; *Ovl*, ovariole; *p*, pulvinus; *Rect*, rectum; *rp*, rectal pad; *Sep*, sepal; *Spt*, spermatheca; *Vent*, ventriculus; *VNC*, ventral nerve cord; *VR*, venom reservoir.

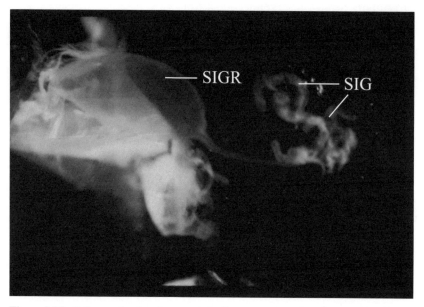

Figure 2.27. Salivary gland and reservoir in *Camponotus modoc* worker. *SIG*, salivary gland; *SIGR*, salivary gland reservoir.

The Malpighian tubules are excretory organs that attach to the alimentary canal at the junction of the ventriculus and the intestine. The tubules lie freely in the body cavity, and their number varies from 16 in minor workers to 26 in queens. The intestine is a short, narrow tube that connects to the rectum, a large sac that opens posteriorly into the anus. On the walls of the rectum are six round rectal pads.

DIGESTIVE GLANDS

The three pairs of glands associated with the digestive system of ants (Forbes and McFarlane 1961) are the postpharyngeal, maxillary, and labial or salivary glands (Figs. 2.24, 2.25, 2.27). The postpharyngeal glands are the largest glands in the head and arise from the posterior, dorsal part of the pharynx. They are composed of two large groups of finger-like tubes, which extend anteriorly over the pharynx and posteriorly over the brain. The maxillary glands lie on either side of the pharynx. The ducts from these glands empty into the infrabuccal pocket. The labial or salivary glands (Figs. 2.25, 2.27) are located in the dorsolateral regions of the prothorax. These tubular glands produce secretions, which are stored in a pair

of ventrally located reservoirs. A duct from each reservoir extends anteriorly, uniting with the other in the neck region to form a single common duct that opens between the hypopharynx and the labium.

In *C. modoc*, there is also a pair of propharyngeal glands located on the anterior surface of the pharynx, with ducts opening into the pharynx. Secretions of the propharyngeal, maxillary, and labial glands have all been associated with extraoral digestion in the infrabuccal pocket.

CIRCULATORY SYSTEM

The primary circulatory organ in insects is the dorsal vessel, which consists of the heart, located in the abdomen, and the aorta, which extends anteriorly from the heart. In *C. modoc*, the heart extends along the dorsal midline of the gaster just beneath the integument (Fig. 2.26). It continues through the petiole and mesosoma as the aorta and ends in the head at the base of the brain. The heart has four pairs of ostia on its lateral walls and is held in place by suspensory filaments and alary muscles. Both the heart and the alary muscles are surrounded by adipose tissue.

RESPIRATORY SYSTEM

The respiratory system of a *C. pennsylvanicus* worker consists of an internal system of branching tubules called tracheae, which open to the surface through spiracles on the thorax and abdomen (Keister 1963). There are 10 pairs of spiracles in *C. modoc*: 2 pairs on the thorax, 1 pair each on the propodeum and petiole, and 6 pairs on the gaster, the last pair of which is hidden (Fig. 2.28). The spiracles are small, round openings, except for those on the propodeum, which are large and elliptical in shape. Each spiracle is connected to the main longitudinal trunk by a short trachea. These spiracular tracheae give rise to branches that supply the viscera of the gaster. At the anterior end of the gaster, the longitudinal trunks are enlarged to form tracheal sacs.

NERVOUS SYSTEM

The three main regions of the nervous system of *C. modoc* are the supraesophageal and subesophageal ganglia in the head, and the ventral nerve cord in the thorax and abdomen.

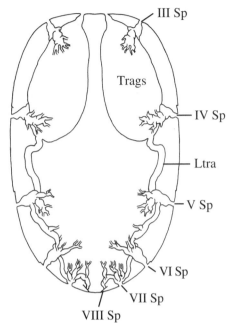

Figure 2.28. Respiratory system in the gaster of a winged female, dorsal view. *Ltra*, longitudinal trunk; *Sp*, spiracle; *Trags*, tracheal sacs.

The supraesophageal ganglion or brain (Figs. 2.24, 2.29) is composed of the protocerebrum or forebrain, the deuterocerebrum or midbrain, and the tritocerebrum or hindbrain. The protocerebrum bears the optic lobes or visual centers, which are small in most species of ants when compared with other hymenopterans (Gronenberg 1996). However, the alates, which depend on vision in their nuptial flights, have larger compound eyes (Fig. 2.30) and optic lobes than workers. The ocelli are connected to the proto-cerebrum by slender stalks (Fig. 2.24). The pedunculate or mushroom bodies on the dorsal side of the forebrain are large and involved in odor discrimination, olfactory learning, and multimodal information processing (Gronenberg 1996). The deuterocerebrum bears the antennal lobes and nerves, from which a smaller antennal chordotonal nerve branches. The antennal lobes are very large and complex, reflecting the importance of olfaction in ants (Gronenberg 1996). In the tritocerebrum, the labral nerves branch off the frontal ganglion connectives, uniting on the anterior surface of the pharynx to form the frontal ganglion.

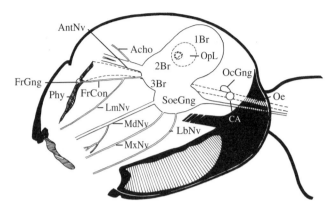

Figure 2.29. Nervous system in the head of a major worker, lateral view. *Acho*, antennal chordotonal nerve; *AntNv*, antennal nerve; *Br*, brain; *CA*, corpus allatum; *FrCon*, frontal connective; *FrGng*, frontal ganglion; *LbNv*, labial nerve; *LmNv*, labral nerve; *MdNv*, mandibular nerve; *MxNv*, maxillary nerve; *OcGng*, occipital ganglion; *Oe*, oesophagus; *OpL*, optic lobe; *Phy*, pharynx; *SoeGng*, subesophageal ganglion.

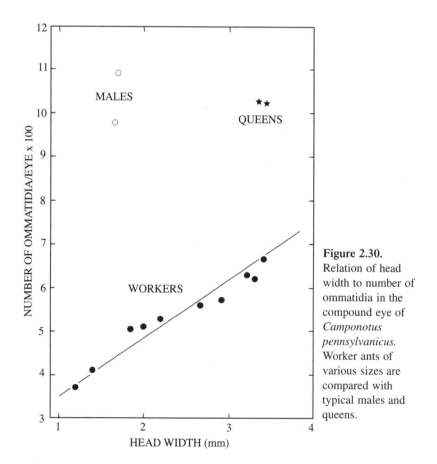

Figure 2.30. Relation of head width to number of ommatidia in the compound eye of *Camponotus pennsylvanicus.* Worker ants of various sizes are compared with typical males and queens.

Figure 2.31. Brain, anterior view. (a) Major worker. (b) Queen. *Br*, brain; *O*, ocelli.

Posterior to the brain are the paired occipital ganglia, also called the "oesophageal" ganglia because of their location (Figs. 2.24, 2.29, 2.31). Nearby, lying alongside the oesophagus, are the paired corpora allata.

The subesophageal ganglion, which is the first ganglion in the ventral chain, innervates the mandibles, maxillae, and labium (Figs. 2.29, 2.32). The ventral nerve cord extends posteriorly from the subesophageal ganglion and includes the thoracic and abdominal ganglia (Fig. 2.33). The three thoracic ganglia innervate the legs and wings (in reproductives) and are much larger than the abdominal ganglia. The first two abdominal ganglia are fused with the metathoracic ganglion and innervate the metathorax, epinotum, and petiole (Fig. 2.34). The next three ganglia located in the gaster are smaller and similar in size. The terminal ganglion, which is formed by the fusion of the last three segmental ganglia (VI, VII, and VIII), is somewhat larger.

REPRODUCTIVE SYSTEMS AND ASSOCIATED GLANDS

Male. The paired testes are located on the dorsal side of the digestive system (Fig. 2.35). Each testis is composed of nine testicular follicles. Each

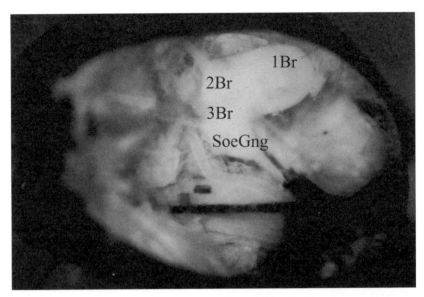

Figure 2.32. Brain of a major worker with nerves in the head, lateral view. *Br*, brain; *SoeGng*, subesophagael ganglion.

follicle opens into a short duct, the vas efferens, which empties into a common duct, the vas deferens. The vas deferens connects with the seminal vesicle, which joins with an accessory gland near its base. The ducts from the accessory glands unite distally to form a common ejaculatory duct, the proximal end of which is enlarged to form a penis bulb, also called the aedeagal bladder.

Maturation of the gonads in *Camponotus* spp. continues up to 25 days following eclosion (Hölldobler 1966). Witherell (1991) studied the internal structure of the male reproductive system in *C. modoc* from the time of eclosion in August until the nuptial flight in April. Males dissected on the first day after eclosion had enlarged testes, narrow seminal vesicles, and small accessory glands (Fig. 2.35a). After one week, the size of the testes was reduced, and the seminal vesicles and accessory glands were enlarged (Fig. 2.35b). Sections through these organs at the time of eclosion show that spermatozoa are present in the testicular follicles, and that within several days they move to the seminal vesicles, where they are stored until spring. The enlargement of the accessory gland is due to growth of glandular tissue

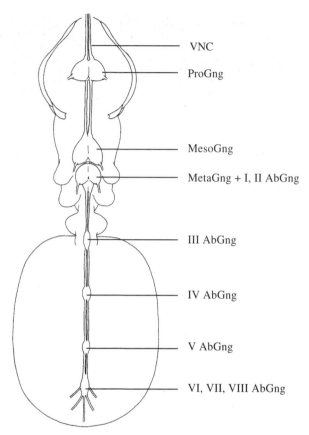

VNC

ProGng

MesoGng

MetaGng + I, II AbGng

III AbGng

IV AbGng

V AbGng

VI, VII, VIII AbGng

Figure 2.33. Nervous system in the thorax and abdomen of a major worker, dorsal view. *AbGng*, abdominal ganglion; *MesoGng*, mesothoracic ganglion; *MetaGng*, metathoracic ganglion; *ProGng*, prothoracic ganglion; *VNC*, ventral nerve cord.

and secretions. A plug is produced between the seminal vesicle and accessory gland and remains in place through the winter and spring months. A similar developmental process is found in *C. festinatus* (Buckley), *C. sayi* Emery, and *C. mina* Forel (Wheeler and Krutzsch 1992).

Female. The female reproductive system in *C. modoc* consists of a pair of ovaries that connect to a pair of lateral oviducts. The oviducts join to form a common oviduct, which opens to the outside at the gonopore (Figs. 2.26, 2.36). Sperm is stored in the spermatheca, which is easily identified by its large size and shape (Fig. 2.37).

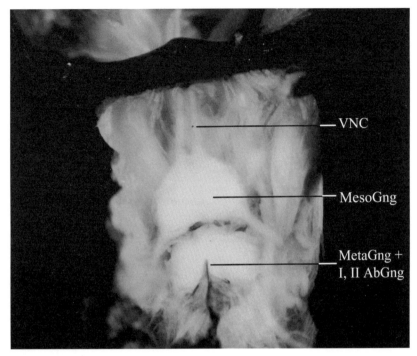

Figure 2.34. Thoracic ganglia in a major worker of *Camponotus modoc*, dorsal view. *AbGng*, abdominal ganglion; *MesoGng*, mesothoracic ganglion; *MetaGng*, metathoracic ganglion; *VNC*, ventral nerve cord.

The ovaries are composed of ovarioles or egg tubes, where the eggs develop. The number of ovarioles per ovary in *C. modoc* queens varies from 46 to 52, with an average of 48 (Table 2.3). The ovariole number in workers varies from 1 to 5, with higher numbers found in majors (Fig. 2.38). The average range in number of ovarioles in queens of other species of *Camponotus* is 13–44 (Table 2.3). Ovaries are well developed in inseminated queens, but smaller and less developed in unfertilized queens.

EXOCRINE GLANDS

The typical ant worker has been described as a walking battery of exocrine glands (Hölldobler and Wilson 1990). In *Camponotus*, the Dufour's gland

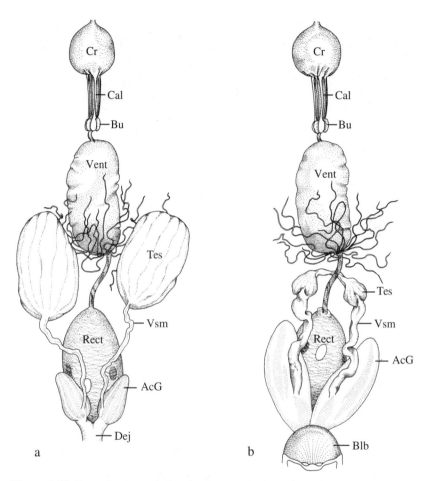

Figure 2.35. Reproductive and digestive systems in the male (a) 1 day and (b) 1 week following eclosion. *AcG*, accessory gland; *Blb*, penis bulb; *Bu*, bulb of proventriculus; *Cal*, calyx; *Cr*, crop; *Dej*, ejaculatory duct; *Rect*, rectum; *Tes*, testis; *Vent*, ventriculus; *Vsm*, seminal vesicle.

and the free filaments of the venom glands are the two main glands that control behavior (Fig. 2.26) (Ayre and Blum 1971). The Dufour's gland is proportionately larger and more developed in workers than in queens (Hansen and Akre 1985) (Fig. 2.26), and is larger in inseminated than in uninseminated queens. It is bilobed, lies ventral to the poison gland, and opens near the egress of the poison gland. Its function has not been deter-

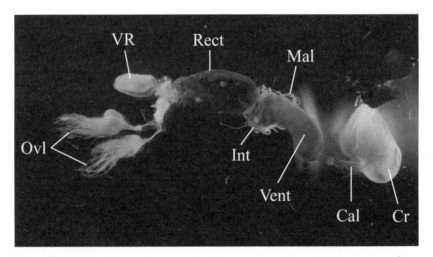

Figure 2.36. Digestive system, reproductive system, and associated structures from the gaster of an inseminated queen of *Camponotus modoc*. *Cal*, calyx; *Cr*, crop; *Int*, intestine; *Mal*, Malpighian tubules; *Ovl*, ovarioles; *Rect*, rectum; *Vent*, ventriculus; *VR*, venom reservoir.

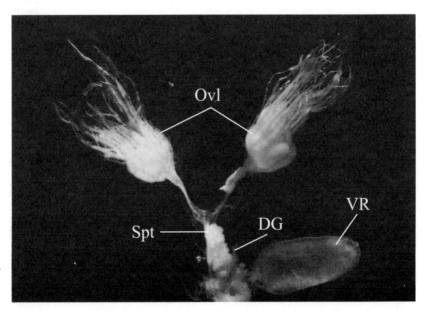

Figure 2.37. Reproductive system of an inseminated queen of *Camponotus modoc*. *DG*, Dufour's gland; *Ovl*, ovarioles; *Spt*, spermatheca; *VR*, venom reservoir.

TABLE 2.3

Ovariole number in winged females and workers

| Species of *Camponotus* | No. Dissected | Ovariole/ovary | |
		Range	Average
Queens			
C. essigi	4	12–16	13
C. semitestaceus	1	22	22
C. vicinus	2	20–22	20.5
C. pennsylvanicus	4	30–38	34
C. noveboracensis	1	44	44
C. herculeanus	2	43–45	44
C. modoc	14	46–52	48.3
Workers			
C. modoc major	5	3–5	3.83
C. modoc media	6	1–3	1.8
C. modoc minor	3	1	1

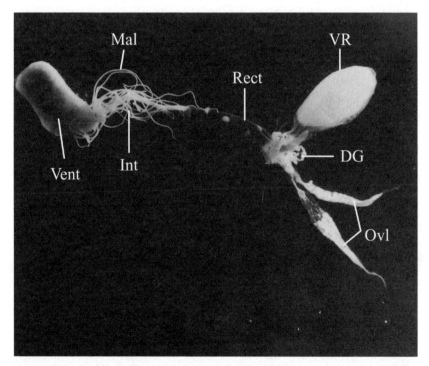

Figure 2.38. Ovaries, poison reservoir, and Dufour's gland in a major worker of *Camponotus modoc*. *DG*, Dufour's gland; *Int*, intestine; *Mal*, Malpighian tubules; *Ovl*, ovarioles; *Rect*, rectum; *Vent*, ventriculus; *VR*, venom reservoir.

Figure 2.39. Mandibular gland and reservoir of a major worker of *Camponotus modoc*. *MdG*, mandibular gland; *MdGR*, mandibular gland reservoir.

mined, but it is thought to be important in alarm, recruitment, and sexual attraction (Hölldobler and Wilson 1990).

The venom apparatus consists of two short, slender filaments that unite at the base of the venom reservoir (Robertson 1968, Hermann et al. 1975). The common gland filament passes into an expanded cushion, or pulvinus, located between the outer and inner layers of the reservoir, and forms a densely packed convoluted duct, which ultimately empties into the reservoir (Robertson 1968). The reservoir has a cuticular lining that insulates it from the toxic effects of the stored formic acid (Hefetz and Blum 1978a, 1978b). Surrounding the reservoir are muscles that expel the venom (Hermann and Blum 1968) as a spray through the nozzle-like acidopore (Fig. 2.26).

The mandibular gland and reservoir are located just above the base of each mandible on the mesal side (Figs. 2.24, 2.25, 2.39). Their morphology is relatively uniform in the Formicidae, although they are generally large in the Formicinae (Hölldobler and Wilson 1990). A variety of compounds that play a critical role in mating behavior of *Camponotus* spp. originate from this gland.

REFERENCES CITED

Ayre, G. L. 1963. Feeding behaviour and digestion in *Camponotus herculeanus* (L.) (Hymenoptera, Formicidae). Entomol. Exp. Appl. 6: 165–170.

Ayre, G. L., and M. S. Blum. 1971. Attraction and alarm of ants (*Camponotus* spp.—Hymenoptera: Formicidae) by pheromones. Physiol. Zool. 44: 77–83.

Bay, D. E., and R. J. Elzinga. 1980. An index to the figure abbreviations appearing in Principles of insect morphology by R. E. Snodgrass. Entomol. Soc. Am. Bull. 26: 335–355.

Eisner, T. 1957. A comparative morphological study of the proventriculus of ants (Hymenoptera: Formicidae). Bull. Mus. Comp. Zool. 16(8): 439–490.

Eisner, T., and G. M. Happ. 1962. The infrabuccal pocket of a formicine ant: a social filtration device. Psyche 69: 107–116.

Eisner, T., and E. O. Wilson. 1952. The morphology of the proventriculus of a formicine ant. Psyche 59: 47–60.

Forbes, J. 1938. Anatomy and histology of the worker of *Camponotus herculeanus pennsylvanicus* DeGeer (Formicidae, Hymenoptera). Ann. Entomol. Soc. Am. 31: 181–195.

Forbes, J. 1952. The genitalia and terminal segments of the male carpenter ant, *Camponotus pennsylvanicus* DeGeer (Formicidae, Hymenoptera). J. N.Y. Entomol. Soc. 60: 157–171.

Forbes, J. 1954. The anatomy and histology of the male reproductive system of *Camponotus pennsylvanicus* DeGeer (Formicidae, Hymenoptera). J. Morphol. 95: 523–555.

Forbes, J. 1956. Observations on the gastral digestive tract in the male carpenter ant, *Camponotus pennsylvanicus* DeGeer (Formicidae, Hymenoptera). Insectes Soc. 3: 505–511.

Forbes, J., and A. M. McFarlane. 1961. The comparative anatomy of digestive glands in the female castes and the male *Camponotus pennsylvanicus* DeGeer (Formicidae, Hymenoptera). J. N.Y. Entomol. Soc. 69: 92–103.

Gotwald Jr., W. H. 1969. Comparative morphological studies of the ants, with particular reference to the mouthparts (Hymenoptera: Formicidae). Memoir 408. Ithaca, N.Y.: Cornell University Agricultural Experiment Station.

Gronenberg, W. 1996. Neuroethology of ants. Naturwissenschaften 83: 15–27.

Hansen, L. D., and R. D. Akre. 1985. Biology of carpenter ants in Washington State (Hymenoptera: Formicidae: *Camponotus*). Melanderia 43: 1–62.

Hefetz, A., and M. S. Blum. 1978a. Biosynthesis and accumulation of formic acid in the poison gland of the carpenter ant *Camponotus pennsylvanicus*. Science 201: 454–455.

Hefetz, A., and M. S. Blum. 1978b. Biosynthesis of formic acid by the poison glands of formicine ants. Biochem. Biophys. Acta 543: 484–496.

Hermann, H. R., R. Baer, and M. Barlin. 1975. Histology and function of the venom gland system in formicine ants. Psyche 82: 67–73.

Hermann, H. R., and M. S. Blum. 1968. The hymenopterous poison apparatus. VI. *Camponotus pennsylvanicus* (Hymenoptera: Formicidae). Psyche 75: 216–227.

Hermann, H. R., and M. S. Blum. 1981. Defensive mechanisms in the social Hymenoptera. *In* H. R. Hermann, ed., Social insects. Vol. II, pp. 77–197. New York: Academic Press.

Hölldobler, B. 1966. Futterverteilung durch Männchen in Ameisenstaat. Z. Vergl. Physiol. 52: 430–455.

Hölldobler, B., and E. O. Wilson. 1990. The ants. Cambridge: Harvard University Press.

Jackson, D. M. 1974. External morphology of a carpenter ant, *Camponotus noveboracensis* Fitch (Hymenoptera: Formicidae). Class project for Entomology 444, Washington State University, Pullman.

Keister, M. 1963. The anatomy of the tracheal system of *Camponotus pennsylvanicus* (Hymenoptera: Formicidae). Ann. Entomol. Soc. Am. 56: 336–340.

Robertson, P. L. 1968. A morphological and functional study of the venom apparatus in representatives of some major groups of Hymenoptera. Aust. J. Zool. 16: 133–166.

Schultz, G. W. 1978. Internal morphology of an alate queen ant, *Camponotus vicinus* Mayr (Hymenoptera: Formicidae). Class project for Entomology 444, Washington State University, Pullman.

Smith, E. L. 1970. Evolutionary morphology of the external insect genitalia. 2. Hymenoptera. Ann. Entomol. Soc. Am. 63: 127.

Snodgrass, R. E. 1935. Principles of insect morphology. New York: McGraw-Hill.

Snodgrass, R. E. 1941. The male genitalia of Hymenoptera. Smithsonian Misc. Coll. 99(4): 1–86 plus 33 plates.

Snodgrass, R. E. 1956. Anatomy of the honey bee. Ithaca, N.Y.: Comstock Publishing, Cornell University Press.

Sparks, S. D. 1941. Surface anatomy of ants. Ann. Entomol. Soc. Am. 34: 572–579.

Wheeler, D. E., and P. H. Krutzsch. 1992. Internal reproductive system in adult males of the genus *Camponotus* (Hymenoptera: Formicidae: Formicinae). J. Morphol. 211: 307–317.

Witherell, J. S. 1991. Gonadal development in reproductive forms of *Camponotus modoc* (Hymenoptera: Formicidae) from fall to spring. M.S. thesis, Eastern Washington University, Cheney.

CHAPTER 3

Taxonomy and Distribution

The Formicidae is a large, cosmopolitan family consisting of 21 subfamilies (Bolton 2003), 296 genera (Bolton 1995), and more than 11,000 described species (L. R. Davis Jr., pers. comm., 2004). The actual number of species may exceed 20,000 (Hölldobler and Wilson 1990). According to Bolton (1995), *Camponotus* comprises 46 subgenera and more than 900 species. The number of valid species in *Camponotus*, however, is questionable because the taxonomy of this genus is in critical need of revision (Snelling 1968, Mackay and Vinson 1989, Hölldobler and Wilson 1990, Bolton 1995). Fortunately, some of the subgenera have been studied extensively (Snelling 1970, 1988).

The subfamily Formicinae, which includes *Camponotus*, is characterized by a one-segmented petiole in the form of a vertical scale and a circular, terminal cloacal orifice, usually with a fringe of hairs forming the acidopore (Fig. 3.1). The worker caste of *Camponotus* is characterized by an evenly convex mesosomal dorsum (Fig. 3.2), mesothoracic spiracles that are located on the sides of the thorax below the basal face of the epinotum, and antennal scapes that insert well behind the posterior edge of the clypeus (Creighton 1950). The workers are polymorphic, and the largest ones, the majors or soldiers, should be collected in order to identify species.

Species of *Camponotus* are found throughout the Western Hemisphere from southern Chile to the Arctic Circle. They have invaded most terrestrial environments, ranging from moist, tropical, and temperate forests to xeric grassland and semidesert. Of particular importance to the taxonomy and geographic distribution of *Camponotus* in the United States are the findings from several studies that have been conducted in individual states or regions (Table 3.1).

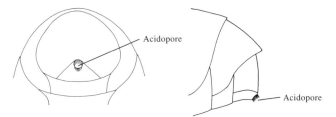

Figure 3.1. The cloacal orifice of ants showing the acidopore in the subfamily Formicinae.

Figure 3.2. The evenly convex dorsum (arrow) of the mesosoma, which is characteristic of carpenter ants.

TABLE 3.1

Ant surveys from various regions where *Camponotus* occurs

Geographical region	Citation
California—Deep Canyon	Wheeler and Wheeler 1973
Colorado	Gregg 1963
Florida	Deyrup et al. 1989, Deyrup 2003
Idaho	Yensen et al. 1977
Illinois	DuBois and LaBerge 1988
Kansas	DuBois 1994
Nevada	Wheeler and Wheeler 1986
New Mexico	Mackay and Mackay 2002
New Mexico—Los Alamos County	Mackay et al. 1988
North Dakota	Wheeler and Wheeler 1963
South Carolina	Sargent et al. 2001
Texas	O'Keefe et al. 2000
Washington	Hansen and Akre 1985

DESCRIPTIONS OF SUBGENERA AND LISTS OF SPECIES

There are seven subgenera of *Camponotus* in the United States and Canada. The following descriptions and lists of species are taken from Krombein et al. 1979 and Bolton 1995. The subgenera and species that might be structural or nuisance pests are indicated with an asterisk. The common names for the few species for which common names have been proposed are given in parentheses (Bosik 1997). Common names accepted by the Entomological Society of America are indicated by the abbreviation ESA.

SUBGENUS *CAMPONOTUS**

Distinguishing Morphological Traits. The major workers are 8 mm or more in length. The clypeus is ecarinate or slightly carinate, with an anterior border that lacks a median notch and impression behind it. The antennal scape is not flattened at the base and the clypeal fossae are well marked. The head, excluding the mandibles, is slightly wider than long.

General Habits. The majority of species in this subgenus nest in wood, hence their common name, carpenter ants. The species that cause the most damage to structures belong to this subgenus.

Species
C. *americanus* Mayr*
C. *chromaiodes* Bolton (red carpenter ant [ESA])*
C. *herculeanus* (L.)*
C. *laevigatus* (Fr. Smith)*
C. *modoc* Wheeler (western black carpenter ant)*
C. *noveboracensis* (Fitch) (New York carpenter ant)*
C. *pennsylvanicus* (DeGeer) (black carpenter ant [ESA])*
C. *quercicola* M. R. Smith
C. *schaefferi* Wheeler
C. *texanus* Wheeler

SUBGENUS *COLOBOPSIS*

Distinguishing Morphological Traits. The head of major workers is circular in cross section and abruptly truncated in front. The truncated portion

consists of the clypeus and adjacent parts of the malar areas, with the mandibles forming the ventral area. There are no media workers.

General Habits. These ants are found only in the southern United States. They are cryptic and difficult to collect. They nest in hollow twigs or galls, usually with only one entrance. The head of the major worker is shaped to block the nest entrance. Only workers that give the correct tactile signal with their antennae are allowed entry (Creighton 1950). There are no structural or nuisance pests in this subgenus.

Species
C. etiolatus Wheeler
C. hunteri Wheeler
C. impressus (Roger)
C. mississippiensis M. R. Smith
C. obliquus M. R. Smith
C. papago Creighton
C. pylartes Wheeler

SUBGENUS *MYRMAPHAENUS*

Distinguishing Morphological Traits. The front of the head on the major worker has obliquely truncated frontal lobes. The clypeus is flat and slightly higher than adjacent portions of the genae.

General Habits. There is little information on the habitats or behaviors of the species in this subgenus (Creighton 1950). It is known that *C. ulcerosus* Wheeler nests in soil under rocks, whereas most individuals of *C. yogi* Wheeler prefer buprestid tunnels in the stems of herbaceous weeds. Neither of these species are structural or nuisance pests.

Species
C. ulcerosus Wheeler
C. yogi Wheeler

SUBGENUS *MYRMENTOMA**

Distinguishing Morphological Traits. Major workers are at most 8 mm long. The anterior border of the clypeus projects slightly and is depressed in the middle, with a narrow median notch, behind which is a short

triangular impression. The revision by Snelling (1988) has provided critical taxonomic information on this subgenus, the members of which are commonly called "small carpenter ants."

General Habits. Most species of *Myrmentoma* nest in preformed cavities in woody tissues of trees and shrubs, or in pithy stalks. However, *C. essigi* and *C. nearcticus* will excavate sound wood. Some species build nests in cynipid galls on oaks and then move into adjacent dead branches. Both *C. anthrax* Wheeler and *C. bakeri* Wheeler nest in soil (Snelling 1988). Workers are small and not easily recognized as *Camponotus* (Hansen 1995). More than half the species are either structural or nuisance pests.

Species
C. anthrax Wheeler
C. bakeri Wheeler
C. caryae (Fitch)*
C. clarithorax Emery*
C. cuauhtemoc Snelling
C. decipiens Emery*
C. discolor (Buckley)*
C. essigi M. R. Smith*
C. hyatti Emery*
C. nearcticus Emery*
C. sayi Emery*
C. snellingi Bolton
C. subbarbatus Emery*

SUBGENUS *MYRMOBRACHYS**

Distinguishing Morphological Traits. These ants have a short mesosoma, which in the major workers is not longer than the head (mandibles excluded). The humeral angles of the pronotum are well marked. When present, the erect hairs on the antennal scapes and legs are fine, short, and usually whitish. On the legs, hair is often confined to a row of bristles on the flexor surface (Creighton 1950).

General Habits. These ants nest under bark, in the hollow branches of trees and shrubs, and in logs and stumps. Colonies are small and difficult to find. The only nuisance pest in this group is *C. planatus*.

Species
C. *mina* Forel
C. *planatus* Roger*
C. *trepidulus* Creighton

SUBGENUS *MYRMOTHRIX**

Distinguishing Morphological Traits. The front of the head of a major worker is not obliquely truncate, but more or less convex. The clypeus is convex or angular and distinctly higher than the adjacent portions of the cheek or malar areas. The antennal scape and legs have numerous, long, coarse, brownish or golden erect hairs.

General Habits. These ants nest in wood and soil and have moderate-sized colonies. Only C. *floridanus* is a pest.

Species
C. *atriceps* (Fr. Smith)
C. *floridanus* (Buckley) (Florida carpenter ant [ESA])*

SUBGENUS *TANAEMYRMEX**

Distinguishing Morphological Traits. The major workers are 8 mm or more in length with either a distinctly carinate clypeus or only a slightly carinate clypeus with the antennal scape flattened at the base. The anterior border of the clypeus lacks a median notch and impression behind it. The antennal fossae are shallow over most of their length, and the head, excluding the mandibles, is at least as long as it is wide, or distinctly longer (Snelling 1970).

General Habits. In this large subgenus six species are structural or nuisance pests. Their nests are located in decayed wood or insulation but may expand into adjacent sound wood. Many species of *Tanaemyrmex* nest in dry, gravelly soil under rocks, or in buried wood.

Species
C. *acutirostris* Wheeler*
C. *castaneus* (Latreille)*
C. *dumetorum* Wheeler
C. *festinatus* (Buckley)

C. incensus Wheeler
C. ocreatus Emery
C. sansabeanus (Buckley)
C. semitestaceus Snelling*
C. socius Roger
C. tortuganus Emery*
C. vafer Wheeler
C. variegatus (Fr. Smith) (Hawaiian carpenter ant)*
C. vicinus Mayr*

Species in and around Structures

Ants belonging to the subgenera *Camponotus*, *Myrmentoma*, *Myrmobrachys*, *Myrmothrix*, and *Tanaemyrmex* that cause structural damage or are nuisance pests are described in this section. Their geographic distribution in the United States and Canada can be divided into eastern and western species. There is some overlap, however, as several species occur in both regions. The following key emphasizes the species that are found in and around structures. This key has been modified from Creighton 1950 and Snelling 1968, 1970, 1988. Anatomical features used in the key are shown in Fig. 3.3. Use of the term gaster refers to abdominal segments after the pedicel. The illustrations include information that is pertinent to a specific couplet, often omitting hairs or other characters. Following the key are descriptions and characteristics of each species as well as their geographic distribution.

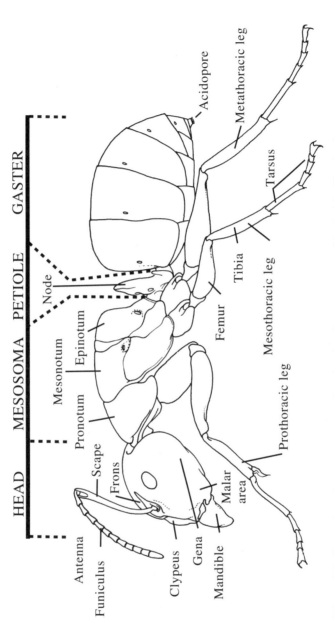

Figure 3.3. Illustration of a carpenter ant major, showing the structures used in the identification key.

ILLUSTRATED KEY TO STRUCTURAL OR NUISANCE PESTS

This key to *Camponotus* is for identifying major workers only.

1. Mesosoma short, that of the major worker no longer than the head (mandibles excluded) (Fig. 3.4a); pronotum angular, with margin edged by a flat border; southern Florida, southern Texas, and Mexico SUBGENUS *MYRMOBRACHYS—C. planatus*

 Mesosoma longer, that of the major worker longer than the head (mandibles excluded) (Fig. 3.4b); pronotum with margin rounded ... 2

Figure 3.4. Profile of head and mesosoma. (a) *C. planatus* (arrow: angular pronotum). (b) *C. decipiens* (arrow: rounded pronotum).

2(1). Scapes and legs with numerous long, coarse, brownish or golden erect hairs on all surfaces (Fig. 3.5a). . . . SUBGENUS *MYRMOTHRIX—* ..*C. floridanus*

 Scapes and legs with fine, short, and usually whitish erect hairs; often confined to a row of bristles on the flexor surface of the legs (Fig. 3.5b, c) ... 3

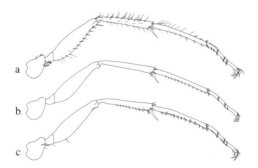

Figure 3.5. Mesothoracic legs. (a) *C. floridanus.* (b) *C. variegatus.* (c) *C. vicinus.*

3(2). Anterior border of the clypeus feebly projecting, depressed in the middle and with a narrow median notch, behind which is a short triangular impression (Fig. 3.6a); length of the major worker less than 8 mm .. SUBGENUS *MYRMENTOMA*—16

Anterior border of the clypeus not feebly projecting and without a median notch (Fig. 3.6b, c); length of the major worker more than 8 mm .. 4

Figure 3.6. Clypeus. (a) Subgenus *Myrmentoma* (arrow: median notch in clypeus). (b) Subgenus *Camponotus*. (c) Subgenus *Tanaemyrmex* (arrow: carinate clypeus).

4(3). Clypeus distinctly carinate (medial ridge) (Fig. 3.6c) or feebly carinate; in the latter case, the antennal scape is flattened at the base; antennal fossae (grooves) shallow over most of their length
.. SUBGENUS *TANAEMYRMEX*—11

Clypeus ecarinate (without a medial ridge) or scarcely carinate (Fig. 3.6b); antennal scapes never flattened at the base; clypeal fossae (pits) well marked SUBGENUS *CAMPONOTUS*—5

5(4). Antennal scapes with numerous short, scattered erect hairs (Fig. 3.7a); entire body jet black and shining *C. laevigatus*

Antennal scapes without erect hairs except for a small cluster at the extreme tip (Fig. 3.7b, c); color variable; if black, the surface is not strongly shining ... 6

Figure 3.7. Anterior view of head with antennae. (a) *C. laevigatus* (arrow: numerous hairs). (b) *C. herculeanus* (arrow: hairs at tip only). (c) *C. modoc* (arrow: scape length surpasses posterior corner by more than diameter of scape).

6(5). Antennal scapes of the major worker reaching or barely surpassing the posterior corners of the head in face view (Fig. 3.7b); propodeum dark red; rest of ant dull black *C. herculeanus*

Antennal scapes of the major worker surpassing posterior corners of the head in face view by an amount greater than their maximum diameter (Fig. 3.7c); color not as above 7

7(6). Pubescence on the gaster absent or very fine and sparse (Fig. 3.8a), the entire surface of the gaster distinctly shining 8

Pubescence on the gaster coarse and dense (Fig. 3.8b, c), surface of the gaster dull except for a narrow band at the posterior edge of each segment ... 9

Figure 3.8. Gasters. (a) *C. noveboracensis*. (b) *C. modoc*. (c) *C. pennsylvanicus*.

8(7). Punctures on the head coarse and conspicuous; mesosoma red; head and gaster brownish black *C. noveboracensis*

Punctures on the head fine and inconspicuous; color variable but the mesosoma never red .. *C. americanus*

9(7). Pubescence on the gaster less than half as long as the erect hairs (Fig. 3.8b); western species .. *C. modoc*

Pubescence on the gaster about as long dorsally as the erect hairs (Fig. 3.8c); eastern species ... 10

10(9). Head, mesosoma, petiole, and gaster dull black; pubescence pale yellow or white ... *C. pennsylvanicus*

Posterior portion of the mesosoma, petiole, and base of first gastral segment bright, reddish brown in color; pubescence golden yellow .. *C. chromaiodes*

11(4). Middle and hind tibiae without a row of graduated erect bristles on their flexor surfaces (Fig. 3.5b) .. 12

Middle and hind tibiae with a row of graduated erect bristles on their flexor surfaces (Fig. 3.5c) .. 13

12(11). Entire body yellow; blackish bands on gastral segments (Fig. 3.9); Hawaii or isolated areas on West Coast *C. variegatus*

Body color rusty red-brown; head darker than the mesosoma; gaster dark brown or black; southern Florida...................... *C. tortuganus*

Figure 3.9. Gaster of *C. variegatus*.

13(11). Scape of the major worker distinctly flattened at the base and with the flattened portion forming a small lateral lobule (small lobe) (Fig. 3.10a)... *C. semitestaceus*

Scape of the major worker either not flattened at the base or flattened but with no lateral lobule (Fig. 3.10b) 14

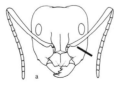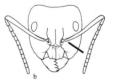

Figure 3.10. Anterior view of the head with antennae. (a) *C. semitestaceus* (arrow: lateral lobule). (b) *C. vicinus* (arrow: no lateral lobule).

14(13). Genae strongly shining with very small, inconspicuous punctures; color uniform chestnut brown...................................... *C. castaneus*

Genae feebly shining or dull, with coarser and conspicuous punctures; color not uniformly brown ... 15

15(14). Scape of the major worker flattened at the base; genae without erect hairs... *C. vicinus*

Scape of the major worker not flattened at the base; genae with erect hairs... *C. acutirostris*

16(3). Mesosomal profile distinctly depressed at metanotal suture (Fig. 3.11a)... *C. hyatti*

Metanotal suture not depressed (Fig. 3.11b, c)........................... 17

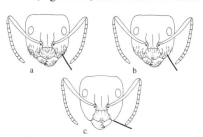

Figure 3.11. Mesosomal profiles. (a) *C. hyatti.* (b) *C. clarithorax.* (c) *C. discolor.*

17(16). Malar area with conspicuous suberect to erect short hairs arising from coarse, elongate foveae (depressions or pits) (Fig. 3.12a, b) ... 18

Malar area without suberect or erect hairs, except sometimes near base of mandible (Fig. 3.12c).. 21

Figure 3.12. Anterior view of the head. (a) *C. caryae* (arrow: with erect hairs). (b) *C. subbarbatus* (arrow: with erect hairs). (c) *C. essigi* (arrow: without erect hairs).

18(17). Clypeus with long erect hairs along margins and numerous shorter hairs across disc (Fig. 3.12a).. 19

Clypeus with long erect hairs along margins and adjacent to the clypeus and less than three hairs across disc (Fig. 3.12b)........... *C. subbarbatus*

19(18). Propodeal (epinotal) profile rounded (Fig. 3.11c)....................... 20

Propodeal profile angular (Fig. 3.11b) *C. clarithorax*

20(19). Erect hairs of clypeus of varying lengths, with shortest about as long as those of the malar area; more erect hairs on malar area (Fig. 3.13a).. *C. caryae*

Erect hairs of clypeus distinctly long and short, with short hairs shorter than those of the malar area; fewer erect hairs on malar area (Fig. 3.13b) .. *C. discolor*

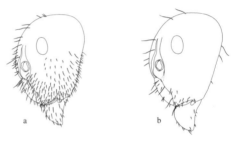

Figure 3.13. Profile of the head. (a) *C. caryae.* (b) *C. discolor.*

21(17). Propodeum (epinotum), in profile, with basal face flat, or nearly so, almost entirely on the same plane as the mesonotum; propodeum abruptly rounded or subangulate at juncture with posterior slope (Fig. 3.14a).. 22

Propodeum, in profile, curved or straight, but sloping toward broadly rounded juncture with posterior slope (Fig. 3.14b)........ 23

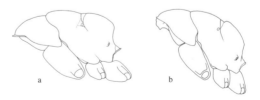

Figure 3.14. Profile of mesosoma. (a) *C. essigi.* (b) *C. decipiens.*

22(21). Head, mesosoma, and appendages rusty red-brown; gaster black; lower malar area and frontal lobes dull, densely tessellated (checkered)... *C. sayi*

Color variable, but often wholly blackish; lower malar area and frontal lobes subpolished to shiny..................................... *C. essigi*

23(21). Head and mesosoma dark red to black; gaster entirely black
... *C. nearcticus*

Head, mesosoma, and appendages red to yellowish red; gaster brown .. *C. decipiens*

Descriptions and Distributions of Structural or Nuisance Pests

Subgenus *Camponotus*

Camponotus americanus Mayr (Plate 1a). The workers are 7 to 10 mm in length and variable in color, but the mesosoma is never red. The ants may be uniformly brown. Punctures on the head are fine and inconspicuous, and pubescence on the gaster is very fine and sparse or absent. The antennal scape of majors surpasses the occipital corner by a length greater than its maximum diameter.

These ants are found over much of the eastern United States and southeastern Canada extending west into the Central States (Map 3.1). Although

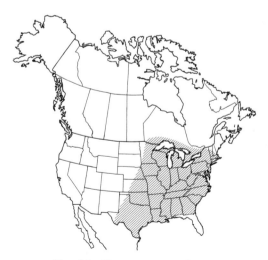

Map 3.1. *Camponotus americanus*

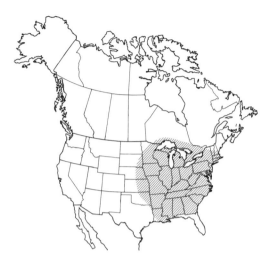

Map 3.2. *Camponotus chromaiodes*

they usually nest in the ground, they are also found under stones or in rotten logs and have been collected in structures by pest management professionals in Tennessee and Louisiana.

Camponotus chromaiodes Bolton (= *C. ferrugineus* Emery) (Plate 1b). Workers range in length from 6 to 13 mm. The propodeum, petiole, and base of the first segment of the gaster are a bright ferrugineous red. Pubescence on the gaster is coarse, dense, golden yellow and as long as the erect hairs. The antennal scape of majors surpasses the occipital corner by more than its maximum diameter.

The common name is red carpenter ant, and the ants are found in the eastern United States extending west into eastern parts of the Central States (Map 3.2). They nest in rotten wood and excavate galleries that may extend into the soil. Although nests have been found in dead standing trees and faulty structural timbers, this species is not a major pest.

Camponotus herculeanus (L.) (Plate 1c). The workers are 6 to 13 mm in length. The head, anterior part of the mesosoma, and gaster are black, while the propodeum and legs are dark red. The head and gaster are moderately shiny. The antennal scape lacks erect hairs except for a small cluster at the tip.

This species is found in both the northeastern and western United States, as well as in Canada and into Alaska (Map 3.3); however, it is rare in North

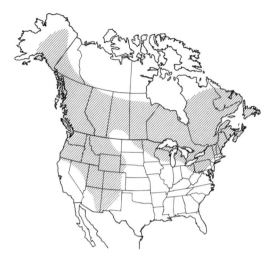

Map 3.3. *Camponotus herculeanus*

Dakota and nonforested regions (Wheeler and Wheeler 1963). It is second only to *C. pennsylvanicus* as a structural pest in Minnesota. The colonies range in size from 3000 to more than 12,000 workers. These ants nest almost exclusively in wood such as standing trees or stumps, and are found in the same habitats as *C. modoc* and *C. pennsylvanicus*. They are structural pests in the eastern United States, across the southern provinces of Canada, and into Alaska, and damage from satellite colonies can be extensive. Although large colonies of this species occur in the Pacific Northwest, they are not commonly reported as infesting structures, but this may be due to misidentification. They are primarily nocturnal and not often seen during the day.

Camponotus laevigatus (Fr. Smith) (Plate 1d). The workers are 7 to 13 mm in length and easy to identify because of their shiny, jet-black appearance, often with a bluish reflection. They are covered with light-colored or white hairs. The antennal scape has a number of short, scattered erect hairs.

The foraging activity of this species is primarily diurnal. They commonly nest outside in railroad ties or decorative driftwood. Although considered by some to be common household pests in the Pacific Northwest (Furniss and Carolin 1977), they are rarely found in houses. Cook (1953) found them tunneling in moist, rotting timbers. This species is found throughout western North America (Map 3.4).

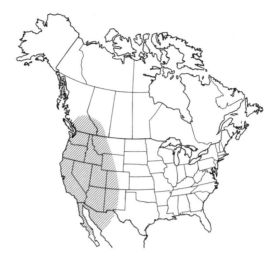

Map 3.4. *Camponotus laevigatus*

Camponotus modoc Wheeler (Plate 1e). The workers are 6 to 13 mm long and characterized by short pubescence that is half the length of erect hairs. Referred to as the western black carpenter ant, they are often confused with the black carpenter ant, but can be distinguished from *C. pennsylvanicus* by its pubescence, which is as long as the erect hairs (Creighton 1950). Colonies may be large, with up to 50,000 individuals in the main and satellite nests.

These ants are the principal structural pests in the western United States and southwestern Canada (Map 3.5). The main or parent nest of *C. modoc* is commonly found outside structures in moist wood such as the heartwood of living trees, old stumps, or landscaping timbers. Within structures, nests are usually satellites and may be found in structural timbers, under insulation, or in voids. They also excavate nests in fiberglass or foam core insulation, and are frequently a nuisance due to the noise they make when they excavate wood or other materials. Although foragers can be seen during daytime, they are primarily nocturnal.

Camponotus noveboracensis (Fitch) (Plate 1f). The workers are 6 to 13 mm long with a moderately shiny, brownish black head and gaster and a dull yellowish red or red mesosoma. If present, pubescence on the gaster is sparse and fine. The antennal scape surpasses in length the occipital lobe by about three times its maximum diameter.

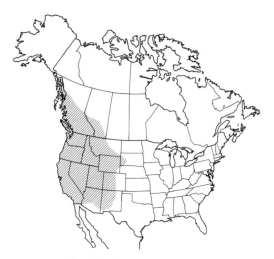

Map 3.5. *Camponotus modoc*

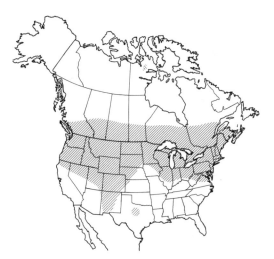

Map 3.6. *Camponotus noveboracensis*

The New York carpenter ant is found throughout the northern United States and southern Canada (Map 3.6), but is most common east of the Dakotas. The distribution extends south into New Mexico, and the species has been recorded in central Texas. This species is the most common car-

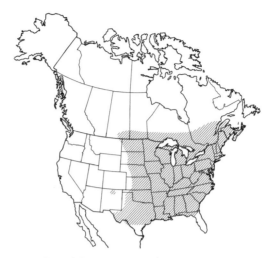

Map 3.7. *Camponotus pennsylvanicus*

penter ant in Minnesota and North Dakota (Wheeler and Wheeler 1963). Colonies nest in standing or fallen trees, but they are also found under rocks and in cow dung (Wheeler and Wheeler 1963). In northern Minnesota they nest in stumps in nearly all logged areas, and in standing dead or fallen trembling aspen and other species of *Populus*. In the eastern United States, they are both a nuisance and a minor structural pest in houses, but their colonies are usually small (about 3000 workers). In the Pacific Northwest, they are not a common household pest, but are found occasionally in the western parts of Washington and Oregon. They are primarily nocturnal.

Camponotus pennsylvanicus (DeGeer) (Plate 2a). The workers are 6 to 13 mm long and similar in size and color to *C. modoc*. The head, mesosoma, petiole, and gaster are dull black with pale yellow or light pubescence. The pubescence on the gaster is coarse, dense, and as long as the erect hairs.

The black carpenter ant nests exclusively in wood (Drooz 1985) and is the principal structural pest of the eastern and central United States and southeastern and south central Canada (Map 3.7). It is the most abundant *Camponotus* sp. in the North Atlantic states and the Midwest (Wheeler 1910). The biology and economic importance of this species parallel those of *C. modoc*, which is found in western North America. The main nests

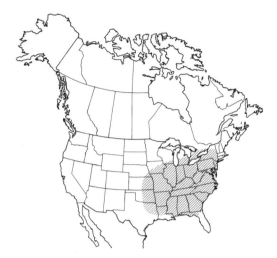

Map 3.8. *Camponotus caryae*

for both species are usually found outside, with satellites inside, such as within voids, under insulation, and in structural timbers. Colonies are smaller than those of *C. modoc* but may reach 10,000 to 15,000 individuals, a figure much larger than previous estimates (Akre et al. 1994). Their foraging behavior is similar to that of *C. modoc*, and they are primarily nocturnal.

SUBGENUS *MYRMENTOMA*

Camponotus caryae (Fitch) (Plate 2b). The workers are 3.5 to 7.7 mm long and are uniformly dark brown to blackish. The clypeus is dull and densely tessellate, and its basal margin has a pair of long setae that arise from large foveae just below the lower end of the frontal carinae. The setae of the clypeal disc are variable in length, and some are nearly as long as the basal pair. The head, in frontal view, has 25 or more hairs that extend beyond its margins.

This species ranges from New York west to Iowa and Kansas and south to Florida (Map 3.8). Creighton (1950) considered *C. caryae* a polytypic species, with *C. discolor* and *C. clarithorax* as subspecies, but Snelling (1988) regards them as separate species. Although *C. caryae* nests within structures, it is found only in hollow areas such as voids. Colonies consist of a few hundred workers.

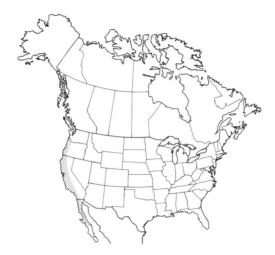

Map 3.9. *Camponotus clarithorax*

Camponotus clarithorax Emery (Plate 2c). The workers are 3.5 to 7.7 mm long, with a yellow head and petiole and a black gaster. The color of the mesosoma may vary, so it is not a reliable character to use to distinguish this species from *C. discolor*. The head, in frontal view, has 8 to 15 hairs that extend beyond its margins. The clypeus is dull and densely tessellate with coarse, shallow punctures that are variably spaced. The propodeal profile is abruptly rounded between the nearly horizontal basal face and the nearly vertical posterior face.

This species occurs only in California, Oregon, and the northern part of Baja, Mexico (Map 3.9), where it may be found in structures, nesting in voids.

Camponotus decipiens Emery (= *C. rasilis* W. M. Wheeler, senior synonym) (Plate 2d). The workers are 4 to 8 mm long and have a yellowish red or red head, mesosoma, and petiole with a black gaster. The base of the first gastral segment is sometimes lighter than the rest of the gaster, and the femora and tibiae have few or no erect hairs. The mesonotal profile is either flat or slightly convex. The dorsal part of the propodeum curves distinctly downward from the metanotal suture to the posterior surface of the propodeum.

This species ranges from Georgia and Florida west to Texas and eastern Mexico and north to North Dakota (Map 3.10). Smith (1965) used the

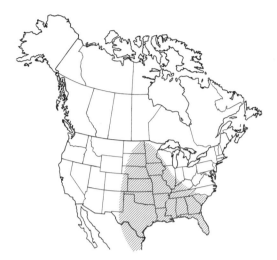

Map 3.10. *Camponotus decipiens*

synonym *C. rasilis* in describing this species as a nuisance pest in structures, where it nests in voids. Colonies consist of a few hundred workers.

Camponotus discolor (Buckley) (Plate 2e). Workers are 3.5 to 7.5 mm long and are red and black, with a dusky red to dark red head, yellowish red mesosoma, red appendages, and black gaster. The head and gaster are shiny, and the mesosoma is dull (Wheeler and Wheeler 1963). The basal margin of the clypeus has a pair of long setae that arise from large foveae at the clypeal margin below the lower end of the frontal carinae. These setae are longer than the others on the clypeal disc.

This species is found farther west than *C. caryae*, from Texas through the southeastern states and north to North Dakota (Map 3.11). It nests in dead or living trees.

Camponotus essigi M. R. Smith (Plate 2f). The workers are 3.5 to 7.7 mm long with variable color. The head and gaster are commonly dark and the mesosoma red or entirely black. In southern California many specimens are mostly yellowish red, with only two or three apical gastral segments being brown or black. The basal face of the propodeum is flat. The mandibles are sparsely punctate, and the entire frontal and malar areas are smooth and shiny.

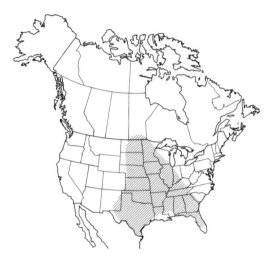

Map 3.11. *Camponotus discolor*

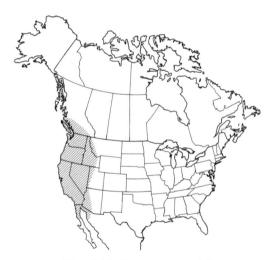

Map 3.12. *Camponotus essigi*

This western species ranges from Mexico to southern Canada (Map 3.12) and is commonly found nesting in structural voids, but causes only minor damage. It is usually seen in structures in the early spring. Colonies may have several hundred workers.

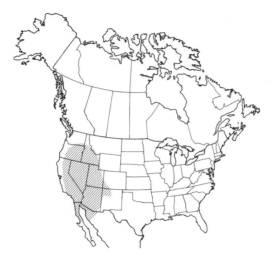

Map 3.13. *Camponotus hyatti*

Camponotus hyatti Emery (Plate 3a). The workers are 3.5 to 7.7 mm long and similar in color to *C. essigi*. They are characterized by a distinct metanotal groove or suture. The clypeus is flattened, shiny, and sparsely punctate, and the entire frontal and malar areas are smooth and shiny. The basal face of the propodeum is convex in profile.

This species ranges from southern California through Oregon, east to the Rocky Mountain states, and into northwestern Mexico (Map 3.13). In their natural habitat these ants nest in wood; in structures they are mainly nuisance pests (Ebeling 1975).

Camponotus nearcticus Emery (Plate 3b). The workers are 4.5 to 7.5 mm long with variable color, some being dark brown or blackish. The head and mesosoma may be partly reddish brown, or the head, mesosoma, and appendages may be bright red (Wheeler and Wheeler 1963). They are distinguished by the roughened surface on the broad clypeus, with numerous erect hairs and a straight occipital margin.

This species has the widest range of all the *Myrmentoma* spp. and is found throughout southern Canada and the eastern and northern parts of the United States, extending south through the Central States (Map 3.14). Colonies nest in dead twigs and branches, under the bark of dead or living trees, in hollow stems of plants, inside insect galls, and in wood structures, especially roofing (Drooz 1985). They have also been reported as nuisance pests in attics, where they nest in voids. Colonies are small, with about 300 workers.

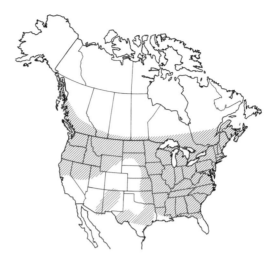

Map 3.14. *Camponotus nearcticus*

Camponotus sayi Emery (Plate 3c). The workers are 4 to 7 mm long with a reddish brown head, mesosoma, and appendages and a blackish gaster. The lower malar area and frontal lobes are dull and densely tessellate, and the clypeus is distinctly arched. The malar area is distinctly sculptured between scattered punctures, in contrast to the polished upper genal area.

This species is found in the southwestern United States and Mexico, extending from southern California north to Nevada and Utah and east to Kansas, Nebraska, and Texas (Map 3.15). It is chiefly a nuisance pest.

Camponotus subbarbatus Emery (Plate 3d). The workers are small and brown to black. They can be distinguished from *C. caryae* and *C. discolor* by the lack of hairs on the clypeal disc.

This species is found along the Atlantic coast from New England to South Carolina, in the southeastern states of Georgia and Mississippi, and westward into Ohio, Kentucky, and Tennessee (Snelling 1988) (Map 3.16). It has been found in structures in Ohio (G. Wegner, pers. comm., 2000).

SUBGENUS *MYRMOBRACHYS*

Camponotus planatus Roger (Plate 3e). The workers are 5 to 6 mm long. The head and mesosoma are dark reddish brown. They are distinguished

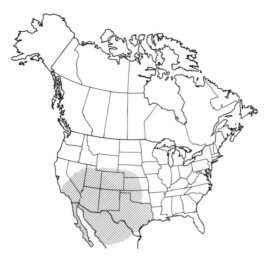

Map 3.15. *Camponotus sayi*

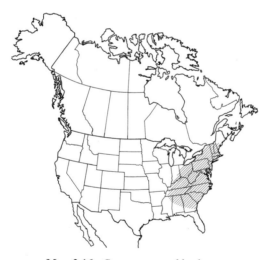

Map 3.16. *Camponotus subbarbatus*

by having a mesosoma that is shorter than the head. The antennal scape of major workers slightly surpasses the occipital corner of the head.

This tropical species is found in southern Florida, southern Texas, and northeastern Mexico (Map 3.17). It is a nuisance pest in south Florida (L.

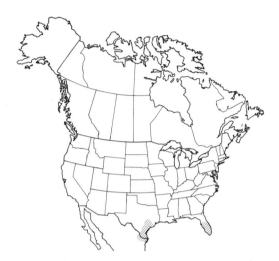

Map 3.17. *Camponotus planatus*

R. Davis Jr., pers. comm., 1999). The colonies are polygynous. The ants are arboreal; they construct nests in decayed branches, hollow twigs, under bark, and in the bases of bromeliads (Creighton 1950). The colonies are small, and foraging is diurnal.

Subgenus *Myrmothrix*

Camponotus floridanus (Buckley) (Plate 3f). The workers are 5.5 to 10 mm long with a red head; yellow or yellowish red mesosoma and petiole, and oftentimes the sternum of the first gastral segment; and a black gaster. The body is covered with long yellow hairs.

 Florida carpenter ants range from Florida north to North Carolina and west to Mississippi and Louisiana (Map 3.18). They are pugnacious and are sometimes called bull ants or bulldog ants (Smith 1965, Vail et al. 1994). They have moderate-size to large colonies and are opportunistic in their nesting sites. Colonies are found in soil beneath objects, in dead branches of trees, in rotting logs and stumps, and in the woodwork of porches, roofs, and paneling and around kitchen sinks. Workers are active day and night. They are serious house-infesting ants in Florida and other parts of the Southeast. They are also pests of beehives, which they raid for food and sometimes usurp for their nest. They are active year-round.

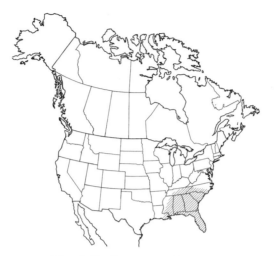

Map 3.18. *Camponotus floridanus*

SUBGENUS *TANAEMYRMEX*

Camponotus acutirostris Wheeler (Plate 4a). The workers are 7 to 10mm long, and although their color is variable, they typically have a reddish brown mesosoma, brown abdomen, and black head. The middle and hind tibiae possess a row of graduated erect bristles on their flexor surfaces. The antennal scape is not flattened at the base, and the malar areas are slightly shiny or dull, with coarse, conspicuous punctures and erect hairs.

The geographic range is limited to the mountain canyons of Arizona, New Mexico, and Texas (Krombein et al. 1979) (Map 3.19). Large colonies have been found in structures in Arizona. In new structures, infestations are associated with buried wood. In older buildings, infestations are found in foam insulation and timbers.

Camponotus castaneus (Latreille) (Plate 4b). The workers are 7 to 10mm long and yellowish to yellowish red, with the head and gaster typically darker than the mesosoma. The clypeus is distinctly but not strongly carinate. The middle of the anterior border of the clypeus extends forward and is scalloped. The antennal scape surpasses the posterior border of the head, and the flagellum is unusually slender. Pubescence on the gaster is sparse, and the middle and hind tibiae have a row of graduated bristles.

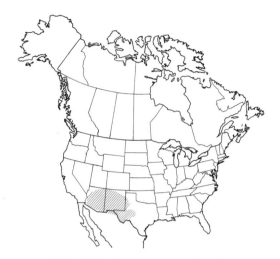

Map 3.19. *Camponotus acutirostris*

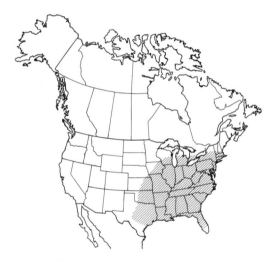

Map 3.20. *Camponotus castaneus*

This species ranges from Kansas and Iowa east to New York and south-ern New England and south to Texas and Florida (Smith 1965) (Map 3.20). It usually nests outside and enters structures at night in search of food. Nests are found in rotten stumps or logs in the soil (Drooz 1985).

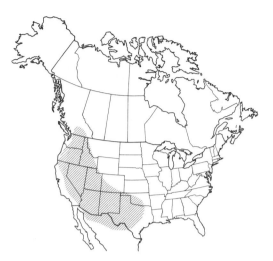

Map 3.21. *Camponotus semitestaceus*

Camponotus semitestaceus Snelling (Plate 4c). The workers are large, 7 to 13 mm long, and variable in color. In some, the top of the head, mandibles, and antennal scapes are blackish brown, and the mesosoma and gaster light brown. Other specimens are almost entirely clay yellow with a pale, dirty brown head. This ant is distinguished by its distinctly carinate clypeus. The antennal scape of major workers is also distinctly flattened at the base, forming a small lateral lobule, and the middle and hind tibiae have a row of graduated erect bristles on their flexor surfaces.

This species is found in the arid regions of the western and southwestern states (Map 3.21), but rarely in structures. The ants are seldom seen due to their nocturnal habits. Nests are usually found under rocks in semi-desert habitats. The nest entrances are cryptic, and the colonies are small. A study in the Columbia Basin of Washington found that 75% of nest entrances were associated with the stems of sagebrush, and only 20% had low-profile crater-shaped mounds (Gano and Rogers 1983).

Camponotus tortuganus Emery (Plate 4d). The workers are 6 to 11 mm long and of variable color, but usually reddish brown with the head darker than the mesosoma, and the gaster dark brown or black. A distinctly carinate clypeus, subopaque head and mesosoma, and middle and hind tibiae without a row of bristles characterize these ants. The anterior margin of the clypeus extends forward as a prominent lobe, and the frontal carinae

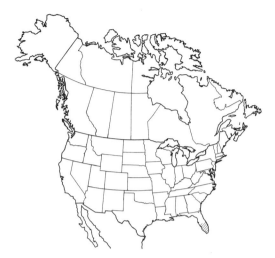

Map 3.22. *Camponotus tortuganus*

are close together, elongate, and lyrate. Their compound eyes are prominent and strongly convex.

This species occurs in southern Florida (Map 3.22), and Smith (1965), Drooz (1985), and Vail et al. (1994) cite it as a common household pest. Small colonies nest in rotting wood or under rocks in the soil. Nests have also been reported in siding, rafters, and porch roofs. These ants are chiefly nocturnal foragers.

Camponotus variegatus (Fr. Smith) (Plate 4e). The workers are 7.5 to 11.0 mm in length. The head and mesosoma are yellow, as is the gaster except for the posterior edge of each tergum, which is darker brown or black. This ant lacks the row of erect bristles on the flexor surfaces of the middle and hind tibiae.

The Hawaiian carpenter ant was introduced into Hawaii from Southeast Asia (Wilson and Taylor 1967). It is a serious nuisance pest in houses on all of the Hawaiian Islands (Huddleston and Fluker 1968, Yates 1988). It has been collected on the coast of Washington, and there are unconfirmed reports from coastal areas of Oregon (Map 3.23). It was possibly transported to the mainland in wood crating used for packing equipment. It prefers dry habitats (less than 100 cm rainfall), where it nests under rocks, in trash, or in dead branches. The big-headed ant, *Pheidole megacephala*, has limited its spread in some locations (Illingworth 1926). It is a noctur-

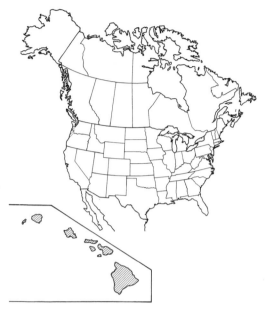

Map 3.23. *Camponotus variegatus*

nal forager and causes little or no structural damage (Yates 1988). It nests in wood that has been hollowed out by termites, inside rotting logs and tree stumps, and in structural voids. These ants are not known to excavate solid wood, but they will smear linen and furniture with a waxy material that they use for nesting (Phillips 1934). In pineapple groves, they tend mealybugs on the fruit and roots.

Camponotus vicinus Mayr (Plate 4f). The workers are 6 to 13 mm long and variable in color. The most common color variant has a red mesosoma with a black head, gaster, and legs. Workers can be all black, but this is uncommon. The head and mesosoma are dull, and the gaster moderately shiny. They are characterized by a distinctly carinate clypeus and a scape with a flattened base whose length surpasses the occipital corner by an amount equal to or greater than the length of the first funicular joint. The middle and hind tibiae have a row of graduated erect bristles on their flexor surfaces.

This western species ranges from Mexico to southern Canada, inland to the Rocky Mountains and east to Alberta, the Dakotas, and Kansas (Map

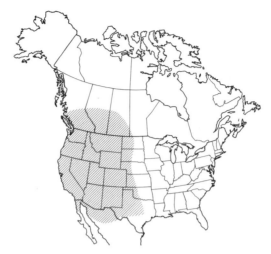

Map 3.24. *Camponotus vicinus*

3.24). The ants nest in a variety of habitats such as under rocks in wood-lands, in rotting stumps and dead trees, in the heartwood of living trees, and in structures. They are also found under flat rocks and among small rocks used as fill or in decorative landscaping, but the larvae are usually in cavities in wood scraps or bark buried beneath the rocks. In the grass-lands of North Dakota, colonies have also been found nesting under rocks (Wheeler and Wheeler 1963). *C. vicinus* is an important structural pest, second only to *C. modoc* in Washington State (Hansen and Akre 1985). These ants will excavate solid wood but are more attracted to damaged wood. Nests are found in logs on dry, sunny hillsides, primarily in pon-derosa pine. Their nest locations are much drier and warmer than are those of *C. modoc*. Workers forage at low temperatures (Bernstein 1979). Colonies are polygynous and may contain more than 100,000 workers (Akre et al. 1994). Workers of *C. vicinus* are extremely defensive and pug-nacious. They instantly attack predators or humans that disturb their nest, and major workers are large enough to draw blood with their mandibles as they spray formic acid into the wound.

REFERENCES CITED

Akre, R. D., L. D. Hansen, and E. A. Myhre. 1994. Colony size and polygyny in carpenter ants (Hymenoptera: Formicidae). J. Kans. Entomol. Soc. 67: 1–9.

Bernstein, R. A. 1979. Relations between species diversity and diet in communities of ants. Insectes Soc. 26: 313–321.

Bolton, B. 1995. A new general catalogue of the ants of the world. Cambridge: Harvard University Press.

Bolton, B. 2003. Synopsis and classification of Formicidae. Mem. Am. Entomol. Institution. 71: 1–370.

Bosik, J. J. (Chairman). 1997. Common names of insects and related organisms. Lanham, Md.: Entomological Society of America.

Cook, T. W. 1953. The ants of California. Palo Alto: Pacific Books.

Creighton, W. S. 1950. The ants of North America. Bull. Mus. Comp. Zool. 104: 1–585.

Deyrup, M. 2003. An updated list of Florida ants (Hymenoptera: Formicidae). Fla. Entomol. 86: 43–48.

Deyrup, M., C. Johnson, G. C. Wheeler, and J. Wheeler. 1989. A preliminary list of the ants of Florida. Fla. Entomol. 72: 91–101.

Drooz, A. T., ed. 1985. Insects of eastern forests. U.S. Dept. Agric. For. Serv. Misc. Pub. 1426.

DuBois, M. B. 1994. Checklist of Kansas ants. Kans. School Nat. 40: 3–16.

DuBois, M. B., and W. E. LaBerge. 1988. Annotated list of ants in Illinois (Hymenoptera: Formicidae). *In* J. C. Trager, ed., Advances in myrmecology, pp. 133–156. Leiden: E. J. Brill.

Ebeling, W. 1975. Urban entomology. Los Angeles: University of California, Division of Agricultural Science.

Furniss, R., and V. M. Carolin. 1977. Western forest insects. U.S. Dept. Agric. For. Serv. Misc. Publ. 1339.

Gano, K. A., and L. E. Rogers. 1983. Colony density and activity times of the ant *Camponotus semitestaceus* (Hymenoptera: Formicidae) in the shrub steppe community. Ann. Entomol. Soc. Am. 76: 958–963.

Gregg, R. E. 1963. The ants of Colorado. Boulder: University of Colorado Press.

Hansen, L. D. 1995. Distribution and categorization of *Camponotus* spp. north of Mexico as nuisance or structurally damaging pests. *In* Proceedings of the 5th International Pest Ant Symposia and the 1995 Annual Imported Fire Ant Conference. Vol. 5, pp. 18–26. College Station: Texas A&M University.

Hansen, L. D., and R. D. Akre. 1985. Biology of carpenter ants in Washington State (Hymenoptera: Formicidae: *Camponotus*). Melanderia 43: 1–62.

Hölldobler, B., and E. O. Wilson. 1990. The ants. Cambridge: Harvard University Press.

Huddleston, E. W., and S. S. Fluker. 1968. Distribution of ant species in Hawaii. Proc. Hawaiian Entomol. Soc. 20: 45–69.

Illingworth, J. F. 1926. A study of ants in their relation to the growing of pineapples in Hawaii. Univ. Hawaii Exp. Sta. Assoc. Hawaiian Pineapple Canners Bull. 7: 1–16.

Krombein, K. V., P. D. Hurd Jr., D. R. Smith, and B. D. Burks. 1979. Catalog of Hymenoptera in America north of Mexico. Vol. 2, pp. 1199–2209. Washington, D.C.: Smithsonian Institution Press.

Mackay, W., D. Lowrie, A. Fisher, E. Mackay, F. Barnes, and D. Lowrie. 1988. The ants of Los Alamos County, New Mexico (Hymenoptera: Formicidae). *In* J. C. Trager, ed., Advances in myrmecology, pp. 79–131. Leiden: E. J. Brill.

Mackay, W., and E. Mackay. 2002. The ants of New Mexico (Hymenoptera: Formicidae). Lewiston, N.Y.: Edwin Mellen Press.

Mackay, W. P., and S. B. Vinson. 1989. A guide to the species identification of the New World ants (Hymenoptera: Formicidae). Sociobiology 16: 3–47.

O'Keefe, S. T., J. L. Cook, T. Dudek, D. F. Wunneburger, M. D. Guzman, R. N. Coulson, and S. B. Vinson. 2000. The distribution of Texas ants. Southwest. Entomol. Suppl. 22.

Phillips, J. S. 1934. The biology and distribution of ants in Hawaiian pineapple fields. Univ. Hawaii Exp. Sta. Pineapple Prod. Coop. Assoc. Bull. 15: 1–67.

Sargent, J. M., E. P. Benson, P. A. Zungoli, and W. C. Bridges. 2001. Carpenter ant (Hymenoptera: Formicidae) fauna of South Carolina. J. Agri. Urban Entomol. 18: 227–236.

Smith, M. R. 1965. House-infesting ants of the eastern United States: their recognition, biology, and economic importance. Agricultural Research Service, U.S. Dept. Agric. Tech. Bull. 1326.

Snelling, R. R. 1968. Studies on California ants. 4. Two species of *Camponotus* (Hymenoptera: Formicidae). Proc. Entomol. Soc. Wash. 70: 350–358.

Snelling, R. R. 1970. Studies on California ants. 5. Revisionary notes on some species of *Camponotus*, subgenus *Tanaemyrmex* (Hymenoptera: Formicidae). Proc. Entomol. Soc. Wash. 72: 390–397.

Snelling, R. R. 1988. Taxonomic notes on Nearctic species of *Camponotus*, subgenus *Myrmentoma* (Hymenoptera: Formicidae). *In* J. C. Trager, ed., Advances in myrmecology, pp. 55–78. Leiden: E. J. Brill.

Vail, K., L. Davis, D. Wojcik, P. Koehler, and D. Williams. 1994. Structure-invading ants of Florida. Coop. Ext. Bull. SP 164.

Wheeler, G. C., and J. Wheeler. 1963. The ants of North Dakota. Grand Forks: University of North Dakota.

Wheeler, G. C., and J. Wheeler. 1973. Ants of Deep Canyon, Colorado Desert, California. Riverside: Regents University of California.

Wheeler, G. C., and J. Wheeler. 1986. The ants of Nevada. Los Angeles: Los Angeles County Museum of Natural History.

Wheeler, W. M. 1910. The North American ants of the genus *Camponotus* Mayr. Ann. N.Y. Acad. Sci. 20: 295–354.

Wilson, E. O., and R. W. Taylor. 1967. The ants of Polynesia (Hymenoptera: Formicidae). Pacific Insects Monograph 14. Honolulu: Entomology Department, Bernice P. Bishop Museum.

Yates, J. R. 1988. Biology and control of the Hawaiian carpenter ant. Univ. Hawaii Coop. Ext. 1(2). Oahu: University of Hawaii, Urban Pest Press.

Yensen, N. P., W. H. Clark, and A. Francoeur. 1977. A checklist of Idaho ants (Hymenoptera: Formicidae). Pan-Pac. Entomol. 53: 181–187.

CHAPTER 4

Life History

Ants establish colonies in a variety of ways. In temporary social parasitism, a queen of one species may usurp an established colony of another species, the members of which then become her "slaves." In the so-called tramp species, colony multiplication is by fission or budding, where at least one queen and a group of workers, some carrying brood, split off from the colony and migrate to a new nest site.

In carpenter ants, winged male and female reproductives (alates) emerge from nests distributed over a large geographic region to depart on a mating flight. After the mating flight, the newly fertilized queen falls to the ground and searches for a suitable nest site. She sheds her wings and digs a chamber in soil or wood. Here she lays many eggs, most of which serve as food for her or for her developing larvae. She also obtains nutrition from her nonfunctional wing muscles, which are broken down and reabsorbed.

After the first workers emerge, they care for the subsequent brood. The nest expands and foraging begins. The queen's sole duty now is to lay eggs. When the colony reaches considerable strength, a new group of alates is produced.

MATING FLIGHTS

The mating flights of *Camponotus* take place in the spring. They consist of alates produced in the previous year, that have overwintered in nests. The timing of these flights for each species varies, and they may happen more than once during a season. The flights are triggered by environmental factors such as photoperiod and changes in temperature or humidity.

Alates of *C. modoc* Wheeler, for example, tend to swarm in the spring during the late afternoon and early evening on warm, sunny, humid days, often after a heavy rainfall and cool temperatures (Hansen and Akre 1990).

The mass exodus of alates from nests prior to the mating flight is called swarming (Hölldobler and Wilson 1990). In the hours prior to swarming, alates of *C. modoc* and *C. herculeanus* (L.) engage in "sun bathing" (Hölldobler and Maschwitz 1965; L. D. Hansen, unpubl. observ., 1984–1987). In this behavior, alates cluster outside the nest entrance and sun themselves. Swarming of *C. herculeanus* is synchronized by a pheromone released from the mandibular glands of males (Hölldobler and Maschwitz 1965). The chemical composition of these glandular secretions is highly variable among species as well as between males, female reproductives, and workers (Torres et al. 2001). Males leave the secretions of this gland around the nest entrance as they take flight, which stimulates the departure of the females (Hölldobler and Maschwitz 1965). Females of *C. herculeanus* are also stimulated by the mandibular gland secretion of males of *C. ligniperdus* Latreille (Hölldobler and Maschwitz 1965). All three castes of *C. pennsylvanicus* (DeGeer) respond to the mandibular gland secretions of the males, with female alates being the most sensitive, followed by workers and then males (Payne et al. 1975). The major volatile component of this gland in *C. noveboracensis* Fitch and *C. pennsylvanicus* is methyl 6-methyl salicylate (Brand et al. 1973). Species in the subgenus *Myrmentoma*, such as *C. nearcticus* Emery, *C. subbarbatus* Emery, and *C. decipiens* Emery, have a more complex blend of volatiles (Brand et al. 1973). The largest number of volatiles has been found in the mandibular glands of *C. clarithorax* Creighton (Torres et al. 2001), which has 10 different compounds (Lloyd et al. 1975).

The premating behavior of *C. modoc* was studied in two large colonies that were brought into the laboratory just before the spring mating flights in Washington State (Hansen and Akre 1985). The infested wood containing each colony was placed in a large plastic container fitted with a nylon mesh tent suspended over the top, with its lower edges taped to the floor. The males were the most active on the first day of flights, but by the second day the females were equally active. Both males and females crawled to the highest point on the nest. There, in stereotypic fashion, they twisted their abdomens from side to side while beating their wings and holding onto the substrate (Fig. 4.1). Then they took flight. Their flight activity peaked in the late afternoon of the second day and stopped on the third day. Males briefly mounted females but did not mate. Although copulation

PLATE 1

a. *Camponotus americanus*

b. *Camponotus chromaiodes*

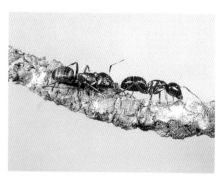

c. *Camponotus herculeanus*

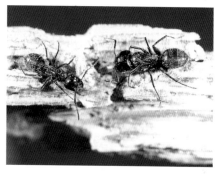

d. *Camponotus laevigatus*

e. *Camponotus modoc*

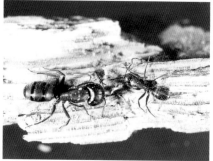

f. *Camponotus noveboracensis*

PLATE 2

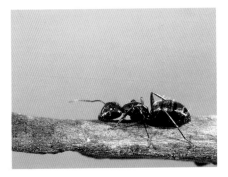

a. *Camponotus pennsylvanicus*

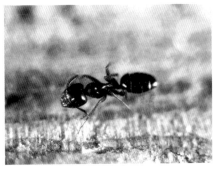

b. *Camponotus caryae*

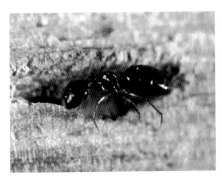

c. *Camponotus clarithorax*

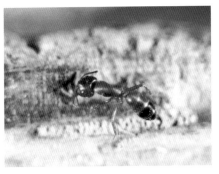

d. *Camponotus decipiens*

e. *Camponotus discolor*

f. *Camponotus essigi*

PLATE 3

a. *Camponotus hyatti*

b. *Camponotus nearcticus*

c. *Camponotus sayi*

d. *Camponotus subbarbatus*

e. *Camponotus planatus*

f. *Camponotus floridanus*

PLATE 4

a. *Camponotus acutirostris*

b. *Camponotus castaneus*

c. *Camponotus semitestaceus*

d. *Camponotus tortuganus*

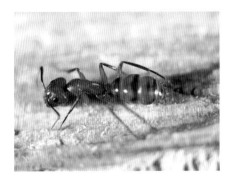

e. *Camponotus variegatus*

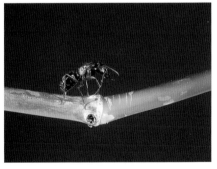

f. *Camponotus vicinus*

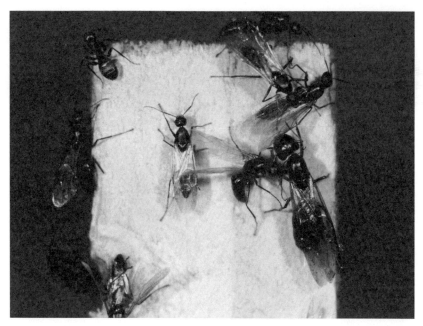

Figure 4.1. Premating behavior of winged reproductives of *Camponotus modoc*.

in carpenter ants is assumed to take place during flight, it has been observed on the ground (Goetsch and Kathner 1937 cited in Sanders 1971).

INCIPIENT COLONIES

After mating, the male dies and the inseminated female seeks a nest site. A newly mated queen breaks off her wings by pressing each one against the substrate, either by wing flexion or rotation of the thorax (Sanders 1971). The dealate females of *C. herculeanus* and *C. modoc* can be found on the ground searching for nest sites for as long as three days following a swarm (Fig. 4.2) (Sanders 1971, Hansen and Akre 1985). Carpenter ant nests are often started under loose bark or wood debris on the ground, in the decayed wood of live or dead trees, in fallen logs or landscape timbers, and in the moist wood of structures.

In what is termed claustral colony founding, the queen seals herself off in a chamber and rears her first brood in isolation (Pricer 1908, Mintzer

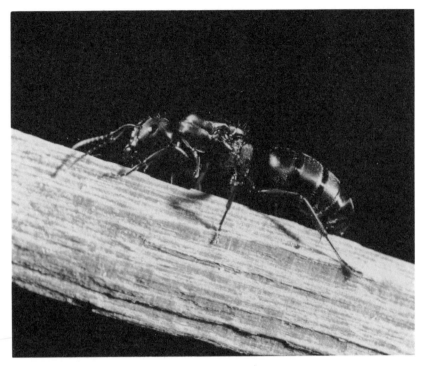

Figure 4.2. Inseminated queen of *Camponotus modoc* seeking a nesting site.

1979, Hansen and Akre 1985). A clutch of 9 to 16 eggs is laid by *C. lae-vigatus* (Fr. Smith), *C. vicinus* Mayr, and *C. modoc* (Mintzer 1979, Hansen and Akre 1985). A similar number of eggs is laid by the queens of *C. penn-sylvanicus* (Pricer 1908); however, *C. planatus* Roger queens lay smaller clutches of 6 or fewer eggs (Mintzer 1979). The eggs vary in shape, from elongate and cylindrical in the subgenera *Camponotus* (Fig. 4.3), *Myrmentoma*, and *Myrmobrachys* to oval in *Tanaemyrmex* (Mintzer 1979). They stick to one another in a cluster, enabling the queen to move them as a unit.

Depending on the temperature and species, the eggs hatch over a two- to five-week period (Mintzer 1979, Hansen and Akre 1985). The larvae are soft, white, and legless. They have rounded elongate bodies, with the thorax and first abdominal segment forming a short stout neck, which is strongly curved ventrally (Fig. 4.3). Their mouthparts are directed posteriorly over a shallow ventral pocket, the praesaepium. The queen and

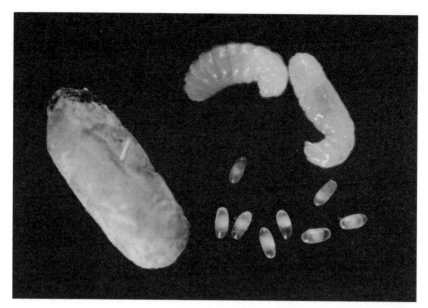

Figure 4.3. Eggs, larvae, and a pupa of *Camponotus modoc*.

workers place food in this pocket for the larva to feed on. The larvae are covered with branched and unbranched hairs that are curved at their tips into hooks (Fig. 4.4). When the larvae are stacked together, these hooks interlock (Wheeler and Wheeler 1976, Hansen and Akre 1990, Akre et al. 1992, chap. 52) such that like the eggs, the larvae can be moved as a unit.

The queen obtains nourishment for herself and her first larvae by metabolizing her fat body and flight muscles. Nutrient reserves in the fat body include fats, proteins, and glycogen, whereas the large flight muscles provide protein (Wheeler 1994). Another possible source of protein and carbohydrates for founding queens may be the seminal fluid transferred from the male during copulation (Wheeler 1994). In addition, the postpharyngeal gland of the queen may be a source of food for the brood (Hölldobler and Wilson 1990).

The larvae of *C. modoc* progress through four instars in two to three weeks. The larval midgut is not connected to the hindgut, so wastes accumulate as a mass of fecal material, known as meconium. At the last larval molt, the gut becomes connected, and the meconium is voided. A mature larva spins an elliptical web of silk around itself, voids the meconium into

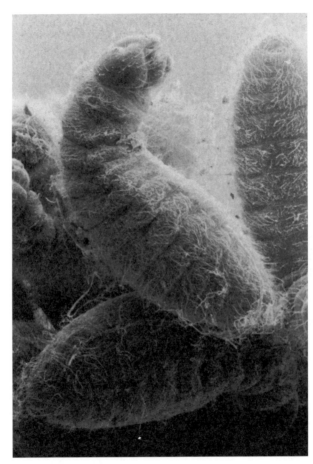

Figure 4.4. Hooked hairs on *Camponotus modoc* larvae as seen by scanning electron microscopy. Photograph courtesy of G. Paulson, Shippensburg University, Shippensburg, Pennsylvania.

the cocoon wall, and becomes a semipupa. This prepupal stage resembles the larva except that the body is straight and constricted behind the epinotal somite. As the semipupa enters the pupal stage, the larval exoskeleton is shed alongside the meconium.

The prepupal-pupal stages last from two to four weeks (Pricer 1908, Mintzer 1979, Hansen and Akre 1985). Emerging adults are incapable of freeing themselves from their cocoons and therefore must be assisted by the queen. The small workers in the first brood are called minims or minors and have little size variation (Fig. 4.5) (Mintzer 1979, Hansen and Akre 1985). These first workers forage, feed and groom the queen (Fig. 4.6),

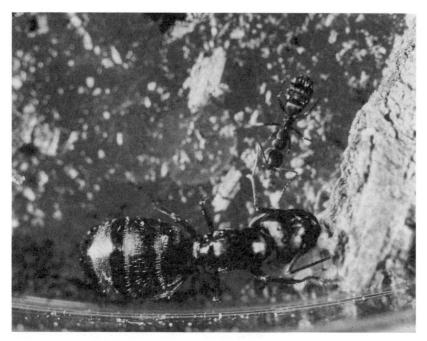

Figure 4.5. *Camponotus modoc* queen with her first worker.

maintain and enlarge the nest, and assist in caring for the brood. The developmental cycle from egg to adult ranges from 48 to 74 days.

The queen begins to lay a second clutch of eggs when the brood from her first clutch has developed to the prepupal stage in late summer (Fig. 4.7) (Pricer 1908, Hansen 1985, Gibson and Scott 1990). These eggs hatch and the larvae advance to the second, third, or fourth instar before the colony enters a winter dormancy. Thus, only the first brood completes development during the first year, producing 4 to 25 workers (Fig. 4.7) (Pricer 1908, Hansen and Akre 1985). In the spring of the following year, the presence of cocoons stimulates egg-laying by queens of *C. modoc*, *C. noveboracensis*, and *C. pennsylvanicus*, which may synchronize the production of larvae with the emergence of adult workers to care for them (Gibson and Scott 1990).

Colony growth is slow during the first two years (Fig. 4.8). For example, the average number of workers in 53 *C. modoc* colonies that were maintained in a laboratory for 30 months was 19 (Fig. 4.9). Carpenter ant

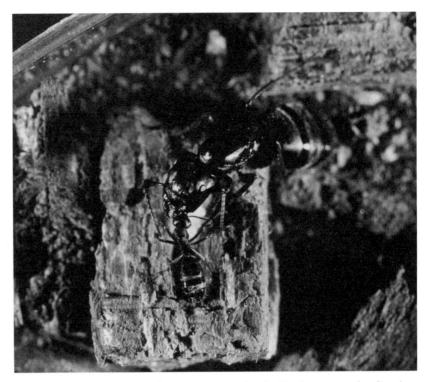

Figure 4.6. A minor worker of *Camponotus modoc* feeding her queen after foraging.

queens also vary in their ability to initiate and maintain colonies. In the laboratory, 96 (67%) of 144 *C. modoc* queens and 10 (77%) of 13 *C. vicinus* queens started colonies (Hansen and Akre 1985). In another laboratory, only 14 (40%) of 35 *C. pennsylvanicus* queens that started colonies survived for two years (Cannon and Fell 1990). Colony founding under natural conditions is probably less successful, owing to predation on founding queens.

ESTABLISHED COLONIES

Queens in colonies of *C. modoc* and *C. pennsylvanicus* that are more than a year old have two annual periods of oviposition. The first is in late winter or early spring (February or March), when the larvae break diapause and

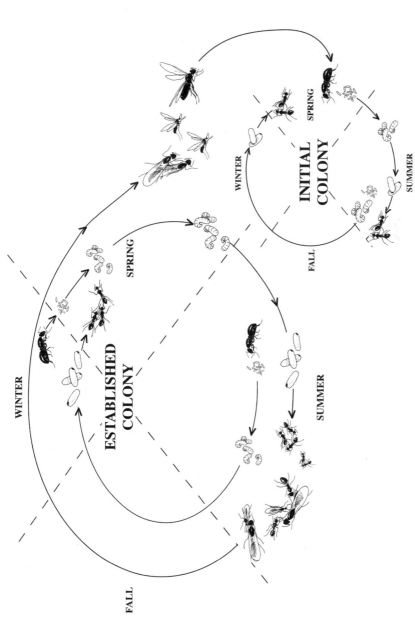

Figure 4.7. Life cycle of carpenter ants. In an initial colony started after a spring flight, the founding queen produces eggs that develop into workers. Eggs are laid in late summer, hatch, and then overwinter before completing development. In an established *Camponotus* colony, a queen has two egg-producing periods. A summer brood develops in one season, and an overwintering brood, which is produced in late summer, completes development in early spring.

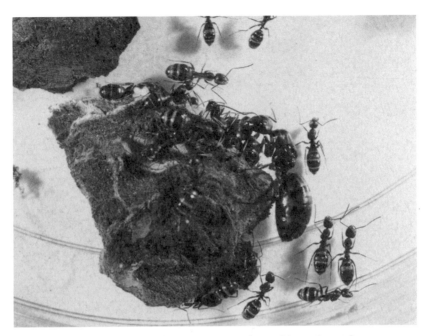

Figure 4.8. Founding queen of *Camponotus modoc* and her colony after two years. Note adipogastry of workers entering diapause.

Figure 4.9. Average populations of eggs, larvae, pupae, and workers in laboratory colonies founded by 53 individual queens of *Camponotus modoc* over two years.

Figure 4.10. Larvae of *Camponotus modoc*: dormant (left) and developing (right).

develop into pupae (Fig. 4.7). The second oviposition produces a summer brood, which enters dormancy as larvae in late summer or fall (Fig. 4.10) (Pricer 1908, Hansen and Akre 1985).

Nutrients are transferred among members of the colony by trophallaxis, glandular secretions, and trophic eggs. Proteins are needed by the queen to produce eggs and by the brood for normal development. Carbohydrates are the primary energy source for workers. Adult ants store fats, proteins, and glycogen in the fat body (Wheeler 1994). The fats and proteins are mobilized by transfer into the hemolymph, and from there possibly into trophic eggs and glandular secretions (Wheeler 1994). Trophic eggs are not characteristic of *Camponotus* (Wheeler 1994), but they have been found in the ovarioles of *C. modoc* workers, and their consumption has also been documented (Fig. 4.11) (Hansen and Akre 1985). Cannibalism of larvae is common in *C. pennsylvanicus* and *C. modoc* and increases when food is scarce (Smith 1942, Hansen and Akre 1985).

The postpharyngeal glands may also be a source of nutrients in

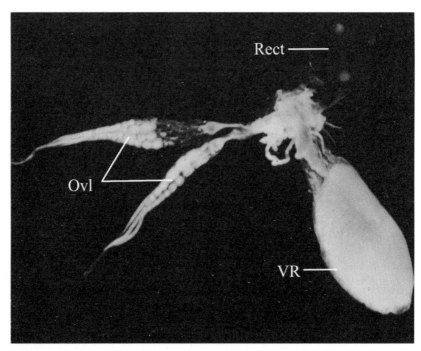

Figure 4.11. Ovaries of a major worker of *Camponotus modoc* with trophic eggs. *Ovl*, ovarioles; *Rect*, rectum; *VR*, venom reservoir.

Camponotus. These glands have been associated with lipophilic secretions in *Formica* and probably have a nutritive role in other formicines as well (Hölldobler and Wilson 1990). In addition to trophallaxis with other adults, workers also solicit oral and anal secretions from larvae (Hölldobler and Wilson 1990).

Food distribution in males of *C. herculeanus* and *C. ligniperdus* can be divided into four phases (Hölldobler 1966): (1) social—from adult emergence until winter dormancy, when males exchange food with other adult members of the colony but rarely obtain food on their own; (2) resting—during dormancy, when food exchange is reduced; (3) sexual—after dormancy and before swarming, when males receive small quantities of food from workers and increase uptake on their own; and (4) final—after swarming, when the males are nearly inactive until death. The fat bodies in males are nearly depleted by the time spring flights begin (Hölldobler 1966), and males die soon after mating.

Figure 4.12. Polymorphic workers of *Camponotus modoc*.

Workers of most species of *Camponotus* are polymorphic (Fig. 4.12). The average size of workers generally increases with colony growth, probably as a result of improved nutrition (Hölldobler and Wilson 1990). Thus, the minims in incipient colonies are generally smaller than minor workers in mature colonies (Hölldobler and Wilson 1990). A colony of *C. pennsylvanicus* will produce larger workers with greater size variation when optimal nutrition is provided, and progeny of smaller average stature when food is reduced (Smith 1942).

Major and media workers are not produced until the third season in *C. pennsylvanicus*, *C. chromaiodes* Bolton, *C. modoc*, and *C. vicinus* (Pricer 1908, Hansen and Akre 1985). In *C. noveboracensis*, however, a few majors are produced in the second season (Gibson 1989). Their numbers continue to increase with colony size, probably owing to the increased

Figure 4.13. A mature colony of *Camponotus pennsylvanicus*.

TABLE 4.1

Distribution of the number of infestations by quarter for 1979–1984 from samples in Washington

Species of *Camponotus*	Jan.–Mar.	Apr.–Jun.	July–Sep.	Oct.–Dec.	Total	%
C. modoc	84	370	132	17	603	77.41
C. vicinus	39	64	13	4	120	15.4
C. noveboracensis	3	22	9	2	36	4.62
C. essigi	9	2	0	0	11	1.41
C. laevigatus	1	1	4	0	6	0.77
C. herculeanus	0	1	2	0	3	0.39
Total	136	460	160	23	779	100

amount of food available, as well as their longer life span in comparison with smaller workers (Fig. 4.13).

The period of most intense activity for structural infestations of *C. modoc* is from April through August (Table 4.1), which coincides with their highest respiration rates (Table 4.2) (Hansen and Akre 1985). Their lowest respiration rates are in January, when they are dormant (Hansen and Akre

TABLE 4.2

Oxygen consumption of worker ants of *Camponotus modoc*

Date	No. tested	Oxygen (μL/100 mg/h)			
		Range	Median	Average	SD
Jan. 1984	29	9.60–84.17	32.01	35.28	17.59
Apr. 1984	30	19.86–125.49	62.34	67.27	27.07
June 1984	30	24.28–126.00	59.05	65.05	25.9
July 1984	30	34.42–109.31	74.81	72.23	19.58

1985). In preparation for winter, carpenter ants stop foraging and plug nest entrances. Their entry into winter diapause is not triggered solely by temperature, photoperiod, or food source (Hölldobler 1961, Hansen and Akre 1985). Winter diapause is probably a combination of these factors and other events.

The overwintering workers and queen in a colony of *C. pennsylvanicus* have large reserves of fat (Cannon 1990). The fat bodies of *C. modoc* workers are so enlarged that the intersegmental membranes of the gaster are exposed (Fig. 4.8). Glycerol, a cryoprotectant, is produced in the larvae and adults of *C. pennsylvanicus* (Cannon and Fell 1992). This compound acts as antifreeze, preventing destructive ice crystals from forming. The supercooling points range from −17°C in major workers to −22°C in larvae. Adults fill their crop partly or completely with a 30% to 35% glucose solution. Workers will lose about half their fat and carbohydrate reserves during the dormant phase from November to April (Cannon and Fell 1990).

PARENT AND SATELLITE NESTS

Mature carpenter ant colonies are partitioned into parent and satellite nests (Sanders 1964; Kloft et al. 1965; Hansen and Akre 1985, 1990). Nests are connected by trails, and contact is maintained by the movement of workers and brood (Sanders 1964, Hansen and Akre 1985). Members of a colony remain in their separate nests during winter but reestablish contact in spring.

The queen, eggs, early-instar larvae, and workers are located in the parent nest, which is often established in a standing live or dead tree (Fig. 4.14), rotting log or stump, or wood in a building that is in contact with the soil or has a high moisture content. Eggs and early-instar larvae require high humidity. For some species, colony growth can be affected by humidity (Mankowski 2002, chap. 3). Significantly fewer workers developed in

Figure 4.14. A nest of *Camponotus modoc* in a live tree.

C. modoc colonies kept at 70% versus 100% relative humidity, whereas there was no difference between worker production in colonies of *C. vicinus* kept at these two humidities.

Satellite nests usually are found higher than parent nests in dead and living trees. They are also more commonly seen in structures under insulation (Fig. 4.15) and in wall voids, attics, or crawl spaces. These satellite nests can account for as much as 75% of structural infestations (see Table 6.6) (Hansen and Akre 1985). Satellite colonies prefer drier, warmer nests, which are often excavated in solid wood (Fig. 4.16). Workers, mature larvae, pupae, and winged reproductives are found in satellite nests (Table 4.3). The number of satellite nests per colony varies, as does their population. There were as many as eight satellite nests for both *C. herculeanus* and *C. noveboracensis* in New Brunswick (Sanders 1964), and the population of *C. modoc* satellite colonies ranged from 180 to over 12,000

Figure 4.15. A satellite nest of *Camponotus modoc* under insulation.

Figure 4.16. Sand-papered appearance of walls in nest gallery of *Camponotus modoc*.

TABLE 4.3

Composition of satellite colonies of *Camponotus modoc* collected from structural infestations in western Washington

Date	Location	Winged		Workers			Brood		
		Females	Males	Major	Media	Minor	Larvae	Pupae	Cocoons
Oct. 1981	Stacked lumber	0	47	1151	2352	2402	22	0	0
July 1981	Under attic insulation	1	4	539	1450	2815	75	5	331
Mar. 1982	Under floor insulation	17	487	24	44	128	0	0	372
May 1982	Under roof insulation	0	0	680	3880	3228	0	0	16
May 1982	Under floor insulation	197	0	398	1168	2178	105	8	1764
June 1982	Stacked lumber	1	0	219	1948	2005	1426	83	0
Aug. 1982	Wall void	25	0	625	2047	9331	48	999	2337
Aug. 1982	Stacked lumber	0	0	240	504	1467	15	1090	409
Sep. 1982	Roof beam	16	1	116	148	290	0	78	245
June 1983	Porch roof	0	0	121	142	252	4	11	0
Apr. 1984	Under attic insulation	13	722	43	62	75	0	0	59,446

workers (Table 4.3). A large number of empty pupal cases (60,000+) were collected at one perennial nest site (Hansen and Akre 1985).

The distribution and location of carpenter ant nests vary among species and habitat (Klotz et al. 1998). Colonies of *C. pennsylvanicus* in an Indiana woodlot nested in standing, live trees and occupied from 1 to 6 trees; colonies of *C. floridanus* (Buckley) in Florida scrub nested in rotten logs or in the ground beneath objects, and occupied from 1 to 10 nest sites; and colonies of *C. laevigatus* in the San Bernardino Mountains of southern California nested in stumps or fallen logs, and only 1 of 17 nests was a satellite.

All ants will abandon their nests and emigrate when conditions become unfavorable (Hölldobler and Wilson 1990). During emigration, the workers carry eggs, larvae, pupae, and other workers or induce the latter to follow.

COLONY GROWTH AND THE PRODUCTION OF ALATES

Colonies with only one egg-laying queen (monogynous) grow slowly (Hansen and Akre 1985). For example, colonies of *C. pennsylvanicus* must be at least three to six years old before they produce alates (Pricer 1908). Alates may be produced sooner in colonies with multiple egg-laying queens (polygynous), where growth is accelerated.

Alate females and workers develop from the fertilized eggs of mated queens. In some species of *Camponotus*, workers can also produce workers (Skaife 1961). Generally though, workers are sterile and possess non-functional ovaries (Forbes 1938). Males develop from unfertilized eggs of old queens whose supply of spermatozoa has been exhausted (Sanders 1964) and from eggs of workers after the loss of a queen (Wheeler 1994). For example, when a queen of *C. pennsylvanicus* dies or is killed, the major workers lay eggs that develop into males (Pricer 1908, Vanderschaaf 1970). In addition, uninseminated queens of *C. modoc* and *C. vicinus*, which are readily accepted into established colonies, can contribute to the production of males (Hansen and Akre 1985).

The developmental time for males of *C. modoc* and *C. vicinus* is more than twice that of workers. Some complete development in 17 to 20 weeks, and others enter diapause as larvae to overwinter and emerge as adults the following year (Hansen and Akre 1985).

Colony growth in *C. floridanus* is influenced by food availability and the presence of predators or competitors, and is mediated by the perception of these factors by workers (Nonacs 1991, Nonacs and Calabi 1992, Calabi and Nonacs 1994). Colonies have a high growth rate when they subsist on an intermediate diet of insect prey, but a low growth rate in the presence of unrelated conspecifics or predators. The explanation for these responses lies in the behavioral flexibility of workers to accommodate changing circumstances. The ant response to an ephemeral resource, such as insect prey, is to store it in the form of brood, which can be cannibalized later when food is scarce. In contrast, less brood is produced in the presence of competitors or predators in order to reduce the demand on foraging and its associated risk of mortality.

Estimates vary on the longevity of carpenter ant colonies and queens. One of the authors (L. D. H.) monitored a colony of *C. modoc* for 20 years in western Washington until a storm uprooted the tree in which they were nesting. The life spans of queens of four species of *Camponotus* that were maintained in laboratory nests ranged from 7 to 21 years (Hölldobler and Wilson 1990).

Colony Size

Determining the population of carpenter ant colonies is difficult because they may consist of more than one nest (polydomous) (Sanders 1964; Hansen and Akre 1985, 1990; Akre et al. 1994), and extracting them from wood is not easy. Nearly a century ago, Pricer (1908) collected and counted colonies of *C. pennsylvanicus* and *C. chromaiodes* (Table 4.4). The largest colonies consisted of about 3000 workers. The largest colony of *C. pennsylvanicus* collected by Cannon and Fell (1990) had 2047 workers.

TABLE 4.4

Colony size of carpenter ants reported in literature

Species of *Camponotus*	Workers	Queens	Winged females	Winged males	Larvae	Reference
C. pennsylvanicus	3018	1	196	174	843	Pricer 1908
C. chromaiodes	3212	1	233	176	724	Pricer 1908
C. herculeanus	5945	—	539	14	6490	Sanders 1964
C. herculeanus	1994	—	23	22	—	Sanders 1964
C. herculeanus	12,240	—	1059	77	10,280	Sanders 1970
C. noveboracensis	8900	—	1560	400	802	Sanders 1970

A population of 3000 to 6000 workers is commonly given as the average colony size for most species (Fowler 1986). However, Akre et al. (1994) collected a colony of *C. pennsylvanicus* in Minnesota that had approximately 8000 workers, and Sanders (1970) recorded over 12,000 workers in a colony of *C. herculeanus* and 8900 workers in a colony of *C. noveboracensis* (Table 4.4). The numbers of reproductives that emerged from a single nest of *C. herculeanus* were 4500 males and 1800 winged queens (Hölldobler and Maschwitz 1965). To produce this number of alates, a colony would need to have many thousands of workers. It is now known that mature colonies of *C. modoc* and *C. vicinus* can have 50,000 to 100,000 workers (Table 4.5) (Akre et al. 1994). Even satellite colonies of *C. modoc*, collected from structures, had from 180 to over 12,000 workers (Hansen and Akre 1985), with over half of the nests containing more than 3500 workers (Table 4.3).

Bergmann's rule, which states that within a genus of endothermic vertebrates the larger species tend to be found in cooler environments (Freckleton et al. 2003), might also apply to colony size in social insects (Kaspari and Vargo 1995). The shorter growing season in temperate latitudes eliminates small-colony species through overwintering starvation. The intraspecific version of Bergmann's rule, which states that within a species animals tend to be larger in colder environments (Mayr 1956), might apply to carpenter ants. Larger colonies of *C. modoc*, *C. vicinus*, and *C. pennsylvanicus* are more common farther north (unpubl. reports from pest management professionals; Sanders 1964; Cannon and Fell 1990).

POLYGYNY

Although monogamy is the typical condition for established colonies of *Camponotus*, polygyny is also common (Hölldobler and Wilson 1977). Multiple egg-laying queens of *C. herculeanus* and *C. ligniperdus* can coexist in large nests, but they are aggressive toward one another (Hölldobler 1962). In this special case of polygyny, termed oligogyny, queens cohabit but are intolerant of one another and maintain territories within the nest (Hölldobler and Wilson 1977). Polygyny in *Camponotus*, such as found in *C. vicinus*, may be derived from colony founding by multiple queens (pleometrosis). In the case of some monogynous species, the supernumerary queens in incipient colonies are later rejected, usually when the first brood matures, and the number of queens is reduced to one (Hölldobler and Wilson 1977).

TABLE 4.5

Numbers of colonies (workers only) collected in Washington, Idaho, and Minnesota, according to population range

Colony population	Species of *Camponotus*					
	C. modoc	*C. vicinus*	*C. herculeanus*	*C. noveboracensis*	*C. laevigatus*	*C. pennsylvanicus*
<2999	21	22	11	10	1	9
3000–4999	11	4	1	0	0	1
5000–9999	16	3	0	0	0	0
10,000–24,999	12	5	1	2	0	0
25,000–49,999	4	1	0	0	0	0
>50,000	1	1	0	0	0	0

Colonies of *C. modoc*, which are typically monogynous, have been established with multiple queens in the laboratory (Hansen and Akre 1985). In two of five colonies maintained, the queens coexisted for only a few days, while in the other three colonies the queens coexisted for 4 months, 6 months, and 18 months before one of the queens attacked and killed the others. In another colony with three queens that was collected in the spring, the eggs and brood were kept in a central pile, and the queens were equally attentive in caring for them throughout the first summer. They were not aggressive and often groomed one another. All three appeared to be functioning as queens based on the number of eggs and brood produced. After three months, the queens attacked one another. One queen was killed and the other two had missing body parts. The two survivors coexisted and laid eggs for the fall brood. The following spring both queens died.

Colonies of *C. herculeanus*, *C. pennsylvanicus*, *C. noveboracensis*, and *C. modoc* with multiple queens are rare, but have been collected (Akre et al. 1994). For example, colonies of *C. modoc* with two and four functional queens were collected in northeastern Washington (Akre et al. 1994). However, colonies of *C. vicinus* frequently have multiple queens, with as many as 41 collected from a single nest (Akre et al. 1994).

COLONY INITIATION BY USURPATION

Since many species of carpenter ants have multiple satellite colonies, it is probable that new queens usurp some of these satellites in the spring (Akre et al. 1994). Colonies that are initiated by usurpation may have a better chance of survival than those founded by a single queen, because the former have a ready-made worker force to care for the brood, maintain and protect the nest, and forage for food.

REFERENCES CITED

Akre, R. D., L. D. Hansen, and E. A. Myhre. 1994. Colony size and polygyny in carpenter ants (Hymenoptera: Formicidae). J. Kans. Entomol. Soc. 67: 1–9.

Akre, R. D., G. S. Paulson, and E. P. Catts. 1992. Insects did it first. Fairfield, Wash.: Ye Galleon Press.

Brand, J. M., R. M. Duffield, J. G. MacConnell, M. S. Blum, and H. M. Fales. 1973. Caste-specific compounds in male carpenter ants. Science 179: 388–389.

Calabi, P., and P. Nonacs. 1994. Changing colony growth rates in *Camponotus floridanus* as a behavioral response to conspecific presence (Hymenoptera: Formicidae). J. Insect Behav. 7: 17–27.

Cannon, C. A. 1990. Demography, cold hardiness, and nutrient reserves of overwintering nests of the carpenter ant *Camponotus pennsylvanicus* (DeGeer) (Hymenoptera: Formicidae). M.S. thesis, Virginia Polytechnic Institute and State University, Blacksburg.

Cannon, C. A., and R. D. Fell. 1990. Understanding the overwintering carpenter ant nest. Pest Management 9: 12–16.

Cannon, C. A., and R. D. Fell. 1992. Cold hardiness of the overwintering black carpenter ant. Physiol. Entomol. 17: 121–126.

Forbes, J. 1938. Anatomy and histology of the worker of *Camponotus herculeanus pennsylvanicus* DeGeer (Formicidae, Hymenoptera). Ann. Entomol. Soc. Am. 31: 181–195.

Fowler, H. G. 1986. Biology, economics, and control of carpenter ants. *In* S. B. Vinson, ed., Economic impact and control of social insects, pp. 272–289. New York: Praeger.

Freckleton, R., P. H. Harvey, and M. Pagel. 2003. Bergmann's rule and body size in mammals. Am. Nat. 161: 821–825.

Gibson, R. L. 1989. Soldier production in *Camponotus novaeboracensis* during colony growth. Insectes Soc. 36: 28–41.

Gibson, R. L., and J. G. Scott. 1990. Influence of cocoons on egg laying of colony-founding carpenter ant queens (Hymenoptera: Formicidae). Ann. Entomol. Soc. Am. 83: 1005–1009.

Hansen, L. D. 1985. Biology of carpenter ants in Washington State. Ph.D. dissertation, Washington State University, Pullman.

Hansen, L. D., and R. D. Akre. 1985. Biology of carpenter ants in Washington State (Hymenoptera: Formicidae: *Camponotus*). Melanderia 43: 1–62.

Hansen, L. D., and R. D. Akre. 1990. Biology of carpenter ants. *In* R. K. Vander Meer, K. Jaffe, and A. Cedeno, eds., Applied myrmecology: a world perspective, pp. 274–280. Boulder, Colo.: Westview Press.

Hölldobler, B. 1961. Temperaturunabhaengige rhythmische Erscheinungen bei Rossameisenkolonien (*Camponotus ligniperda* Latr. und *Camponotus herculeanus* L.) (Hym., Form.). Insectes Soc. 8: 13–22.

Hölldobler, B. 1962. Zur Frage der Oligogynie bei *Camponotus ligniperda* Latr. und *Camponotus herculeanus* L. (Hym. Formicidae). Z. Angew. Entomol. 49: 337–352.

Hölldobler, B. 1966. Futterverteilung durch Männchen im Ameisenstaat. Z. Vergl. Physiol. 52: 430–455.

Hölldobler, B., and U. Maschwitz. 1965. Der Hochzeitsschwarm der Rossameise *Camponotus herculeanus* L. (Hym. Formicidae). Z. Vergl. Physiol. 50: 551–568.

Hölldobler, B., and E. O. Wilson. 1977. The number of queens: an important trait in ant evolution. Naturwissenschaften 64: 8–15.

Hölldobler, B., and E. O. Wilson. 1990. The ants. Cambridge: Harvard University Press.

Kaspari, M., and E. L. Vargo. 1995. Colony size as a buffer against seasonality: Bergmann's rule in social insects. Am. Nat. 145: 610–632.

Kloft, W., B. Hölldobler, and A. Haisch. 1965. Traceruntersuchungen zur Abgrenzung von Nestarealen holzzerstörender Rossameisen (*Camponotus herculeanus* L. und *C. ligniperda* Latr.). Entomol. Exp. Appl. 8: 20–26.

Klotz, J. H., L. Greenberg, B. L. Reid, and L. Davis Jr. 1998. Spatial distribution of colonies of three carpenter ants, *Camponotus pennsylvanicus*, *Camponotus floridanus*, *Camponotus laevigatus* (Hymenoptera: Formicidae). Sociobiology 32: 51–62.

Lloyd, H. A., M. S. Blum, and R. M. Duffield. 1975. Chemistry of the male mandibular gland secretion of the ant, *Camponotus clarithorax*. Insect Biochem. 5: 489–494.

Mankowski, M. E. 2002. Effect of substrate type and moisture requirements in relation to colony initiation in two carpenter ant species. Ph.D. dissertation, Oregon State University, Corvallis.

Mayr, E. 1956. Geographical character gradients and climatic adaptation. Evolution 10: 105–108.

Mintzer, A. 1979. Colony foundation and plemetrosis in *Camponotus* (Hymenoptera: Formicidae). Pan-Pac. Entomol. 55: 81–89.

Nonacs, P. 1991. Less growth with more food: how insect-prey availability changes colony demographics in the ant: *Camponotus floridanus*. J. Insect Physiol. 37: 891–898.

Nonacs, P., and P. Calabi. 1992. Competition and predation risk: their perception alone affects ant colony growth. Proc. R. Soc. Lond. 249: 95–99.

Payne, T. L., M. S. Blum, and R. M. Duffield. 1975. Chemoreceptor responses of all castes of a carpenter ant to male-derived pheromones. Ann. Entomol. Soc. Am. 68: 385–386.

Pricer, J. L. 1908. The life history of the carpenter ant. Biol. Bull. 14: 177–218.

Sanders, C. J. 1964. The biology of carpenter ants in New Brunswick. Can. Entomol. 96: 894–909.

Sanders, C. J. 1970. The distribution of carpenter ant colonies in the spruce-fir forests of northwestern Ontario. Ecology 51: 865–873.

Sanders, C. J. 1971. Aggregation of alate carpenter ants in Ontario. Proc. Entomol. Soc. Ont. 102: 13–16.

Skaife, S. H. 1961. The study of ants. London: Longmans.

Smith, F. 1942. Effect of reduced food supply upon the stature of *Camponotus* ants (Hymen.: Formicidae). Entomol. News 53: 133–135.

Torres, J., R. R. Snelling, M. S. Blum, R. C. Flournoy, T. H. Jones, and R. M. Duffield. 2001. Mandibular gland chemistry of four Caribbean species of *Camponotus* (Hymenoptera: Formicidae). Biochem. Syst. Ecol. 29: 673–680.

Vanderschaaf, P. 1970. Polymorphism, oviposition by workers, and arrested larval development in the carpenter ant, *Camponotus pennsylvanicus*, DeGeer (Hymenoptera: Formicidae). Ph.D. dissertation, Kansas State University, Manhattan.

Wheeler, D. E. 1994. Nourishment in ants: patterns in individuals and societies. *In* J. H. Hunt, and C. D. Nalepa, eds., Nourishment and evolution in insect societies, chap. 8. Boulder, Colo.: Westview Press.

Wheeler, G. C., and J. Wheeler. 1976. Ant larvae: review and synthesis. Memoirs of the Entomological Society of Washington, No. 7. Washington, D.C.: Entomological Society.

CHAPTER 5

Foraging

Carpenter ant colonies can have more than 100,000 workers (Akre et al. 1994) and life spans that exceed 10 years (Hansen and Akre 1990). To sustain colonies of this size and longevity, worker ants disseminate from the nest in search of food. Their navigational skills are remarkable, especially since many species are nocturnal. They establish a network of trails, linking their nests and feeding sites, that are used year after year (David and Wood 1980, Hansen and Akre 1985).

TRAILS

Due to intraspecific and interspecific competition for limited resources, carpenter ants have evolved a variety of behaviors that enable them to exploit food quickly and efficiently. The physicochemical trails they construct facilitate rapid transit to and from the nest to both semipermanent and ephemeral resources. A well-worn path to a tree harboring aphid colonies might be used year after year, while a fresh pheromone deposit leads a new recruit to recently discovered prey.

PHYSICAL TRAILS OF CAMPONOTUS MODOC

The trails of *C. modoc* Wheeler are both above and below ground (Hansen and Akre 1985). Surface trails are often covered with fir needles to create a canopy (Fig. 5.1). Subterranean trails follow tree roots, where ants forage on aphids and other fauna. The ants will use excavated sawdust to construct an enclosed tubular pathway, particularly along stacked boards or

Figure 5.1. A trail covered with fir needles constructed by *Camponotus modoc.*

sill plates. They rebuild many of the same surface and subterranean trails in spring that they used the previous year. In one case, they constructed a narrow trail 1 cm wide by the end of April, and they expanded it to 3 cm by June (Figs. 5.2, 5.3). In open fields or lawns, the ants cut a swath through the grass (Fig. 5.4). In Washington, subterranean trails are common at depths of 5 to 25 cm (Fig. 5.5) and are frequently lined with sawdust from the nest. One trail was found 1.2 m deep when tree roots were cut to install utility pipes.

In urban areas, workers of *C. modoc* tunnel under patio blocks, sidewalks, and driveways (Hansen and Akre 1985). Adjacent to structures, they trail along the edges of lawns, pavement, foundations, garden hoses, and landscaping timbers (Fig. 5.6). Inside structures they follow the edges of floors, cabinets, and furniture (Fig. 5.7). Within walls, they excavate through insulation (Fig. 5.8) and follow utility lines. Trailing on structural elements is an adaptation derived from the natural proclivity of ants to

Figure 5.2. The beginning of trail construction in early spring by *Camponotus modoc*. Note the narrowness of this early trail.

follow guidelines such as tree branches and the ridges and grooves in bark. Their use of these physical guidelines conserves foraging time (Klotz et al. 2000).

CONSTRUCTION BY *CAMPONOTUS MODOC*

Trails are constructed mainly at night by workers of all sizes (Hansen and Akre 1985). The tasks include cutting blades of grass, removing dead grass, excavating small pebbles and soil, carrying away debris, and dragging needles from evergreens over the trail to make a canopy. Workers carry excavated material 1 to 6 cm away from the trail and discard it. Ants

Figure 5.3. A well-established trail of *Camponotus modoc* in late summer.

Figure 5.4. A trail constructed by *Camponotus modoc* through dense turf.

Figure 5.5. An underground trail constructed by *Camponotus modoc* following a log.

Figure 5.6. Workers of *Camponotus modoc* trailing along the edge of a bender board used in landscaping.

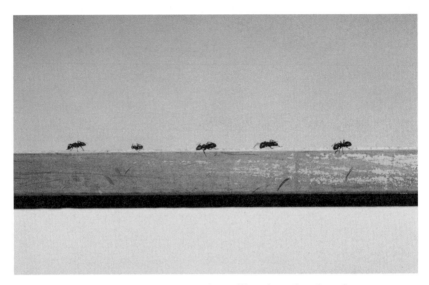

Figure 5.7. Workers of *Camponotus modoc* trailing along the edge of a counter top.

Figure 5.8. A trail constructed by *Camponotus modoc* through insulation in a wall void.

leaving the nest to forage become involved in trail construction for one to five minutes. Returning ants help only when debris has fallen in their path.

CHEMICAL TRAILS AND RECRUITMENT

The methods used to recruit carpenter ants to food sources range from primitive tandem running, to group recruitment, to more advanced behaviors (Hölldobler and Wilson 1990). In tandem running, a scout leads while a follower maintains antennal contact with her. In group recruitment, a scout leads 5 to 30 followers to the food. Several species of *Camponotus* use group recruitment (Hölldobler and Wilson 1990). In *C. socius* Roger, a scout deposits a trail of hindgut material from the site of the food to the nest (Hölldobler 1971). After stimulating workers by a "waggle" display, she leads up to 30 ants to the food along the trail. The major component of the hindgut material is a pheromone, 2,4-dimethyl-5-hexanolide, that serves as an orientation cue. The lead ant also secretes formic acid from the poison gland, which induces the recruited ants to follow the trail (Kohl et al. 2001).

A more advanced form of recruitment is used by *C. pennsylvanicus* (DeGeer), in which a scout's guidance is no longer needed (Traniello 1977). The scout deposits a hindgut trail by dragging the tip of her gaster over the substrate (Fig. 5.9), leaving a series of parallel streaks produced by a group of hairs ventral to the acidopore (Hartwick et al. 1977, Traniello 1977). When she encounters nestmates, she performs a waggle display consisting of rapid movements of the head and thorax in a horizontal plane, followed by food exchange. After a fast run, she repeats the waggle and food exchange to other groups of ants. Recruited ants leave the nest and follow the trail, which consists of hindgut material and formic acid

Figure 5.9. A carpenter ant depositing a hindgut trail.

(Traniello 1977), and possibly secretions from Dufour's gland (Hillery and Fell 2000). In analyses of the contents of Dufour's glands in *C. herculeanus* (L.), *C. pennsylvanicus*, and *C. americanus* Mayr, *n* -undecane was the main component; it acts as a mild attractant and as a strong synergist with formic acid in attracting and settling ants (Ayre and Blum 1971). The trail pheromone of *C. pennsylvanicus* is not species-specific, as *C. americanus* will also follow it (Barlin et al. 1976). Workers of *C. modoc* also orient to hindgut extract, which remains active for up to two hours (Hansen and Akre 1985).

Mass communication by chemicals, the most advanced form of recruitment, probably exists in the subfamily Formicinae but has not been documented (Hölldobler and Wilson 1990). Here the trail pheromone by itself stimulates recruitment, with the number of ants following it being a linear function of the amount of pheromone (Wilson 1971).

ORIENTATION

The physical and chemical aspects of their trails provide carpenter ants with cues for orientation. Tactile and olfactory cues are clearly important because of the low light conditions under which many species must forage. Thus, the odor trail is a primary orientation cue for members of *C. pennsylvanicus*; however, they also use visual cues such as landmarks and directional light from the sun, moon, and artificial sources, and in total darkness orient along structural guidelines (Hartwick et al. 1977, David and Wood 1980, Klotz 1985, Klotz and Reid 1992, 1993).

The Swiss psychiatrist and myrmecologist Auguste Forel (1929) proposed that ants could also navigate using a topochemical sense, capable of recalling "smells as round, square, elongated, hard, soft, etc., and as having a certain height, and being in a certain direction." Indeed, *C. pennsylvanicus* can learn to use both substrate and airborne chemical cues from plants for orientation (Helmy and Jander 2003). This chemical knowledge might be organized into a topochemical map that the ants use for locating resources. For example, the odorants released by plants under attack by homopterans could signal the location of honeydew.

Within this assembly of cues, there is built-in redundancy. Foraging ants rely on more than one cue. For instance, a forager can use an odor trail as well as a light source to orient. As a consequence, the ants possess backup cues with which they can orient in the absence of any one particular cue. This arrangement provides carpenter ants with the ability to forage in daylight and total darkness.

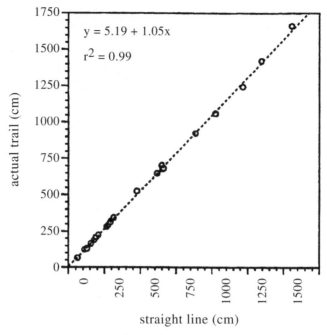

Figure 5.10. The relationship between the actual trail length that *Camponotus pennsylvanicus* and *C. floridanus* followed, to the straight-line distance of the same trail. The straight trails in open, featureless terrain suggest that the ants use vector orientation.

There are differences in the behavior of *C. modoc* on trails at night versus day (Hansen and Akre 1985). During daytime, workers run short distances of 10 to 15 cm and stop briefly, while at night they move at a steady pace without stopping. The difference in locomotory behavior may be a function of the sensory modality the ants are using at a particular time of day. During daytime they might depend more on vision for orientation, while at night olfaction predominates.

In open areas carpenter ants form trails in a straight line (Fig. 5.10), indicating that workers can use vector orientation. But when structural guidelines are present, the ants follow them (Fig. 5.11). In crest-line trailing, carpenter ants follow natural guidelines such as tree branches or structural elements such as conduits, pipes, and wires. The ants oscillate from side to side of the guideline's crest, turning upslope after reaching a particular downslope (Fig. 5.12) (Klotz et al. 1985). This geoklinotaxis was demonstrated with *C. pennsylvanicus* trailing on the surface of two

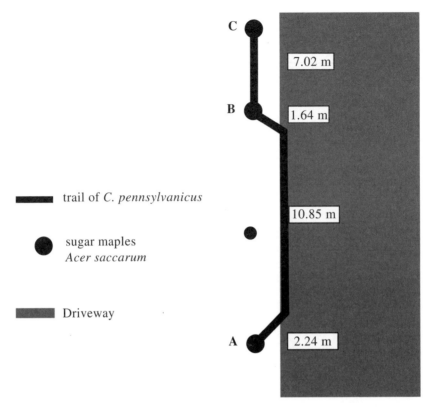

Figure 5.11. A trail of *Camponotus pennsylvanicus* through mowed grass and along the edge of a driveway and between sugar maple trees. The time required to travel 1 m on the mowed grass was more than twice that for ants trailing the same distance along the edge of the paved driveway.

paper tubes, one twice the diameter of the other. The oscillation amplitude of the ant on the larger tube was twice that on the smaller tube.

FORAGING POPULATION

By most estimates the foraging force makes up only a small fraction of the colony. But these estimates are problematic because although mark-recapture studies can be used to assess the foraging population, in order to estimate the size of the colony one must excavate the entire nest—a difficult and laborious task.

Figure 5.12. Crest-line orientation of *Camponotus pennsylvanicus* on a cylindrical surface.

What little research has been done on this topic suggests that the foragers represent only a small percentage of the total colony population. Ayre (1962) attempted to measure the size of *C. herculeanus* laboratory colonies by mark-recapture and obtained estimates of the foraging population that were less than 10% of the total colony size. Tripp et al. (2000) used mark-recapture and estimated that four field colonies of *C. pennsylvanicus* had average foraging populations of 1166, 1877, 1329, and 364. Using estimates of 15,000 workers in a mature colony, Akre et al. (1994) determined that foraging populations in this species also account for less than 10% of the total colony population. These percentages, however, are likely to fluctuate depending on the nutritional needs of the colony (Traniello 1989).

The foraging population is relatively resilient to perturbations. Upon leaving the protective confines of the nest, foragers are vulnerable to predation. The loss of foragers may be considerable, since *Camponotus* spp. are a major dietary component of some birds.

In simulated predation experiments, Fowler (1984) removed various numbers of foragers from colonies of *C. pennsylvanicus*. Only under heavy predation (removal of 100 foragers once a month for two months) was foraging intensity affected. At lower rates of removal of the same number of ants (50 every two weeks and 25 every week for two months), the ants lost were quickly replaced by new foragers.

SIZE DIFFERENCES IN WORKERS

Certain individuals in the foraging population perform specific tasks. For example, the smallest workers of *C. pennsylvanicus* guard aphids while

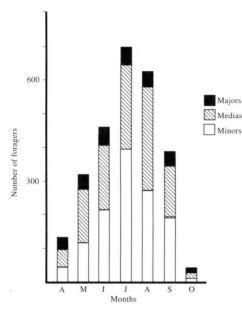

Figure 5.13. Monthly activity of *Camponotus modoc* showing average numbers of major, media, and minor workers on 11 trails from April through October. Counts were made biweekly for 15-minute intervals every 4 hours for 24 hours. Total number of trail counts was 154.

larger workers transport honeydew (Fowler and Roberts 1980), and in *C. noveboracensis* (Fitch) sap collectors are larger than honeydew collectors (Gotwald 1968).

A preponderance of small- to medium-sized workers makes up the foraging populations of *C. noveboracensis* and *C. americanus* (Buckingham 1911). Media and minor workers of *C. modoc* make up the largest percentage of foraging ants in every month except October, when there is a higher percentage of majors (Fig. 5.13) (Hansen and Akre 1985). A higher percentage of major workers also occurs early in the season.

There are also differences in the circadian rhythm of *C. modoc* workers. The percentage of major workers is higher from 4 to 8 a.m. and from 8 a.m. to 12 noon, while the relative percentage of medias and minors remains constant (Fig. 5.14) (Hansen and Akre 1985).

ACTIVITY RHYTHMS

Foraging activity is affected by temperature, water stress, and other physical factors (Traniello 1989). It also varies with species and location. The

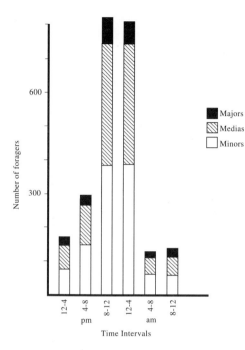

Figure 5.14. Diel activity of *Camponotus modoc* showing average numbers of major, media, and minor foragers on 11 trails. Counts were made biweekly from April to October for 15-minute intervals every 4 hours. Total number of trail counts was 154.

biological clocks of ants are attuned to the daily and seasonal fluctuations of abiotic factors, such as light intensity and temperature, and biotic factors, such as resources and stress sources. Their activity rhythms are not rigidly set but can change in response to environmental conditions and colony demands. Abiotic factors provide the ants with proximal cues to set their clocks, while biotic factors such as predation and competition shape the particular rhythm of each species. For example, the nocturnal activity of *C. pennsylvanicus* appears to be triggered by light intensity, with two peaks of activity, one right after sunset and one right before sunrise (Fig. 5.15) (Nuss et al., unpubl. data, 1999). The adaptive significance of this behavior is probably to reduce the risk of predation by birds and competition from diurnal species of ants. In Kansas, for example, *C. pennsylvanicus* and *Formica subsericea* Say share the same aphid colonies by foraging at different times of the day (Klotz 1984). A similar situation occurs with *C. floridanus* (Buckley) and *C. socius* in Florida, where the latter is primarily diurnal and the former nocturnal (Hölldobler and Wilson 1990).

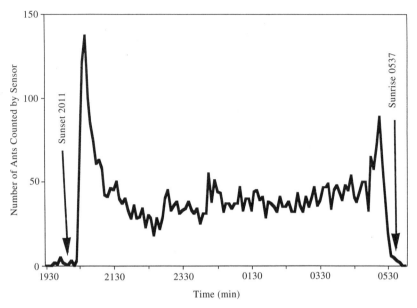

Figure 5.15. Typical nocturnal rhythm of *Camponotus pennsylvanicus* foragers. Note the increase in the number of ants counted just after sunset and just before sunrise. Courtesy of A. B. Nuss and D. R. Suiter, University of Georgia, Griffin, GA, and G. W. Bennett, Purdue University, West Lafayette, Indiana.

CAMPONOTUS MODOC

In western Washington State, foraging of *C. modoc* begins in April or May, when the average daily temperature ranges from 10.0°C to 13.9°C, and ends in October, with peak activity in June through August (Fig. 5.13) (Hansen and Akre 1985). Foraging has been reported in December during unseasonably high temperatures. In eastern Washington, the foraging season is shorter, from May through August. At the beginning and end of the season in California, foragers are active throughout the day, but in July and August they are primarily nocturnal (David and Wood 1980).

In western Washington, most foraging activity takes place from 8 P.M. to 4 A.M. (Hansen and Akre 1985). The least activity is between 4 A.M. and 12 noon (Fig. 5.14). A burst of activity occurs 5 to 10 minutes after sunset, when light intensity drops to 0 foot candles (fc). A precipitous drop in activity occurs around sunrise (Fig. 5.16), when the light intensity increases to 1 to 7 fc, 8 to 10 minutes after sunrise. During the

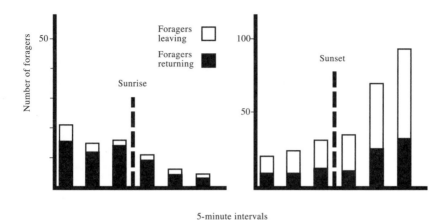

5-minute intervals

Figure 5.16. Average foraging activity of *Camponotus modoc* at 5-minute intervals before and after sunrise and sunset on two trails in Spokane, Washington. Six counts were made at each time interval spanning sunrise and 7 counts were made at each time interval spanning sunset.

rest of the day the number of ants leaving and returning to the nest is constant.

Temperatures recorded at peak foraging times (8 P.M. to 4 A.M.) at the height of the season (May through September) range from 8.5°C to 25.3°C. Relative humidity does not seem to affect foraging activity, which continues even during rain. Vegetation and excavations by the ants protect the trails.

OTHER SPECIES

Camponotus vicinus Mayr is a cryophilic species that starts foraging when the temperature is just above freezing and stops at about 20°C (Hölldobler and Wilson 1990). Among 20 species of ants in 11 communities that were surveyed in the Mojave and Great Basin Deserts, *C. vicinus* had the lowest temperature range (2.2°C to 23.3°C) and was one of three primarily nocturnal species (Bernstein 1979).

Foraging activity of *C. herculanus*, *C. noveboracensis*, and *C. pennsylvanicus* in northwestern Ontario begins in May, and its onset is temperature dependent (Sanders 1972). Peak activity occurs in June and early July. Daily patterns peak in midafternoon in early June and gradually shift

into the night as the season progresses. Foraging activity stops in October, independent of temperature.

The foraging activity of a colony of *C. noveboracensis* in New York was diurnal when honeydew was collected, and crepuscular and nocturnal when sap was collected (Gotwald 1968). Foraging decreased with lower temperature and increased wind velocity, and stopped when it rained. Wind disrupted foraging by blowing both the ants and the membracids they were tending off the trees.

Foraging by *C. pennsylvanicus* also stops when it rains (Fowler and Roberts 1980, Klotz 1984). Temperature is most closely correlated with the foraging activity of *C. pennsylvanicus* from mid-June through October in Indiana, but night length and wind speed are also correlated (Nuss et al., unpubl. data, 1999). Ants travel faster as temperature increases and are therefore able to make more foraging trips on warmer evenings (Nuss et al., unpubl. data, 1999). Temperature and saturation deficit were strongly linked to foraging activity of *C. pennsylvanicus* in New Jersey (Fowler and Roberts 1980). The peak activity occurred in July, which may be correlated with brood maturation.

FEEDING

As a result of their long-term mutualistic association with homopterans, carpenter ants have developed specialized digestive tracts and feeding behaviors to collect, transport, and share honeydew. Indeed, they are uniquely adapted for handling liquid foods such as honeydew, a major dietary component that is rich in carbohydrates. To meet the protein demands of the colony, foragers can also be effective predators and scavengers. In addition, foraging workers can be opportunistic feeders, which is why they become nuisance pests in our homes.

DIET

Carpenter ants feed on homopteran honeydew, plant exudates, and animals, particularly insects (Figs. 5.17, 5.18). They scavenge on carcasses of dead vertebrates and are important predators of the western spruce budworm in Oregon and Montana (Youngs and Campbell 1984). However, in northwestern Ontario they are not major predators of spruce budworm,

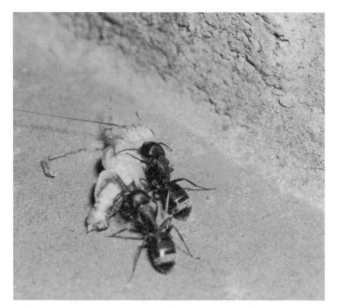

Figure 5.17. Workers of *Camponotus modoc* preying on a cricket.

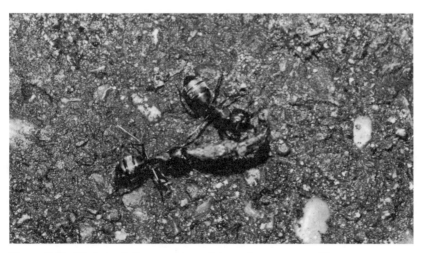

Figure 5.18. Workers of *Camponotus modoc* preying on a caterpillar.

Figure 5.19. A worker of *Camponotus modoc* carrying insect prey in her mandibles.

suggesting that across their geographic range carpenter ants may be of limited importance in biological control (Sanders and Pang 1992).

Camponotus modoc preys mostly on arthropods, including grasshoppers, crickets, leafhoppers, aphids, crane flies, mosquitoes, honeybees, moisture ants, thatching ants, spiders, harvestmen, and larvae of Lepidoptera, Diptera, and Hymenoptera (Hansen and Akre 1985). However, only about 1% of foragers carry prey (Hansen and Akre 1985). Solid food is carried in the mandibles (Fig. 5.19).

Although *Camponotus* spp. will fortuitously prey on termites (Beard 1973, Hölldobler and Wilson 1990), there are few records of this. Van Pelt (1958) suggested that termites might be food for *C. floridanus*, which nests in the same type of wood. If a log where the two are nesting together is broken open, the ants carry off the termites in their mandibles.

Carpenter ants are found foraging in and around structures, feeding on many different kinds of food, including candy, honey, syrup, soda pop, apples, raisins, cakes, pastries, and pet food (Fig. 5.20) (Hansen and Akre 1985).

Figure 5.20. Workers of *Camponotus modoc* foraging on doughnuts.

FOOD CONSUMPTION

The black carpenter ant, *C. pennsylvanicus*, has a distinct cycle of protein consumption that coincides with brood production in the summer and fall (Cannon and Fell 2002). Soluble proteins and amino acids are fed to the larvae by the workers, who lack the necessary endopeptidases for digestion (Stradling 1978). The quantity and quality of nitrogen in the proteins and amino acids fed to the larvae are the key factors for their growth and development (Hagen et al. 1984). The consumption of carbohydrates, on the other hand, is relatively constant and more than twice as high as that of protein (Cannon and Fell 2002). Carbohydrates are the primary energy source for adults (Abbott 1978).

TROPHALLAXIS

Most of the food brought into a carpenter ant nest is in liquid form. The role of trophallaxis in the distribution of this liquid food among workers and from workers to larvae and the queen has long been recognized as

Figure 5.21. Trophallaxis between *Camponotus modoc* workers on the surface of a nest.

contributing to a fundamental bond in the social behavior of ants (Fig. 5.21) (Hölldobler and Wilson 1990). In trophallaxis, liquid food stored in the crop of a worker is regurgitated and shared with other colony members. The crop, therefore, is called a "social stomach." As the crop fills, the segments of the gaster expand, thereby exposing integument that is normally hidden from view by the overlapping terga and sterna (Fig. 5.22). These areas lack pubescence and give the gaster a striped appearance.

The capacity to store liquid depends on the proventriculus, which regulates the amount of food passing from the crop into the midgut. The crop-filling capacity of *C. mus* Roger, a South American species, increases with increasing concentration of sucrose, reaching a maximum at 42.6% w/w (Josens et al. 1998). Crop-filling rate also increases with increasing concentration of sucrose up to a limit (30.8% w/w) and then declines, owing to viscosity. Hemolymph and water-soluble proteins are also transported in the crop, but solid proteins are not (Ayre 1963, Cannon and Fell 2002).

In *C. pennsylvanicus*, particles 200 μm or larger are excluded by the mouthparts, and 150-μm particles are prevented from entering the crop by

Figure 5.22. Workers of *Camponotus modoc* with normal (worker on left) and distended gasters.

filtration of the infrabuccal cavity. Particles from 10 to 100 μm that are ingested are progressively removed as food is passed from one worker to another (Eisner and Happ 1962).

Many species of ants intermittently eject the contents of the infrabuccal pocket. In laboratory colonies of *C. modoc* and *C. vicinus*, however, ejection of the food pellet is infrequent. In fact, a food pellet can be retained within the pocket for several days, where enzyme activity aids in the digestion of solid materials (Hansen et al. 1999).

HOME RANGE

Like all ants, carpenter ants are central-place foragers. Workers leave the nest to find food and then return with it to provide for the colony. The distance traveled to obtain food varies. For example, surface trails of *C. modoc* in California were 200 m long (David and Wood 1980), and the total length of tunnels for a *C. herculeanus* colony in Ontario was 185 m (Sanders 1970). The daily range of the colony's forays defines the home range or territory. As the colony grows in size, its territory expands to accommodate the increasing numbers of ants. At maturity, a colony may

become polydomous, occupying more than one nest. The satellite nests extend the territory of the colony, sometimes resulting in disputes with other ants and other colonies.

SIZE

Exact measurements of a colony's home range are difficult to determine because it varies depending on internal factors such as the colony's resource demand and external factors such as resource availability and interactions with other ants. Under normal conditions, carpenter ant colonies live side by side, coexisting even at high densities (Klotz et al. 1998).

To estimate territory size, agonistic tests are conducted to group individuals from various nests. A worker from one nest is carefully introduced into a container with an ant from a different nest. Interactions are either aggressive (mandibular grasping, gaster flexing) (Fig. 5.23) or nonaggres-

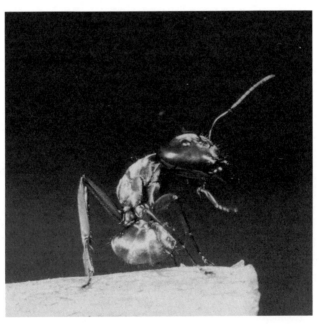

Figure 5.23. *Camponotus sericeus* Fabricius in a defensive posture spraying formic acid. Photograph by Roger D. Akre.

sive (licking, trophallaxis) as described by Morel and Blum (1988). If there is no aggression between ants, they are nestmates. If there is mild or intense aggression, the ants are from different colonies.

In Florida, a 0.5-hectare tract of sandhill was populated by 20 nests of *C. floridanus* (Klotz et al. 1998). Seven of these were unrelated to other nests and thus constituted individual colonies, with populations ranging from 154 to 2379. An eighth colony consisted of three nests, with a worker population of 2731, occupying a territory approximately 15.8 m across. The ninth colony resided in 10 distinct nest sites, was populated by 8099 workers, and was spread over an area measuring 43 m across. Only 7 of the 20 nests were located in natural sites, such as beneath logs or in hollow tree stumps. The remaining 13 were in trash.

In an area of similar size in Indiana, a 0.4-hectare cemetery plot bounded on all sides by a road, *C. pennsylvanicus* was found to be active in or on 24 of the 29 trees in the plot, represented by seven distinct colonies (Klotz et al. 1998). Each colony occupied from 1 to 6 trees (average of 3.8 trees), spread over an area 6 to 28 m across (average of 16.3 m). All of the colonies were nesting within hollows of standing trees.

The distribution of nests of *C. laevigatus* (Fr. Smith) in an 8.1-hectare plot in the San Bernardino National Forest had a different pattern (Klotz et al. 1998). With the exception of one nest in a standing dead pine tree, all 17 colonies were in fallen logs in early stages of decay (Fig. 5.24). Only one satellite colony was found. Ants from two related nests were living in two logs that were nearly touching end to end.

DISPUTES

There are few accounts of territorial skirmishes between colonies of carpenter ants. In the Pacific Northwest, *C. modoc* colonies have been seen in territorial conflicts, with some workers locked in combat and others injured and dead (Fig. 5.25) (Akre et al. 1995). In one case, workers faced off along the top of a large log for approximately 25 m, with several engaged in mandibular combat and spraying formic acid. The others faced each other in the typical threat posture. The battle continued on the second day. By the fifth day all workers were gone except for the scattered dead.

Workers in colonies of *C. festinatus* (Buckley) instantly evacuate the nest, carrying their brood, when they encounter army ants, *Neivamyrmex nigrescens* (LaMon and Topoff 1981, Topoff 1987). Contact with a single army ant is sufficient to initiate evacuation. The ants apparently sense the

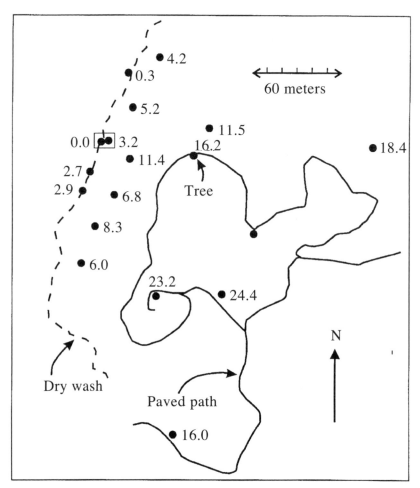

Figure 5.24. Map of Children's Forest in the San Bernardino National Forest, the study site for *Camponotus laevigatus*. Each point on the map shows one colony. The numbers next to each point show the altitude in meters with respect to the lowest point. The smallest box around two of the points indicates the only two sites with nonaggressive worker interactions.

army ants by a combination of chemical cues and movement. In contrast, colonies of *C. ocreatus* Emery and *C. vicinus* defend their nests by recruiting major workers to the nest entrance to aggressively attack the army ants.

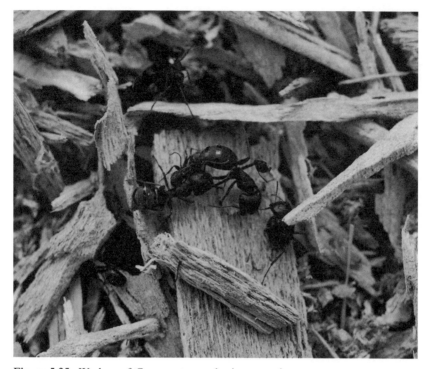

Figure 5.25. Workers of *Camponotus modoc* in aggressive encounters.

REFERENCES CITED

Abbott, A. 1978. Nutrient dynamics of ants. *In* M. V. Brian, ed., Production ecology of ants and termites, pp. 233–244. Int. Biol. Prog. 13. London: Cambridge University.

Akre, R. D., L. D. Hansen, and E. A. Myhre. 1994. Colony size and polygyny in carpenter ants (Hymenoptera: Formicidae). J. Kans. Entomol. Soc. 67: 1–9.

Akre, R. D., L. D. Hansen, and E. A. Myhre. 1995. My house or yours? The biology of carpenter ants. Ann. Entomol. Soc. Am. 41: 221–226.

Ayre, G. L. 1962. Problems in using the Lincoln Index for estimating the size of ant colonies (Hymenoptera: Formicidae). J. N.Y. Entomol. Soc. 70: 159–166.

Ayre, G. L. 1963. Feeding behavior and digestion in *Camponotus herculeanus* (L.) (Hymenoptera, Formicidae). Entomol. Exp. Appl. 6: 165–170.

Ayre, G. L., and M. S. Blum. 1971. Attraction and alarm of ants (*Camponotus* spp. Hymenoptera: Formicidae) by pheromones. Physiol. Zool. 44: 77–83.

Barlin, M. R., M. S. Blum, and J. M. Brand. 1976. Species-specificity studies on the trail pheromone of the carpenter ant, *Camponotus pennsylvanicus* (Hymenoptera: Formicidae). J. Ga. Entomol. Soc. 11: 162–164.

Beard, R. L. 1973. Ants as predators of *Reticulitermes flavipes*. Environ. Entomol. 2: 397–399.

Bernstein, R. A. 1979. Schedules of foraging activity in species of ants. J. Anim. Ecol. 48: 921–930.

Buckingham, E. N. 1911. Division of labor among ants. Proc. Am. Acad. Arts Sci. 46: 425–507.

Cannon, C. A., and R. D. Fell. 2002. Patterns of macronutrient collection in the black carpenter ant, *Camponotus pennsylvanicus* (DeGeer) (Hymenoptera: Formicidae). Environ. Entomol. 31: 977–981.

David, C. T., and D. L. Wood. 1980. Orientation to trails by a carpenter ant, *Camponotus modoc* (Hymenoptera: Formicidae), in a giant sequoia forest. Can. Entomol. 112: 993–1000.

Eisner, T., and G. M. Happ. 1962. The infrabuccal pocket of a formicine ant: a social filtration device. Psyche 69: 107–116.

Forel, A. 1929. The social world of the ants. New York: Albert and Charles Boni.

Fowler, H. G. 1984. Colony-level regulation of forager caste ratios in response to caste perturbations in the carpenter ant, *Camponotus pennsylvanicus* (DeGeer) (Hymenoptera: Formicidae). Insectes Soc. 31: 461–472.

Fowler, H. G., and R. B. Roberts. 1980. Foraging behavior of the carpenter ant, *Camponotus pennsylvanicus*, (Hymenoptera: Formicidae) in New Jersey. J. Kans. Entomol. Soc. 53: 295–304.

Gotwald, W. H., Jr. 1968. Food gathering behavior of the ant, *Camponotus noveboracensis* (Fitch) (Hymenoptera: Formicidae). J. N.Y. Entomol. Soc. 76: 278–296.

Hagen, K. S., R. H. Dadd, and J. Reese. 1984. The food of insects. *In* C. B. Huffaker and R. L. Rabb, eds., Ecological entomology, pp. 79–112. New York: Wiley.

Hansen, L. D., and R. D. Akre. 1985. Biology of carpenter ants in Washington State (Hymenoptera: Formicidae: *Camponotus*). Melanderia 43: 1–62.

Hansen, L. D., and R. D. Akre. 1990. Biology of carpenter ants. *In* R. K. Vander Meer, K. Jaffe, and A. Cedeno, eds., Applied myrmecology: a world perspective, pp. 274–280. Boulder, Colo.: Westview Press.

Hansen, L. D., W. J. Spangenberg, and M. M. Gaver. 1999. The infrabuccal chamber of *Camponotus modoc* (Hymenoptera: Formicidae): ingestion, digestion, and survey of bacteria. *In* W. H. Robinson, F. Rettich, and G. W. Rambo, eds., Proceedings of the 3rd International Conference on Urban Pests, pp. 211–219. Grafické závody Hronov, Czech Republic.

Hartwick, E. B., W. G. Friend, and C. E. Atwood. 1977. Trail-laying behavior of the carpenter ant, *Camponotus pennsylvanicus* (Hymenoptera: Formicidae). Can. Entomol. 109: 129–136.

Helmy, O., and R. Jander. 2003. Topochemical learning in black carpenter ants (*Camponotus pennsylvanicus*). Insectes Soc. 50: 32–37.

Hillery, A. E., and R. D. Fell. 2000. Chemistry and behavioral significance of rectal and accessory gland contents in *Camponotus pennsylvanicus* (Hymenoptera: Formicidae). Ann. Entomol. Soc. Am. 93: 1294–1299.

Hölldobler, B. 1971. Recruitment behavior in *Camponotus socius* (Hym. Formicidae). Z. Vergl. Physiol. 75: 123–142.

Hölldobler, B., and E. O. Wilson. 1990. The ants. Cambridge: Harvard University Press.

Josens, R. B., W. M. Farina, and F. Roces. 1998. Nectar feeding by the ant *Camponotus mus*: intake rate and crop filling as a function of sucrose concentration. J. Insect Physiol. 44: 579–585.

Klotz, J. H. 1984. Diel differences in foraging in two ant species (Hymenoptera: Formicidae). J. Kans. Entomol. Soc. 57: 111–118.

Klotz, J. H. 1985. Topographic orientation in four species of ants. Ph.D. dissertation, University of Kansas, Lawrence.

Klotz, J. H., S. L. Cole, and H. R. Kuhns. 1985. Crest-line orientation in *Camponotus pennsylvanicus* (DeGeer). Insectes Soc. 32: 305–312.

Klotz, J. H., L. Greenberg, B. L. Reid, and L. Davis Jr. 1998. Spatial distribution of colonies of three carpenter ants, *Camponotus pennsylvanicus*, *Camponotus floridanus*, *Camponotus laevigatus* (Hymenoptera: Formicidae). Sociobiology 32: 51–62.

Klotz, J. H., and B. L. Reid. 1992. The use of spatial cues for structural guideline orientation in *Tapinoma sessile* and *Camponotus pennsylvanicus*. J. Insect Behav. 5: 71–82.

Klotz, J. H., and B. L. Reid. 1993. Nocturnal orientation in the black carpenter ant *Camponotus pennsylvanicus* (DeGeer) (Hymenoptera: Formicidae). Insectes Soc. 40: 95–106.

Klotz, J., B. Reid, and J. Hamilton. 2000. Locomotory efficiency in ants using structural guidelines (Hymenoptera: Formicidae). Sociobiology 35: 79–88.

Kohl, E., B. Hölldobler, and H. J. Bestmann. 2001. Trail and recruitment pheromones in *Camponotus socius* (Hymenoptera: Formicidae). Chemoecology 11: 67–73.

LaMon, B., and H. Topoff. 1981. Avoiding predation by army ants: defensive behaviours of three ant species of the genus *Camponotus*. Anim. Behav. 29: 1071–1081.

Morel, L., and M. S. Blum. 1988. Nestmate recognition in *Camponotus floridanus* callow worker ants: are sisters or nestmates recognized? Anim. Behav. 36: 718–725.

Sanders, C. J. 1970. The distribution of carpenter ant colonies in the spruce-fir forests of northwestern Ontario. Ecology 51: 865–873.

Sanders, C. J. 1972. Seasonal and daily activity patterns of carpenter ants (*Camponotus* spp.) in northwestern Ontario (Hymenoptera: Formicidae). Can. Entomol. 104: 1681–1687.

Sanders, C. J., and A. Pang. 1992. Carpenter ants as predators of spruce budworm in the boreal forest of northwestern Ontario. Can. Entomol. 124: 1093–1100.

Stradling, D. J. 1978. Food and feeding habits of ants. *In* M. V. Brian, ed., Production ecology of ants and termites, pp. 81–106. Intl Biol. Prog. 13. London: Cambridge University.

Topoff, H. 1987. Ant wars. Nat. Hist. 96: 63–66, 68, 70–71.

Traniello, J. F. A. 1977. Recruitment behavior, orientation and the organization of foraging in the carpenter ant *Camponotus pennsylvanicus* DeGeer (Hymenoptera: Formicidae). Behav. Ecol. Sociobiol. 2: 61–79.

Traniello, J. F. A. 1989. Foraging strategies of ants. Annu. Rev. Entomol. 34: 191–210.

Tripp, J. M., D. R. Suiter, G. W. Bennett, J. H. Klotz, and B. L. Reid. 2000. Evaluation of control measures for black carpenter ant (Hymenoptera: Formicidae). J. Econ. Entomol. 93: 1493–1497.

Van Pelt, A. F. 1958. The ecology of the ants of the Welaka Reserve, Florida (Hymenoptera: Formicidae). Part II. Annotated list. Am. Midl. Nat. 59: 1–47.

Wilson, E. O. 1971. The insect societies. Cambridge: Harvard University Press.

Youngs, L. C., and R. W. Campbell. 1984. Ants preying on pupae of the western spruce budworm, *Choristoneura occidentalis* (Lepidoptera: Tortricidae), in eastern Oregon and western Montana. Can. Entomol. 116: 1665–1669.

CHAPTER 6

Economic Importance and Management

Ants are considered by pest management professionals (PMPs) to be the most serious economic pest in the United States (Penn Survey in Anonymous 2002), and by homeowners to be more important than cockroaches (Whitmore et al. 1992). Smith (1965) described 49 species of house-infesting ants in the eastern United States, and Thompson (1990) discussed approximately 35 species in the United States that are urban or agricultural pests. Carpenter ants are among the top five pest ants in this country (Hedges 2001), and the most frequently treated by pest control companies (Anonymous 1994). In the Pacific Northwest, carpenter ants are the most common pest (Hedges 1997, Klotz 2004), and in some cases account for about 35% of the pest control business (T. Whitworth, pers. comm., 2003). Pest control personnel in Canada indicate that carpenter ants are ranked among the leading urban pests, particularly in the southern and western parts of the country (unpubl. comm., 1980–2004).

As Structural Pests

Carpenter ants are the principal insect pests causing damage to structures in the northern states and southern Canada (Akre et al. 1995, Hansen 1996). In the Pacific Northwest and the northeastern United States, they can be as destructive as termites (Ebeling 1975, Furniss and Carolin 1977, Fowler 1983, Fowler and Roberts 1983).

Records from various states confirm their economic importance throughout the United States (Table 6.1) (Akre and Hansen 1988, Akre et al. 1995). In Oregon and Washington, 66% of all structural treatments by

TABLE 6.1

Pest ranking of carpenter ants in various states by Cooperative Extension Services, 1979–1994

State	Year(s)	Pest ranking	Extension personnel
Michigan	1979, 1980, 1981	1	G. Dunn
	1988, 1990	1	H. Russel
Minnesota	1983, 1984, 1986, 1987, 1990	1	J. Hahn
	1985, 1988, 1989	2	
New York	1986–1993	1*	C. Klass
Ohio	1983, 1987, 1988	1	W. F. Lyon
	1984, 1985	2	
	1986	3	
Virginia	1987, 1988, 1989, 1991	1*	E. R. Day
	1984, 1990, 1992, 1993	2*	
	1986	3*	
Washington	1978, 1979–1983, 1990	1	A. L. Antonelli
	1987	2	
	1985, 1986, 1989	3	
	1984	4	

* Pest rankings included for structural pests only.

pest control companies were for carpenter ants, versus 11% for termites (Suomi and Akre 1993). In Washington, at least 42,000 structures per year were treated for carpenter ants (Hansen and Akre 1985); the estimate for 1994 was 50,000 (Akre et al. 1995). In Florida, carpenter ants were the most frequently encountered ant pest by PMPs (Klotz et al. 1996).

In the past, some extension entomologists considered carpenter ants to be primarily nuisance pests (Rachesky 1970), but they are now known to be significant wood-destroying organisms (Fig. 6.1) (Pomerantz 1955; Hansen and Akre 1985; Akre and Hansen 1988, 1990; Hedges 1993; Akre et al. 1995). Of particular importance to structural pest control are the species that inhabit forest ecosystems.

Human activities can influence the distribution and abundance of carpenter ants. For example, Washington State University in Pullman is located on what used to be a prairie ecosystem. It was an unlikely habitat for carpenter ants, but as people built houses, established lawns, and planted trees, the ecology of the region changed dramatically. Because of the hilly terrain, homeowners have extensively used railroad ties and landscaping timbers in terracing yards, thereby providing prime nesting sites for carpenter ants. With the energy crisis of 1973, wood became popular as a fuel for homes, and homeowners bought substantial numbers of uncut log decks (Akre and Hansen 1990). Most of the logs came from forests in northern Idaho, and many contained carpenter ants. As the logs were cut

Figure 6.1. Typical damage caused by carpenter ants in structural support beams. (a) *Camponotus modoc* damage in a 4 × 4-in. beam. (b) *Camponotus modoc* damage in a 12 × 8-in. beam.

and split for firewood, the ants moved into the landscape and houses. Pullman now has severe carpenter ant problems. In other cities, such as Seattle and Minneapolis, carpenter ants are no longer a problem in downtown areas because trees have been removed, but the suburbs continue to have severe infestations.

TYPES OF DAMAGE

DAMAGE TO BUILDINGS AND PROPERTY

Carpenter ants nest in wood structures or other wood products (Ebeling 1975, Furniss and Carolin 1977, Hansen and Akre 1985, Hedges 1997, Klotz 2003, 2004). They prefer moist wood that contains decay fungi, but will nest in dry, sound wood. Their nests can be found throughout a structure: porch pillars, support timbers, window framing and sills, roofs, shingles, siding, girders, joists, studs, and casings of houses, garages, and other buildings (Table 6.2). Nests have also been found in chest and cabinet drawers, behind books in libraries, in hollow doors, under floors and in attic spaces, below bay or box windows, under bathtubs or showers, and in false ceilings, stored cardboard boxes, ceiling voids around skylights, and hollow ceiling beams (Ebeling 1975, Levi and Moore 1978, Klotz 2003). Frame buildings without basements (Table 6.3) and structures in or near forests are most susceptible to attack (Table 6.4) (Hansen and Akre 1985).

Carpenter ants also infest materials other than wood. For example, they readily infest insulation (Figs. 6.2, 6.3): the stressed-skin panels or rigid foam insulation sandwiched between layers of pressed wood, drywall, or flakeboard (Coleman 1989); and extruded polystyrene, isocyanurate, urethane, and fiberglass batt insulation used in attics, walls, cathedral ceilings, subfloors, or below grade. Homes with open beams and cathedral ceilings with sheet insulation are especially prone to infestation.

Hot tubs, with their wood exterior and rigid foam or fiberglass insulation, are favorite nesting sites for carpenter ants (Fig. 6.4), which are probably attracted to the warmth and moisture as well as the soft nesting material (Allegretti 2001).

In the Pacific Northwest, where carpenter ants are particularly destructive, the primary culprits are *C. modoc* Wheeler and *C. vicinus* Mayr, with the former species accounting for about 75% of the damage (Table 6.5)

TABLE 6.2

Nest locations in structural infestations, 1981–1984

Nest location	Species of *Camponotus*		
	C. modoc (96)	*C. vicinus* (14)	*C. essigi* (9)
Inside the structure			
Floor	18.8	28.6	33.3
Attic	20.8	0	0
Interior wall void	9.4	21.4	22.2
Exterior wall void	35.4	21.4	33.3
Ceiling	18.8	14.3	0
Roof	3.1	0	0
Sill plate/supports in crawl space	3.1	7.1	0
Stacked lumber	2.1	0	0
Unknown	3.1	0	0
None	14.6	28.6	11.1
Outside the structure			
Forest within 50 m	27.1	7.1	0
Infested tree in yard	16.7	35.7	0
Wood in landscaping	7.3	21.4	0
Buried wood	8.3	7.1	0
Firewood	3.1	0	0
Stacked lumber	3.1	0	0
Stump/dead tree	15.6	7.1	0
Unknown	21.9	21.4	100
None	3.1	7.1	0

Note: Multiple nests were found both inside and outside structures infested with *C. modoc* and *C. vicinus*. Total numbers of sites are in parentheses. Numbers in table body are percentages.

TABLE 6.3

Types of understructure found in infestations during inspections in Washington State, 1981–1984

Type of understructure	Species of *Camponotus*		
	C. modoc (96)	*C. vicinus* (14)	*C. essigi* (9)
Crawl space	77.1	35.7	33.3
Basement*	11.5	50	55.6
Cement slab	3.1	14.3	11.1
Not applicable	8.3	0	0

Note: Total numbers of infestations are in parentheses. Numbers in table body are percentages.

* Full or partial basement.

TABLE 6.4

Conditions in structures that may have been conducive to the infestation in a survey in Washington State, 1981–1984

Condition	Species of *Camponotus*		
	C. modoc (96)	*C. vicinus* (14)	*C. essigi* (9)
Wood in contact with soil	35.4	64.3	22.2
Vegetation in contact with structure	32.3	35.7	33.3
Wood in landscaping	9.4	21.4	11.1
Buried wood	8.3	7.1	0
Within 50 m of forest	58.8	42.9	33.3
Faulty crawl space	8.3	7.1	11.1
Faulty attic ventilation	3.1	0	11.1
Plumbing leaks	5.2	0	22.2
Roof or gutter leaks	15.6	7.1	0
Infested trees	12.5	21.4	0
Drainage problems	1.0	0	0
Stacked firewood/lumber	4.2	0	0
Stumps or dead trees	7.3	0	0
Unknown	1.0	0	11.1

Note: Total numbers of infestations are in parentheses. Numbers in table body are percentages.

Figure 6.2. Excavations of *Camponotus modoc* in sheet foam insulation.

Figure 6.3. A nest of *Camponotus modoc* in fiberglass batt insulation.

Figure 6.4. Damage by *Camponotus modoc* to foam insulation removed from around a hot tub. Photograph courtesy of Phil Allegretti, Panhandle Pest Control, Naples, Idaho.

TABLE 6.5

Collections of carpenter ant species from structural infestations
in Washington State, 1979–1984 and 1990–1995

Species of *Camponotus*	1979–1984		1990–1995	
	No.	%	No.	%
C. modoc	641	77.8	208	71.2
C. vicinus	124	15.5	41	14.0
C. essigi	11	1.3	30	10.3
Miscellaneous *Camponotus* spp.	48	5.8	13	4.5
Total	824	100	292	100

TABLE 6.6

Main and satellite colonies in structural infestations in Washington State, 1981–1984

Species of *Camponotus*	No. of infestations	Main colony located (no. of infestations)	Satellite colony (sc) located (no. of infestations)		
			1 sc	2 sc	3 sc
C. modoc	96	79	56	24	2
C. vicinus	14	10	7	3	0
C. essigi	9	8	0	0	0

(Akre et al. 1995; Hansen 1985, 1996). In a four-year survey in Washington (Table 6.6), 85% of the *C. modoc* infestations included one to three satellite nests, and 70% of the *C. vicinus* infestations included one or two satellites (Hansen 1985).

In one older home that was being remodeled in Pullman, Washington, most of the studs along a 6-m wall were infested with *C. modoc* (Fig. 6.5). The wood was hollowed out to such an extent that a 5 × 10-cm board, 2.4 m long, weighed less than 0.9 kg (normally 6.8 kg) (Akre et al. 1995). On the Washington State University campus, the oak flooring in Bryan Hall was seriously damaged by *C. modoc* and wood decay fungi. The parent colony was located about 100 m away from the building in a wood retaining wall that was extensively excavated (Fig. 6.6). The total cost for repairs was more than $20,000 (Akre et al. 1995).

Figure 6.5. Damage by *Camponotus modoc* to a wall exposed during remodeling. Photograph by Roger D. Akre.

In western Washington, several houses less than five years old that had been built in a woodlot around a golf course had carpenter ant infestations. At one of the houses the parent colony was nesting in a stump that was buried in landscaping. From there, the ants trailed along an asphalt driveway, entering the house at the corner of the garage. They had established five satellite colonies under the attic insulation. The homeowner discovered the infestation when sawdust from a decorative beam began to accumulate on an outside windowsill. Enough sawdust to fill a five-gallon bucket was collected from the top of the insulation (Fig. 6.7). In another house that had a cathedral ceiling with open beam construction, the ants were nesting in the beam and depositing sawdust on a dining room table below.

In Minnesota, carpenter ants cause damage comparable to that found in Washington. In a home near Spider Lake, for example, there were sawdust

Figure 6.6. Damage by *Camponotus modoc* to timbers used in a retaining wall. Photograph by Roger D. Akre.

Figure 6.7. Sawdust on top of attic insulation excavated by *Camponotus modoc* from a nearby decorative beam.

piles 20 to 25 cm in depth in the basement and attic. In another home, a kitchen wall buckled when the homeowner leaned against it. Black carpenter ants, *C. pennsylvanicus* (DeGeer), had riddled a 3.5-m section of wall and the supporting beams. There was no evidence of decay or water damage to the wood. The cost to the homeowner, who repaired it, was over $5000 (Akre and Hansen 1990, Akre et al. 1995).

A homeowner in Grand Rapids, Minnesota, had two large wooden sculptures in the yard almost destroyed by *C. herculeanus* (L.). This species also caused severe damage to a boathouse and two new folding camper trailers. The canvas and wood components in both campers were severely damaged (Akre and Hansen 1990).

Along with *C. pennsylvanicus* and *C. herculeanus* (L.), *C. noveboracensis* (Fitch) is also a common structural pest in Minnesota (Akre et al. 1995). These same species are the principal structural pests in the eastern United States (Akre et al. 1995).

DAMAGE TO STANDING AND CUT TIMBER

In Blackduck, Minnesota, in 1918, it was estimated that 15% to 25% of standing white cedar in swamps and 40% to 70% on higher land was infested with carpenter ants (Graham 1918). In a survey of eight cedar mills in northern Minnesota in 1988, there was still significant loss of timber (Akre and Hansen 1990). In a New Brunswick woodlot, the incidence of infestation to standing trees, both living and dead, was 5.6% of white cedar, 4.2% of balsam fir and 1.8% of red and white spruce (Sanders 1964). This contributed to losses of about 10% of harvested spruce and balsam fir and even higher losses for white cedar. The loss of merchantable timber to carpenter ants may be a major, largely undocumented problem across the northern United States and southern Canada for a number of tree species, including Douglas fir, western red cedar (Fig. 6.8), larch, jack pine, white pine, and various elms and maples (Akre and Hansen 1990).

While tending aphids, carpenter ants also injure young conifers by gnawing and girdling them in the root collar zone (Johnson 1965, Furniss and Carolin 1977). Most of the damage is to young trees, four to eight years old, but older trees are also attacked (Furniss and Carolin 1977). Douglas fir and western hemlock are attacked by *C. noveboracensis*, and white fir by *C. modoc*.

Figure 6.8. Damage by *Camponotus modoc* to western red cedar brought into a lumber mill.

OTHER DAMAGE

At a meeting of the Philadelphia Academy of Natural Sciences in the early 1900s, a civil engineer affiliated with the railroads reported a freight train wreck caused by carpenter ant damage to a wooden trestle (McCook 1906). Around this time there were also reports of damage by carpenter ants to telephone and telegraph poles (Snyder 1910). From 1933 to 1935, about 10% of the utility poles that were inspected each year by the Southern New England Telephone Company were rejected because of carpenter ant damage (Friend and Carlson 1937). A 1982 survey by a northeastern utility company found that 70% of the utility poles recommended for replacement were infested with carpenter ants, at an estimated cost of $167,000 (Shields et al. 2000). Since that time, utility companies have increased their use of Douglas fir, even though it is more susceptible to damage than some of the other woods because preservatives do not penetrate it as well (Shields et al. 2000). For one major northeastern utility company, the

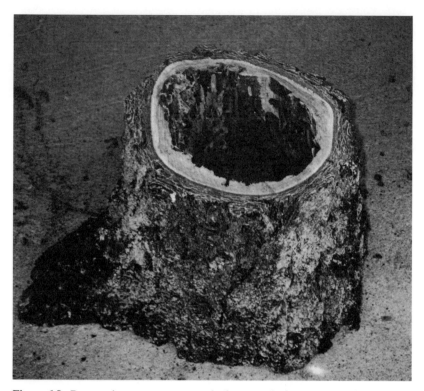

Figure 6.9. Damage by carpenter ants to the heartwood of an ornamental tree.

replacement rate of utility poles damaged by carpenter ants was 100 to 250 poles per year at a cost of $4 to $11 million (Shields et al. 2000). In the Northeast, the carpenter ants most responsible for damage to utility poles are *C. pennsylvanicus* and *C. noveboracensis.*

Carpenter ants cause damage to urban shade trees (Fowler and Parrish 1982, Fowler and Roberts 1982, Fowler 1986). In New Jersey, for example, 75% of urban shade trees sampled in 1981–1982 were infested. The most frequently infested tree was silver maple, while white pine was least attacked. Carpenter ant excavations can extend into the heartwood (Fig. 6.9) and can weaken trees as well as expose them to pests and pathogens (Craighead 1950). The ants also cultivate homopteran pests in trees, which may lead to extensive leaf-curling (Fowler and Parrish 1982).

Carpenter ants are also pests in apiaries. In the southern United States, *C. floridanus* (Buckley) plunders hives for food and nesting space (Smith

1965, Walshaw 1967), and in Missouri, *C. pennsylvanicus* causes structural damage to hives (Burrill 1926). To protect their hives, some beekeepers immerse the leg supports in oil.

COSTS OF CONTROL

In 1980 in central New Jersey, a partial treatment for carpenter ants cost at least $50, while a standard one was $500 or more (Fowler 1986). Based on these figures, and an estimated 24,800 jobs by pest control companies to treat carpenter ants each year, costs for carpenter ant control in Middlesex County were between $1.2 and $12 million, and at least $25 million for the entire state. These estimates, however, do not include the costs of insecticides used by homeowners; repairs to damaged structures; fumigation, which has been used in some cases and ranges from $3000 to $8000 for an average-sized house; and damage to trees, which can be considerable in New Jersey (Fowler and Roberts 1982).

In Washington, the number of carpenter ant treatments has increased since 1985, when a conservative estimate was 42,000 (Hansen 1985). With an average cost per treatment of $300, the total yearly cost was $12.6 million, which does not take into account the indirect costs such as repairs for damage.

In the early 1990s, cost estimates for carpenter ant treatments varied from $325 to $800 for full treatments, and from $75 to $375 for spot treatments (Pinto 1992). The actual costs of carpenter ant control, however, are difficult to assess and are derived mainly from estimates by PMPs.

Carpenter ant damage rarely compromises the structural integrity of a building (Fowler 1986). However, this may be due to early control measures that eliminate the ants before they inflict serious damage. Most homeowners (83.5%) dislike finding any insect in their home (Byrne et al. 1984), and carpenter ants are considered serious pests whether or not they have caused structural damage (Dukes and Robinson 1982, Dukes 1989). Alates in particular arouse the most concern (Fowler 1990).

MANAGEMENT

Nonchemical techniques, such as exclusion and habitat modification, combined with strategic applications of pesticides, can provide an effec-

Figure 6.10. House constructed on a heavily forested lot, which is conducive to attack by carpenter ants.

tive pest management program for carpenter ants (Klotz et al. 1997, Klotz 2003, 2004).

New Construction

It has become increasingly common in the Pacific Northwest, Northeast, and many other parts of the United States to build homes in or near forests (Fig. 6.10) (Hansen and Akre 1985, Fowler 1986, Akre and Hansen 1990). As a result, carpenter ant complaints are on the increase. New homes are frequently invaded and damaged by satellite colonies even before construction is complete (Akre and Hansen 1990). In the past, damage was attributed to small, slowly growing colonies, which developed from a single mated queen. It is now known that large colonies can invade a new house in a short period of time.

It is recommended that before construction begins in or near woodlots, the contractor hire an entomologist or PMP to inspect the site for carpenter ants (Akre and Hansen 1990). Trees containing colonies (Fig. 6.11)

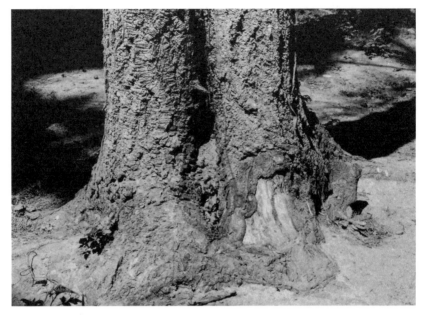

Figure 6.11. A Douglas fir tree with a parent colony of carpenter ants nesting at the base.

should be treated or removed. It is essential that cut trees and waste wood be removed from the construction site or burned (Fig. 6.12); they should not be buried because that provides nesting sites (Akre and Hansen 1988, 1990; Fowler 1986; Mankowski and Morrell 2000).

The ideal time to protect buildings from carpenter ants is before the installation of drywall or interior vapor barriers (Fig. 6.13). One effective technique consists of a light application of insecticidal dust inside the walls after the electrical wiring and plumbing have been installed, but before the insulation is added (Fig. 6.14) (Akre and Hansen 1990). For ants, wires and pipes are the primary routes of travel within a structure (Akre and Hansen 1988, Klotz et al. 1993, Akre et al. 1995). Dusts should also be applied to all sides of foam sheet insulation in open beam or cathedral ceilings as well as the bottom plate between the wall studs. If the dust stays dry, it will remain active for years (Hansen and Akre 1993). Some dust formulations even work well in humid atmospheres (Caruba 1988).

Attics and crawl spaces should have sufficient ventilation to prevent the accumulation of moisture, which can attract carpenter ants. Vapor barriers to cover soil surfaces are recommended for crawl spaces. All supports for

Figure 6.12. A slash pile housing a parent colony of *Camponotus modoc* that produced satellite nests in a nearby structure.

Figure 6.13. Wall interior before drywall is added, showing stud spacing and construction.

Figure 6.14. Wall interior showing wiring within a wall void before insulation is added. Carpenter ants travel through voids on wires and pipes.

Figure 6.15. Structural timber support correctly placed on concrete.

Figure 6.16. An earth-sheltered house with insufficient ventilation and moisture protection that had a severe carpenter ant infestation.

the house, porch, or decking should rest directly on concrete (Fig. 6.15), and not the ground, where they might absorb moisture (Akre and Hansen 1990).

Certain types of construction such as unventilated cathedral ceilings and flat-roofed or earth-sheltered homes (Fig. 6.16) are particularly susceptible to carpenter ant infestations because of ventilation and drainage problems, respectively. In the Pacific Northwest, houses with crawl spaces are the most frequently infested (Table 6.3) (Hansen and Akre 1985), and the damage can be serious when the ants attack support beams (Fig. 6.17).

MAINTENANCE OF STRUCTURES

A pest management program for carpenter ants consists of four steps: (1) client interview, (2) inspection, (3) treatment, and, (4) follow-up evaluation (Hansen 1993, 1996).

Interview. With relevant questions (Table 6.7), the PMP can obtain valuable information from a client concerning the history and details of an infestation. The answers can help the PMP determine the extent and source

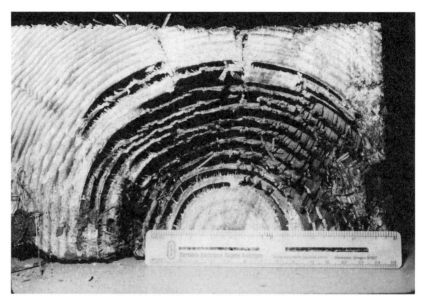

Figure 6.17. Carpenter ant damage to a structural beam.

of an infestation so that the inspection can concentrate on specific areas of the structure for finding nests or determining the point(s) of entry from outside nests.

Inspection. A critical and time-consuming step in carpenter ant pest management is the inspection (Klotz and Bennett 1992; Hansen 1993, 2001; Klotz 2003). The objectives are threefold: (1) to identify the species of carpenter ant(s) causing the problem, (2) to find nests located inside the structure, and (3) to find nests located on the property outside the structure (Akre et al. 1994a, 1994b; Hansen 2002a). Accomplishing these objectives is challenging because nests are notoriously difficult to locate and trails are often hidden in vegetation. Table 6.4 lists several conditions that contribute to carpenter ant infestation and where nests are often found (Hansen and Akre 1985, 1993).

For high-risk homes in the Pacific Northwest, inspections are essential during the peak activity period from April through August. Because many species of carpenter ants are primarily nocturnal, inspections after sunset are particularly helpful for locating nests and trails (Suiter and Bennett 1999), and just as in termite control, an inspection diagram or sketch showing possible nesting sites and trails can be useful.

TABLE 6.7

Interview questions asked to homeowners for the purpose of obtaining a history of the structure and of the carpenter ant infestation

History of the stucture
1. How old is the structure?
2. Is the exterior brick or siding? Is siding wood, vinyl, or aluminum?
3. How long have you lived in the structure?
4. Is the understructure a crawl space, slab, or basement?
5. If a basement, is it finished?
6. If a crawl space, is there access?
7. Do you have a cathedral ceiling or an open beam ceiling?
8. Is there access to the attic?
9. Have remodeling or additions been made to the structure?
10. What types of insulation are in the walls, attic, and subfloor?
11. Is the roof flat, gently sloped, or steeply sloped?
12. Has the roof or siding been replaced?
13. Have there been roof or gutter leaks?
14. Have there been plumbing repairs?
15. Have you had any other water leaks?
16. Does frost or water vapor occur on the inside of windows?
17. How many bathrooms, kitchens, and laundry rooms are in the house?

Interior infestation
1. How long have you seen ants in the house?
2. In what rooms are you seeing the ants?
3. Are the ants winged?
4. How many ants are you seeing in a 24-hour period?
5. Have the ants been attracted to a particular food product?
6. Have you noticed sawdust anywhere that may have been excavated by the ants?
7. Have you heard any rustling noises in the walls?
8. Have children observed ants or heard rustling noises?

Exterior infestation
1. Have you observed ants outside the structure?
2. Have you noticed ant trails along foundations or landscaping timbers?
3. Do you use decorative bark in your landscaping? If so, how deep is the bark?
4. Are trees or shrubs touching the roof or sides of the house?
5. What type and size are the trees in your yard?
6. Have any trees been removed from the yard? If so, were the stumps removed?
7. How far are the trees from your house?
8. Are landscaping timbers or railroad ties used in your yard?
9. Have major disturbances such as new water, sewer, or electrical lines occurred?
10. Do you have a deck or hot tub? If so, is there access under these areas?
11. Is there a wooden fence around the yard? Does it touch the house?
12. Is there stacked lumber or firewood near the house? If so, how long has it been stacked?

The presence of ants, sawdust (Fig. 6.18), and rustling noises in the walls or ceiling (Table 6.8) indicates an infestation (Hansen and Akre 1985, 1993; Klotz et al. 1994). If carpenter ant workers or alates emerge in a structure during the winter or early spring, then one can assume that there is at least one interior nest. On the other hand, if ants are found inside

Figure 6.18. Sawdust extruded by *Camponotus modoc* from a ceiling over a cabinet.

TABLE 6.8

Indicators of structural infestation found during inspections in Washington State, 1981–1984

Indicators	Species of *Camponotus*		
	C. modoc (96)	*C. vicinus* (14)	*C. essigi* (9)
Presence of foragers	98.9	100	100
Extruded sawdust	55.2	35.7	11.1
Rustling noises	20.8	7.1	0
Foraging trails	65.6	57.1	0

Note: Multiple signs were found with each species. Total numbers of infestations are in parentheses. Numbers in table body are percentages.

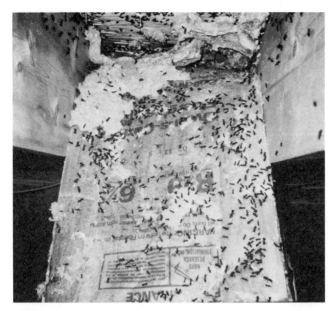

Figure 6.19. Satellite nest of *Camponotus modoc* under subfloor insulation. Photograph courtesy of Phil Allegretti, Panhandle Pest Control, Naples, Idaho.

during the peak of their seasonal activity, then they may only be scouts from an outside nest.

The inspection should include crawl spaces (Fig. 6.19) and attics (Fig. 6.20), with special attention given to insulation. Rigid foam and fiberglass batt insulation are ideal nesting sites for carpenter ants because they retain moisture and heat, and are easy to excavate (Allegretti 2002). Where batt insulation is used in attics and subfloors, the inspector should check for ant activity along the edges where insulation meets the joists (Fig. 6.21). The exterior of a structure should also be inspected (Fig. 6.22) (Hansen 1993). Insulation on the foundation below grade should be inspected for nesting sites. In the surrounding property, trees, stumps, driftwood, or any wood item used in landscaping should be carefully inspected. Tree branches or vines touching the structure often provide a foraging trail or connection between parent and satellite colonies (Fig. 6.23). Even if treated with creosote, decorative railroad ties and other landscaping timbers often have cracks or other openings that allow carpenter ants access to the untreated interior wood for nesting (Figs. 6.24, 6.25)

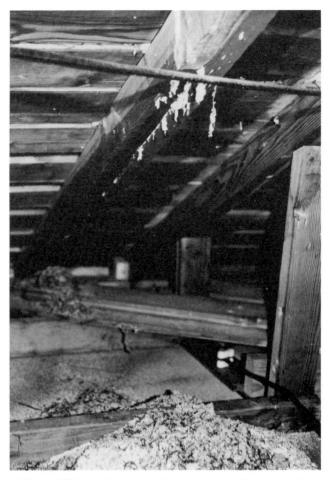

Figure 6.20. Satellite nest of *Camponotus modoc* in an attic.

(Allegretti 2003). These nests often go unnoticed when the ants have deposited the sawdust under or behind the timber, or used it to line their underground foraging trails, which sometimes emerge several meters from the nest.

Finding the parent colony may be time-consuming but it is essential for long-term management (Anonymous 1994, Klotz et al. 1994). Nontoxic baits such as sugar milk, honey, or freshly killed crickets or mealworms can be placed on foraging trails in order to "feed and follow" the ants to their nest (Klotz and Akre 1991, Akre et al. 1994b). In infestations where

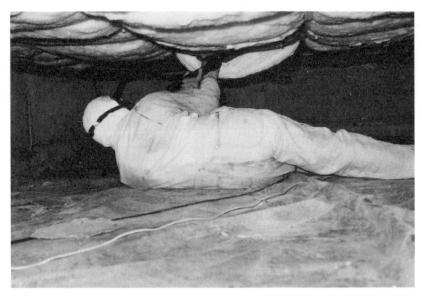

Figure 6.21. Inspection of subfloor insulation in a crawl space, with a technician checking edges where insulation meets the floor joists.

thick brush or bramble thickets surround a structure, finding the parent colony can be extremely difficult. From a total of 31 structures infested with *C. modoc*, Akre et al. (1994a, 1994b) found the parent colony within five minutes to one hour for 22 of the structures. At the remaining sites, the probable location of the parent colony was determined in less than one hour.

TREATMENT

CHEMICAL CONTROL

There are a number of treatment options for the chemical control of carpenter ants (Hansen 2000, 2002a). A full chemical treatment consists of an insecticide application to wall voids plus a perimeter spray to the exterior foundation. For houses with a crawl space, the sill plate should also be treated. A partial or spot treatment can be used for a new or localized infestation. For example, during the month of July in the Pacific Northwest, satellite colonies move into structures. If the infestation is detected early,

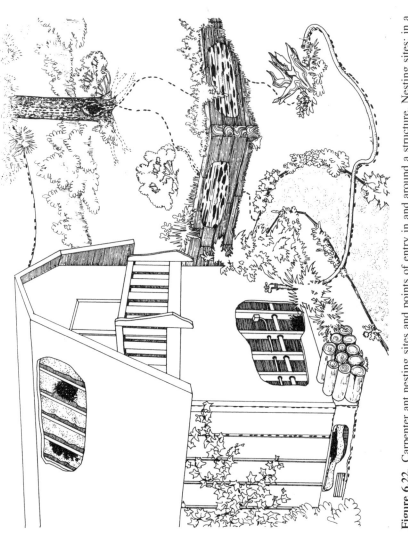

Figure 6.22. Carpenter ant nesting sites and points of entry in and around a structure. Nesting sites: in a wood pile, in exterior wall voids, under subfloor insulation, in a living tree, under attic insulation, in timbers in retaining wall, in driftwood. Points of entry: holes for plumbing or wiring, edge of siding, crawl-space vent, roof eaves, vine on the structure, vegetation touching structure.

Figure 6.23. Vines on the exterior of a house used by foraging carpenter ants.

a spot treatment might be all that is necessary. All satellite nests within a structure should be eliminated because the workers can survive even if their parent colony is destroyed. A satellite colony cannot produce additional workers, but the ones there can continue to excavate wood.

Toxic baits are an option for homeowners reluctant to use sprays, but baiting requires more time for application and follow-up, and of course is limited to the foraging season. A protective treatment, consisting of a perimeter spray applied each spring, might be necessary for high-risk homes (Akre and Hansen 1990, Hedges 1993, Hansen 2002a, Klotz 2003).

There are a number of different insecticide formulations for carpenter

Figure 6.24. Railroad ties used in landscaping often harbor parent colonies.

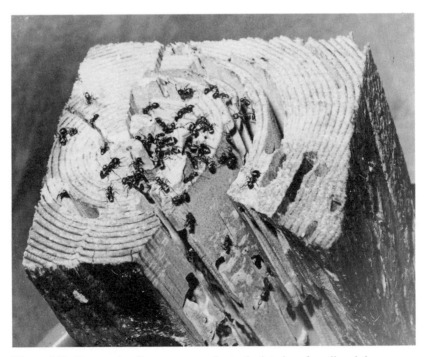

Figure 6.25. Damage by *Camponotus modoc* to the interior of a railroad tie.

Figure 6.26. A dust application behind an electrical box to treat wires where carpenter ants travel.

ant control, and they contain a variety of active ingredients. Dusts are the most effective for wall voids. To gain access into voids, the wall plates of electrical outlets and switches, and plumbing flanges can be removed (Fig. 6.26). If there are no convenient access points, small holes (3 mm) can be drilled into the walls in inconspicuous locations, and the dust applied with a wand. It is not necessary to treat between all of the wall studs. Treatment of the wires and pipes within accessible wall voids will usually be sufficient because these are the main routes of travel for ants.

Some PMPs inject liquid formulations into wall voids. This is an effective strategy. However, in a comparison of the amount of active ingredient used in a dust versus a liquid application, there was 60 times less active ingredient used in the former (Akre et al. 1995). The lowest amount of chemical that will effectively control the infestation provides the lowest exposure and least risk to nontarget organisms and residents.

A perimeter spray should be applied to the foundation, with the spray directed under the lower edge of the siding (Fig. 6.27), where carpenter ants often trail. The insecticide is protected here from degradation by direct sunlight and rainfall (Hansen and Akre 1993, Tripp et al. 2000). In addition,

Figure 6.27. A perimeter spray application under the lower edge of siding.

frames around doors and windows should be treated. If the house has a crawl space, spray should also be applied to the inside of the foundation, sill plate, house supports, wires, and pipes. Perimeter sprays are most effective when applied with a low-pressure hand sprayer because it allows more precise placement using less insecticide than does a power sprayer (Akre et al. 1995). With some of the new nonrepellent active ingredients, carpenter ant infestations can be controlled with a perimeter spray alone.

Tent fumigation is generally not recommended for carpenter ant control (Hansen 1987), but some companies resort to it in difficult cases. For an average-size home (1500 square feet) about 20 pounds of active ingredient is used (Akre et al. 1995). If the parent colony is located outside the structure, as has been shown in more than 70% of the infestations with *C. modoc* and *C. vicinus* in the Pacific Northwest (Hansen and Akre 1985), the ants may reinfest the structure soon after fumigation.

BAITS

Baits can be an effective control measure for ants, owing to their recruitment and food-sharing behaviors, which facilitate the distribution of a

Figure 6.28. Workers of *Camponotus modoc* feeding on toxic bait.

toxicant throughout the colony. The use of baits to control carpenter ants is an old remedy recommended more than 60 years ago by the U.S. Department of Agriculture (Back 1937).

Bait formulations can be liquid, gel, or solid. To be effective, they must be sufficiently attractive to stimulate recruitment, which has been a major challenge in bait development (Hansen 2000). In addition, the toxicant must be slow acting so that recruitment and food sharing are not impeded (Fig. 6.28) (Rust et al. 2002).

In a five-year field trial, baits provided 71% to 100% control of carpenter ants (Hansen 2002b). Liquid baits with boric acid took 11 weeks to achieve control, while granular baits with hydramethylnon took 10 weeks. Both provided 100% control. Gel and granular baits with fipronil provided 76% and 92% control in an average of 6 and 7 weeks, respectively. The

highly variable results may be due to the availability of alternative food sources to foraging ants.

There are a number of different baits on the market, with varying degrees of effectiveness. Their limitations may be partly due to the vagaries of diet and behavior of carpenter ants. For example, the dietary requirements of carpenter ants change with the season (Cannon and Fell 2002). Carpenter ants' repetitive activities may explain their attraction and recruitment to a bait or bait station at one location but not at another. Foraging ants repeatedly use the same trail to arrive at foraging sites, a behavior referred to as trail fidelity (David and Wood 1980). In addition, individual workers have a commitment to a specific task such as foraging or nest building, referred to as task fidelity (Fowler and Roberts 1980). Carpenter ants also exhibit site fidelity, repeatedly visiting the same foraging site, which may be particularly rich in a specific food source (Dukes 1989). Therefore, it is important to monitor food preference and foraging territories in order to determine what the ants are feeding on and where. It is recommended that a number of different baits be offered simultaneously to determine the most preferred one at a particular time and location (Hansen 2000, 2001; Klotz 2003, 2004).

CULTURAL CONTROL

Repairs to older or improperly constructed houses are important cultural control measures (Fig. 6.29) (Akre and Hansen 1990, Klotz and Warder 1993). All moisture damage should be corrected by providing proper ventilation, installing effective vapor barriers, and repairing broken or leaky pipes and gutters. Wood that has been seriously damaged by decay fungi should be replaced (Fig. 6.30).

All potential entry points into a structure should be caulked or sealed. Common entry points include those for telephone, electrical (Fig. 6.31), and water lines. Tree branches, shrubs, and vines in contact with a structure should be trimmed away because they provide access for ants (Fig. 6.32). Buried wood, such as stumps, should be chemically treated or removed (Akre and Hansen 1990).

Proper landscaping is important in carpenter ant management. Deep piles of decorative bark, especially Douglas fir and western red cedar, sold for landscaping purposes are one of the prime sources of new queens and small carpenter ant colonies. Occasionally even large satellite colonies, particularly of *C. vicinus*, which has multiqueen colonies, will nest in

Figure 6.29. Structural gaps in poor housing construction provide access for carpenter ants.

decorative bark. Consequently, only shallow layers (less than 5 cm) of decorative bark should be used on property that is at high risk for carpenter ants (Akre and Hansen 1990).

Decorative bark or soil placed adjacent to a foundation should be at least 15 to 20 cm below the lower edge of the siding and for proper drainage should slope away from the structure (Hansen and Akre 1993).

Stacking firewood against houses is a common practice that can lead to problems if the wood is infested with carpenter ants (Fig. 6.33). Therefore, prospective firewood should be inspected for carpenter ants before it is cut or purchased, and it should be stacked away from the house in a shelter to keep it dry (Akre and Hansen 1990).

Other Strategies

Excluding carpenter ants by using building materials that prevent their attack is an alternative strategy. These include materials that incorporate plastics into processed lumber, which can be used in exterior structures such as decks; lumber treated with the preservative ammoniacal copper

Figure 6.30. Damage to structure by wood decay fungi.

zinc arsenate (ACZA), which kills ants on contact (Hansen and Thies 1998); insulation materials, particularly foam boards, impregnated with borates and other compounds that repel or kill the ants when they contact or excavate it; and a bed of plastic roofing cement on which foam core panels are set, to prevent entry of carpenter ants (Coleman 1989).

The fungi *Beauveria bassiana* (Balsoma) Vuillemin and *Metarhizium anisopliae* (Metchnikoff) Sorokin are pathogenic to *C. pennsylvanicus* (Kelley-Tunis et al. 1995). When worker ants are exposed to fungal conidia of the two species during single or continuous feeding in an inoculation chamber, they die faster from exposure to *B. bassiana*. Infections can also be passed from one ant to another through the horizontal transmission of

Figure 6.31. A *Camponotus modoc* worker following an exterior wire into a

structure.
Figure 6.32. Vegetation trimmed away from the house prevents moisture problems

and reduces the potential for carpenter ant infestation.
Figure 6.33. A stack of firewood infested with *Camponotus modoc.*

conidia. Field tests are needed to determine if these fungi can be used effectively as biological control agents for carpenter ants.

FOLLOW-UP EVALUATION

The final step in carpenter ant control is an evaluation by the PMP of the entire program, including inspections as well as any chemical and non-chemical treatments.

REFERENCES CITED

Akre, R. D., and L. D. Hansen. 1988. Carpenter ants. *In* P. A. Zungoli, ed., Proceedings of the National Conference on Urban Entomology, pp. 59–63. Clemson, S. Car.: Clemson University.

Akre, R. D., and L. D. Hansen. 1990. Management of carpenter ants. *In* R. K. Vander Meer, K. Jaffe, and A. Cedeno, eds., Applied myrmecology: a world perspective, pp. 693–700. Boulder, Colo.: Westview Press.

Akre, R. D., L. D. Hansen, and E. A. Myhre. 1994a. Do you know where your parents are? Pest Control Tech. 22(5): 44, 46, 55, 58, 60, 64.

Akre, R. D., L. D. Hansen, and E. A. Myhre. 1994b. Finding the parent colony. *In* W. H. Robinson, ed., Proceedings of the National Conference on Urban Entomology, p. 115. Blacksburg: Virginia Polytechnic Institute and State University.

Akre, R. D., L. D. Hansen, and E. A. Myhre. 1995. Home wreckers. Pest Control Tech. 23(1): 54–57, 60, 77.

Allegretti, P. 2001. Ants love hot tubs, too. Pest Control 69(3): 25–27.

Allegretti, P. 2002. Inspect insulation to find carpenter ants. Pest Control 70(2): 42–43.

Allegretti, P. 2003. Carpenter ants come from the outside first. Pest Control 71(7): 30, 32.

Anonymous. 1994. Finding nest will have ants crying "uncle." Pest Control 62(9): 42.

Anonymous. 2002. State of the industry 2002: pest services drive profits. Pest Control 70(7): S4–S5.

Back, E. A. 1937. House ants. U.S. Dept. Agric. leaflet No. 147.

Burrill, A. C. 1926. Ants that infest bee hives. Am. Bee J. 66: 29–31.

Byrne, D. N., E. H. Carpenter, E. M. Thoms, and S. T. Cotty. 1984. Public attitudes toward urban arthropods. Bull. Entomol. Soc. Am. 30: 40–44.

Cannon, C. A., and R. D. Fell. 2002. Patterns of macronutrient collection in the black carpenter ant, *Camponotus pennsylvanicus* (DeGeer) (Hymenoptera: Formicidae). Environ. Entomol. 31: 977–981.

Caruba, A. 1988. Insecticide dusts make a comeback. Pest Control Tech. 16(11): 44, 46.

Coleman, J. 1989. Carpenter ants and foam-core panels. J. Light Construction 7(7): 20–21.

Craighead, F. C. 1950. Insect enemies of eastern forests. U.S. Dept. Agric. Misc. Publ. 657.

David, C. T., and D. L. Wood. 1980. Orientation to trails by a carpenter ant, *Camponotus modoc* (Hymenoptera: Formicidae), in a giant sequoia forest. Can. Entomol. 112: 993–1000.

Dukes, J. 1989. Aspects of the biology, behavior, and economic importance of *Camponotus pennsylvanicus* (DeGeer) and *Camponotus ferrugineus* (Fabricius) (Hymenoptera: Formicidae). M.S. thesis, Virginia Polytechnic Institute and State University, Blacksburg.

Dukes, J., and W. H. Robinson. 1982. Carpenter ants: economic importance of an eastern wood-infesting pest. Pest Control 50(9): 28, 30–31, 60.

Ebeling, W. 1975. Urban entomology. Los Angeles: University of California, Division of Agricultural Science.

Fowler, H. G. 1983. Urban structural pests: carpenter ants (Hymenoptera: Formicidae) displacing subterranean termites (Isoptera: Rhinotermitidae) in public concern. Environ. Entomol. 997–1002.

Fowler, H. G. 1986. Biology, economics, and control of carpenter ants. *In* S. B. Vinson, ed., Economic impact and control of social insects, pp. 272–289. New York: Praeger.

Fowler, H. G. 1990. Carpenter ants (*Camponotus* spp.): pest status and human perception. *In* R. K. Vander Meer, K. Jaffe, and A. Cedeno, eds., Applied myrmecology: a world perspective, pp. 525–532. Boulder, Colo.: Westview Press.

Fowler, H. G., and M. D. Parrish. 1982. Urban shade trees and carpenter ants. J. Arboriculture 8: 281–284.

Fowler, H. G., and R. B. Roberts. 1980. Foraging behavior of the carpenter ant, *Camponotus pennsylvanicus* (Hymenoptera: Formicidae), in New Jersey. J. Kans. Entomol. Soc. 53: 295–304.

Fowler, H. G., and R. B. Roberts. 1982. Carpenter ant (Hymenoptera: Formicidae) induced wind breakage in New Jersey shade trees. Can. Entomol. 114: 649–650.

Fowler, H. G., and R. B. Roberts. 1983. Activity cycles of carpenter ants (Hymenoptera: Formicidae: *Camponotus*) and subterranean termites (Isoptera: Rhinotermitidae: *Reticulitermes*): inference from synanthropic records. Insectes Soc. 30: 323–331.

Friend, R. B., and A. B. Carlson. 1937. The control of carpenter ants in telephone poles. Conn. Agric. Station. Bull. ARS-H-6.

Furniss, R. L., and V. M. Carolin. 1977. Western forest insects. U.S. Dept. Agric. For. Serv. Misc. Publ. 1339.

Graham, S. A. 1918. The carpenter ant as a destroyer of sound wood. Minn. State Entomol. Rep. 17: 32–40.

Hansen, L. D. 1985. Biology of carpenter ants in Washington State (Hymenoptera: Formicidae: *Camponotus*). Ph.D. dissertation, Washington State University, Pullman.

Hansen, L. D. 1987. Tent fumigation not appropriate for carpenter ant control. Entomol. Newsl. County Agents. Coop. Ext. Washington State University July (3): 13.

Hansen, L. D. 1993. Carpenter ants and urban pest management. Pest Control Tech. 21(3): 52–55.

Hansen, L. D. 1996. Managing carpenter ant populations in urban environments. *In* K. B. Wildey, ed., Proceedings of the 2nd International Conference on Insects Pests in the Urban Environment, pp. 587–595. Exeter, Great Britain: BPC Wheatons.

Hansen, L. D. 2000. Successful bait development is more than a matter of taste. Pest Control 68(5): 52, 54, 58.

Hansen, L. D. 2001. Carpenter ants: a coast-to-coast nemesis. Service Technician 9(5): 25–26.

Hansen, L. D. 2002a. Carpenter ant update. Pest Control Tech. 30(4): 56, 58, 60, 62.

Hansen, L. D. 2002b. Efficacy of different baiting matrices as tools in the management of carpenter ants (Hymenoptera: Formicidae). *In* S. C. Jones, J. Zhai, and W. H. Robinson, eds., Proceedings of the 4th International Conference on Urban Pests, pp. 283–287. Blacksburg, Va.: Pocahontas Press.

Hansen, L. D., and R. D. Akre. 1985. Biology of carpenter ants in Washington State (Hymenoptera: Formicidae: *Camponotus*). Melanderia 43: 1–62.

Hansen, L. D., and R. D. Akre. 1993. Urban pest management of carpenter ants. Proceedings of the 1st International Conference on Insect Pests in the Urban Environ., pp. 271–279.

Hansen, L. D., and D. B. Thies. 1998. Carpenter ant mortality in laboratory tests when exposed to wood treated with ACZA. *In* Chemonite and Carpenter Ants, pp. 1–9. Foster City, Calif.: Chemonite Council.

Hedges, S. A. 1993. 20 questions: carpenter ants. Pest Control Tech. 21(5): 50–52, 54.

Hedges, S. A. 1997. Ants. *In* D. Moreland, ed., Handbook of Pest Control, 8th ed., pp. 502–589. Cleveland, Ohio: Mallis Handbook and Technical Training Company.

Hedges. S. A. 2001. 2001 Pest wrap-up. Pest Control Tech. 29(12): 40, 42, 46, 63–64.

Johnson, N. E. 1965. Reduced growth associated with infestations of Douglas fir seedlings by *Cinara* species (Homoptera: Aphidae). Can. Entomol. 97: 113–119.

Kelly-Tunis, K. K., B. L. Reid, and M. Andis. 1995. Activity of entomopathogenic fungi in free-foraging workers of *Camponotus pennsylvanicus* (Hymenoptera: Formicidae). J. Econ. Entomol. 88: 937–943.

Klotz, J. H. 2003. Hot on the trail. Pest Control Tech. 31(4): 26, 44–49.

Klotz, J. H. 2004. Ants. *In* D. Moreland, ed., Handbook of Pest Control, 9th ed., pp. 634–693. Cleveland, Ohio: Mallis Handbook and Technical Training Company.

Klotz, J. H., and R. D. Akre. 1991. Carpenter ants: fact and fiction. Pest Control 59(6): 54–56.

Klotz, J. H., and G. Bennett. 1992. Carpenter ants: the urban pest management challenge. Pest Control 60(5): 44–50.

Klotz, J. H., G. Goveia, L. Davis, and B. Reid. 1994. Surgical strikes. Pest Control Tech. 22(5): 32–33, 36, 38, 42.

Klotz, J. H., L. Greenberg, H. H. Shorey, and D. F. Williams. 1997. Alternative control strategies for ants around homes. J. Agric. Entomol. 14: 249–257.

Klotz, J. H., B. Reid, L. D. Hansen, and S. A. Klotz. 1996. Ecology to control carpenter ants. Pest Control 64(6): 46, 48, 50.

Klotz, J. H., and B. Warder. 1993. Carpenter ants. Pest Control Tech. Service Technician 1: 52–54.

Klotz, J. H., D. F. Williams, and B. L. Reid. 1993. Hot on the trail. Pest Control Tech. 22(5): 44, 48–49.

Levi, M. P., and H. B. Moore. 1978. The occurrence of wood-inhabiting organisms in the United States. Pest Control 46(2): 14, 16–18, 20, 45, 49.

Mankowski, M., and J. J. Morrell. 2000. Incidence of wood-destroying organisms in Oregon residential structures. For. Products J. 50(1): 49–52.

McCook, H. C. 1906. A guild of carpenter ants. Harper's Monthly Mag. 113: 293–300.

Pinto, L. 1992. Price comparisons of five different treatments for carpenter ants. Pest Control Exec. Pinto and Assoc. Rep. 2: 1, 5.

Pomerantz, C. 1955. The fabulous and destructive carpenter ant. Pest Control 23(10): 9, 10, 14, 64, 66, 70, 71.

Rachesky, S. 1970. March of the ants. Pest Control 38(2): 36.

Rust, M. K., D. A. Reierson, and J. H. Klotz. 2002. Factors affecting the performance of bait toxicants for Argentine ants (Hymenoptera: Formicidae). *In* S. C. Jones, J. Zhai, and W. H. Robinson, eds., Proceedings of the 4th International Conference on Urban Pests, pp. 115–120. Blacksburg, Va.: Pocahontas Press.

Sanders, C. J. 1964. The biology of carpenter ants in New Brunswick. Can. Entomol. 96: 894–909.

Shields, E. J., V. Y. Jacobs-Lorena, M. Blagen, and A. M. Testa. 2000. Economic impact of carpenter ants, *Camponotus* spp., control on utility poles. Am. Entomol. 46: 50–55.

Smith, M. R. 1965. House-infesting ants of the eastern United States: their recognition, biology, and economic importance. Agricultural Research Service, U.S. Dept. Agric. Tech. Bull. 1326.

Snyder, T. E. 1910. Insects injurious to forests and forest products: damage to chestnut telephone and telegraph poles by wood-boring insects. U.S. Dept. Agric., Agric. Bur. Entomol. Bull. 94, Part 1, pp. 1–12.

Suiter, D. R., and G. W. Bennett. 1999. Inspection: the key to successful carpenter ant control. Pest Control Tech. 30(4): 68–70, 72.

Suomi, D. A., and R. D. Akre. 1993. Part 5. Prevention and management of wood-destroying anobiid infestations in structural timbers. Pp. 22–24 *in* D. A. Suomi and R. D. Akre, eds., Biology and management of the structure-infesting beetle, *Hemicoelus gibbicollis* (LeConte) (Coleoptera: Anobiidae). Melanderia 49: 1–39.

Thompson, C. R. 1990. Ants that have pest status in the United States. *In* R. K. Vander Meer, K. Jaffe, and A. Cedeno, eds., Applied myrmecology: a world perspective, pp. 51–67. Boulder, Colo.: Westview Press.

Tripp, J. M., D. R. Suiter, G. W. Bennett, J. H. Klotz, and B. L. Reid. 2000. Evaluation of control measures for black carpenter ant (Hymenoptera: Formicidae). J. Econ. Entomol. 93: 1493–1497.

Walshaw, E. R. 1967. The raiders. Am. Bee J. 107: 14–15.

Whitmore, R. W., J. E. Kelly, and P. L. Reading. 1992. National home and garden pesticide use survey, final report. Vol. 1: Executive summary, results, and recommendations. Washington, D.C.: U.S. Environmental Protection Agency.

Index

Note: Page numbers followed by *f* refer to figures; *m* to maps; *t* to tables.